BLACK JOY
is everywhere

THE BL JOY

MARINER BOOKS
New York Boston

ACK

Project

KLEAVER CRUZ

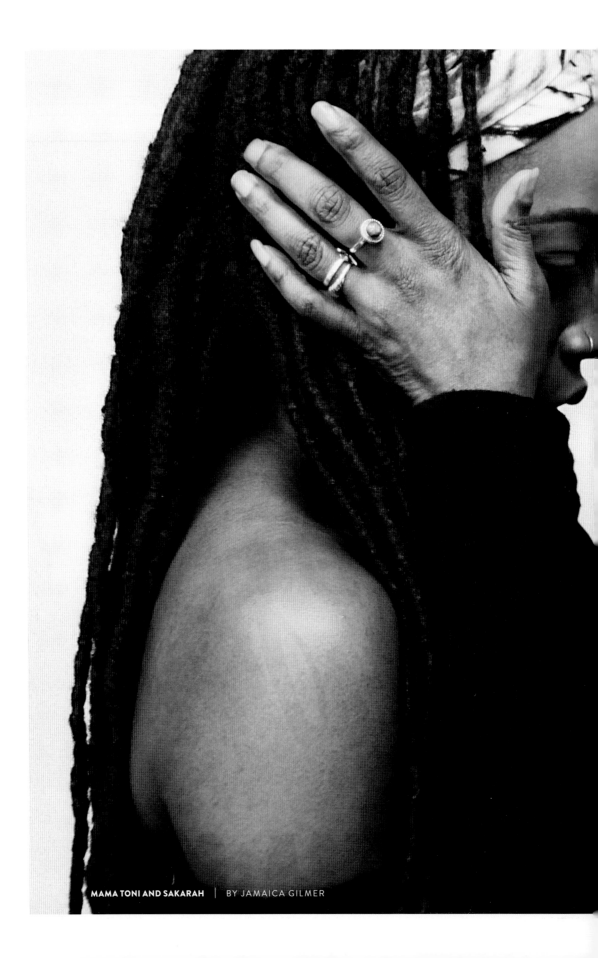

MAMA TONI AND SAKARAH | BY JAMAICA GILMER

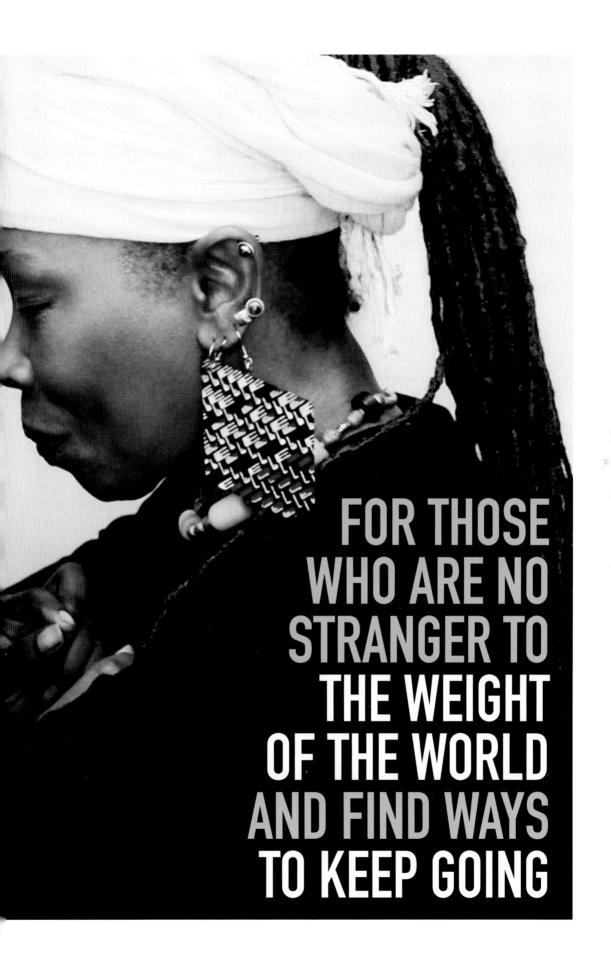

FOR THOSE
WHO ARE NO
STRANGER TO
THE WEIGHT
OF THE WORLD
AND FIND WAYS
TO KEEP GOING

Contents

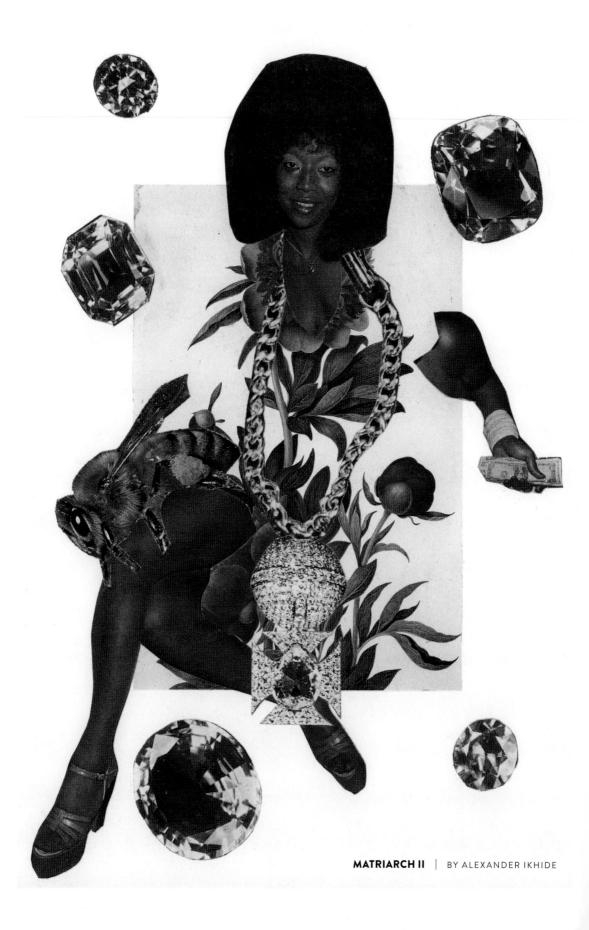

MATRIARCH II | BY ALEXANDER IKHIDE

THE BLACK JOY *Project*

1

BLACK JOY IS AN ACT OF RESISTANCE

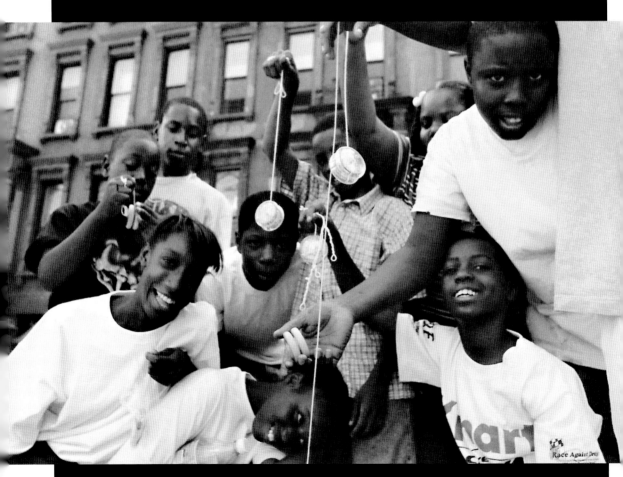

CHILD'S PLAY | BY JAMEL SHABAZZ

Black Joy is everywhere. From the bustling streets of Lagos to hip-hop blasting through apartment windows in the Bronx. From the wide-open coastal desert of Namibia to the lush slopes of the Blue Mountains of Jamaica. From the thriving tradition of Candomblé and the celebration of capoeira in Bahia to the innovative and trendsetting styles of Soweto. In the United Kingdom's Brixton Market, all the way to Nairobi's intricately designed matatus and beyond, Black joy is present in every place that Black people exist.

For centuries, Blackness has been too equated with agony and grief. Persistent and determined fights for racial equity have challenged and made shifts to this old narrative, but the world around us continues to reinforce the worst. It continues to portray Black people as criminal, dangerous, unbeautiful, unworthy, disadvantaged, and good only for what pleasures or labor our bodies can provide. But we know better. We know about bursts of laughter over home-cooked sancocho with family and arguments over the best jollof rice. We know about rousing, poignant protest music during marches for justice on behalf of *all* Black people. We know about cornrows, twist-outs, box braids, high-top fades, the right 'fits, Telfar bags, and dope kicks—hard-bottoms, sneakers, and everything in between—that influence culture around the world. We know about dances that go viral on social media, choreographed by teenage Black girls and then copied around the globe. We know the affirmations our elders speak into us that fortify us each day.

That is how Black joy works. It consistently runs alongside the suffering, pain, trials, and tribulations that we have endured throughout

history and that we endure today. It's a battery in our backs that recharges and powers us through the worst obstacles we face. And then, at the moment of overcoming an obstacle, Black joy is there to celebrate the feat. It is one of our most key, yet unexamined, tools for surviving this world. In every way, Black joy is restorative, regenerative, and generous. It offers the opportunity to go beyond the shallow waters of happiness—a temporary feeling that relies on circumstances outside of ourselves—into the depths and complexity of an emotion and way of being that comes from within and connects us to ourselves as well as the communities of which we are a part.

Blackness is not a monolith, of course. It is a complex and rich existence that, depending on where you are in the world, can show up differently. The nuances are based on many factors, including the

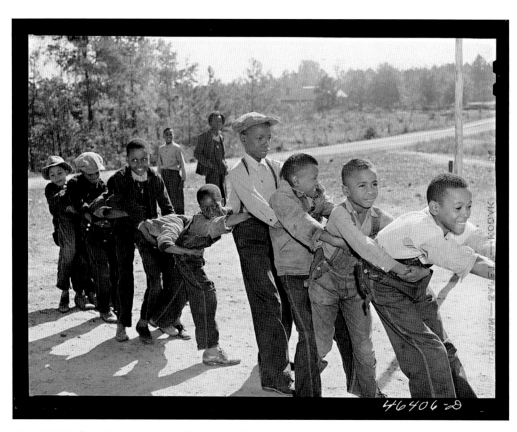

TUG OF WAR (GREEN COUNTY, GA) III AND I | LC/FSA/OWI COLLECTION

violent legacies of white supremacy, racism, colorism, and other historic influences like culture, religion, and language. Besides the notable distinctions, there are still threads that connect all Black people across the globe. Joy is one of those threads.

It is the sense of pride in being Black, no matter if it is "cool" or not. We know too well that our cultures, styles, and ways of being are often more valued than our lives. Yet, generation after generation, we have found ways to come together despite that truth. Even where we may not have a shared language, we have created our own means of communication via aesthetics, architecture, dance, music, food, spiritual practices, art . . . and the list goes on. During the height of the Harlem Renaissance, for example, Arturo Schomburg, the Afro-Puerto Rican founder of the collection that would become the world-renowned

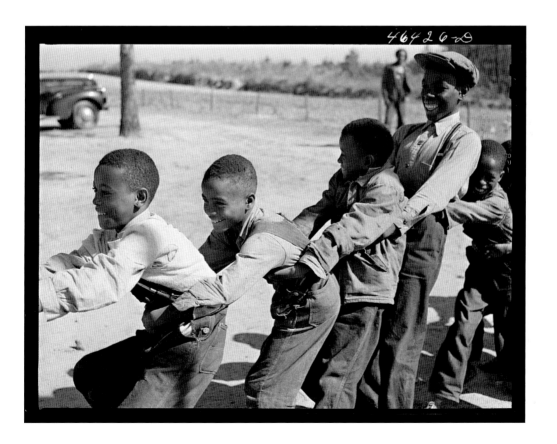

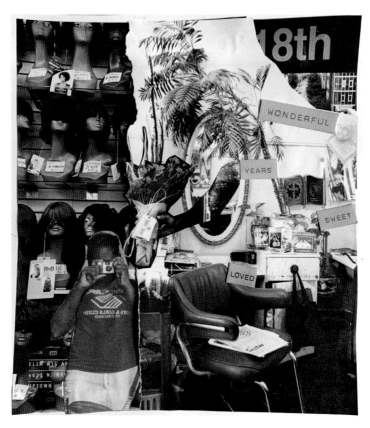

WOMANHOOD | BY LADASIA BRYANT

Schomburg Center for Research in Black Culture in Harlem, wrote a letter for his friend, the writer Langston Hughes, encouraging Hughes to travel to Havana, Cuba. Schomburg desperately wanted Hughes to meet a young Cuban poet named Nicolás Guillén. For Schomburg, it was important to connect the two Black literary virtuosos, even though one wrote in English and the other in Spanish. Schomburg understood the men shared a life experience—their Black experience—that connected them, no matter their mother tongue or home country or hundreds of miles between them. "My brother, when Langston gets to Cuba," Schomburg wrote to Guillén, "I want him to see the African population in Cuba." Afro-Puerto Rican scholar, activist, and founder of the Caribbean Cultural Center African Diaspora Institute Dr. Marta Moreno Vega, who discovered this letter in 1975, describes it as an "absolutely visionary"

moment of connecting Black experiences. The two men would go on to have a long-lasting friendship that gave way to vital work like Hughes's English translations of Guillén's groundbreaking poetry, which was originally written in Black Cuban Spanish and cadence. Guillén would later become Cuba's national Poet Laureate.

This is one story of many—over time and space—of Black people coming together through joyful connection and with common interests. You have probably seen or experienced this yourself. I know I have. I have experienced the thrill of being in a city like, say, Amsterdam, where despite my not speaking Dutch, I could dance at a club with other Black people to Afrobeat-influenced music, performed in Dutch, and not miss a beat.

ZORA NEALE HURSTON AT *NEW YORK TIMES* BOOK FAIR | NYPL

My life in 2015 moved at the pace of a fast and constant rhythm. I had a full-time job in New York City working at a nonprofit organization. I was in a supervisory role, managing a staff of nine people. We coached public high school students across the city to live their lives with passion and purpose while also creating important changes in their communities. It was demanding work that mattered a lot to me. I was also an active member in grassroots efforts to organize Black folks around injustices, mainly as they affected Black women, femmes, and TLGBQIA+ people. It was the same year twenty-five-year-old India Clarke, a trans woman, was brutally murdered in Tampa, Florida, for simply being herself. This was also the year that twenty-eight-year-old Sandra Bland was mysteriously found hanged in a jail cell north of Houston, Texas, after being wrongfully arrested. The climate of protest was strong that summer and was a

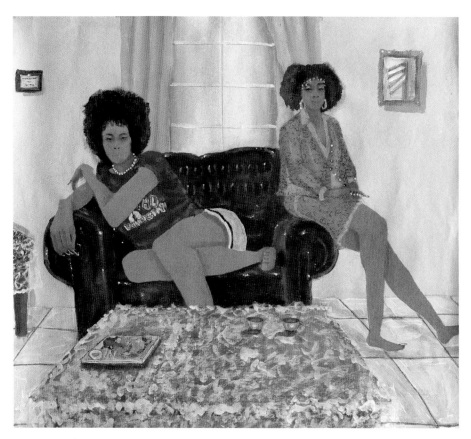

ROYAL #4 | BY DESTINY MOORE

continuation of the many uprisings sparked by the murder of Michael Brown Jr. on August 9 in Ferguson, Missouri, the summer before. It is a momentum that would continue for summers and years to come. I spent a lot of time co-organizing vigils, cohosting fundraisers, participating in all kinds of protests, and working to develop transnational solidarity with activists abroad. On top of all that, I was receiving invitations to speak and write about my perspectives and

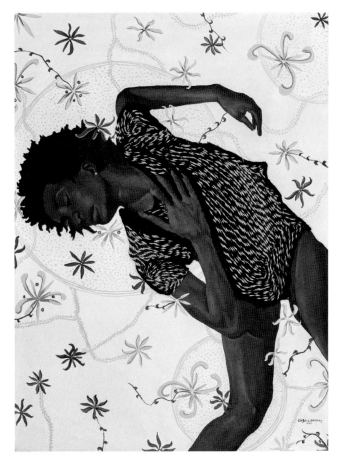

DANCE OF FREEDOM | BY CECILIA LAMPTEY-BOTCHWAY

experiences as a Black, queer, second-generation Dominican from New York City—born in Washington Heights and raised in the Bronx.

I was particularly present to pain and suffering because of the work I was doing. That often meant processing the challenges (and sometimes triggers) of the people I supported in my work. It was a chorus of upset and frustration about hostility toward Black people—particularly the deafening silence around the murders of Black trans women and violence toward TLGBQIA+ folks—or individuals just plain having a tough time in their personal lives. In short, I was holding space for a lot of people. That was also the year my beloved uncle Ali died from an asthma attack. Then, toward the end of that year, in late November, I woke up sad in the corner room of the sixth-floor walk-up apartment in the Bronx that I shared with my twin brother and his partner. It was a morning I wished I hadn't woken up at all. On a spiritual, physical, and mental level, I was frozen. My grief

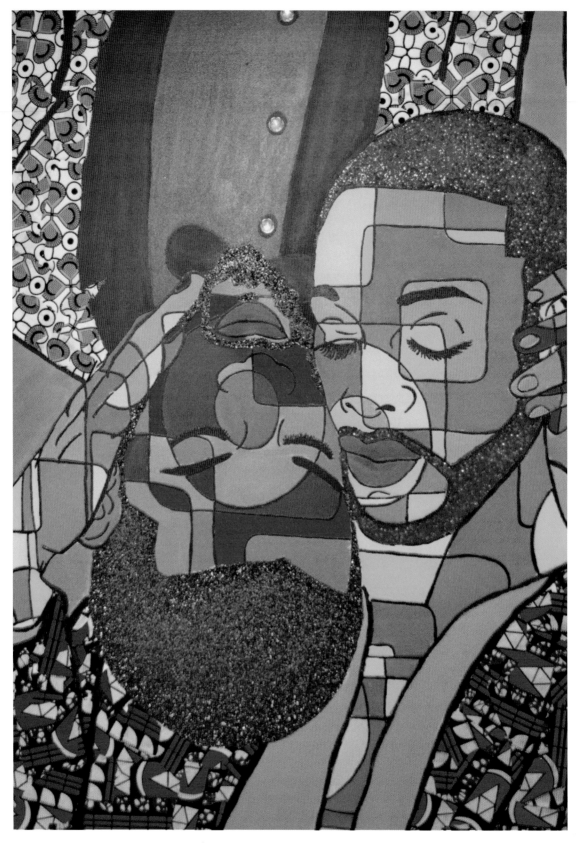

YOUR HANDS HOLD ME TOGETHER | BY JUSTICE DWIGHT

that morning was overwhelming, and I felt more depressed than I had ever felt.

I was stuck, in every sense of the word. I could not physically get out of bed, so I stared at the ceiling and tried to make sense of what was different about that day and why. Eventually, I had what can only be described as a spiritual experience: I felt a sudden rush of memories come over me in the middle of all the grief and other challenges I was processing from the year. They practically flashed above my head like a projector showing a movie. I saw scenes of laughter with the people I loved after a challenging day of work; long threads of funny GIFs and heart emojis in group texts with comrades and close friends; two people dear to me getting married in the middle of Prospect Park in Brooklyn, surrounded by their loving community; hugs from my loved ones during that first season of holidays without my uncle. Then the words "Black" and "Joy" seemed to float in front of me, so clear and so close that I could nearly touch them. I thought immediately of a picture of my mom that I had taken a few weeks earlier. In the photo, she is smiling her big, beautiful smile—my favorite example of Black joy. In my sadness, I decided to share that picture on my social media accounts. I pulled out my phone and added a caption to my mother's photo:

Let's bombard the internet with joy. That is resistance too. Trauma is real mi gente. Let's trigger love as much as the pain as we share important topics we all need to be up on. Love is necessary with the understanding that peace is the exception, not the rule. #BlackJoy.

Right then and there, I decided I would post a picture of someone I loved expressing joy for the next thirty days to help me work through the shadow of sadness that I couldn't seem to shake. The idea was partly inspired by the thirty-day experiences an action coach and friend of mine, Akua Soadwa, led back then with small groups of people—via a digital guide and regular group phone conversations—who wanted to achieve personal breakthroughs. One month felt achievable and worth at least trying.

In response to my daily posts, I started receiving messages of encouragement from people on- and off-line. They wanted me to keep showing Black joy. A close friend encouraged me to take it even further. And so I have. What started as an impulse to move toward my own healing has grown into something much bigger than me. I call it The Black Joy Project.

Since 2015, The Black Joy Project has become both a real-world and a digital movement that amplifies joy and affirms it as a form of resistance to all that works to eliminate our joy—be it an offensive remark overheard in public or the social systems designed to work against Black people's well-being. It is in a long tradition of individual and collective effort to create spaces, places, and experiences that heal and combat the negative impacts of anti-Black systems and action. I have traveled to parts of the world I never imagined as an ambassador for this movement. Interest in it has manifested itself in unexpected ways: hosting a live radio talk show with guest artists for Bondfire Radio, an independently Black-owned and -operated station in Brooklyn; representing the United States at an international conference on prejudice and violence in the Americas, hosted in Brazil; participating on a panel of Black creatives in Europe about the role of joy in their lives and work as part of an annual literary festival in the Netherlands; running a photo booth at a back-to-school celebration in a working-class neighborhood in Columbia, South Carolina, as part of EveryBlackGirl, Inc.'s community-building work; and giving a featured lecture for the Brooklyn Museum's First Saturdays Black History Month program. I even got to be a guest speaker for the Gay-Straight Alliance at my old middle school in the University Heights neighborhood of the Bronx.

Through The Black Joy Project, I have also facilitated writing workshops for dozens of Black women committed to their healing as part of GirlTrek's #StressProtest retreat in Colorado. I have privately codeveloped an archive of hundreds of portraits and written definitions of Black joy. A small team of volunteers and I cocreated an oral history archive and mixtape of long-term Black residents from the Bay Area

and New York City, which is housed at the historic Weeksville Heritage Center in Brooklyn. And my work has sparked countless spontaneous conversations in public that often leave all involved with more joy than they started with. The Black Joy Project has never been any *one* thing, but is, rather, an amalgam of numerous efforts to create and harness the joy in our community for something bigger than our individual selves.

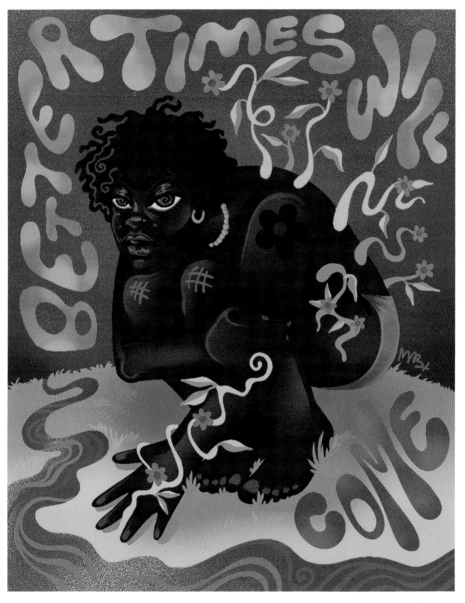

BETTER TIMES WILL COME | BY MITHSUCA BERRY

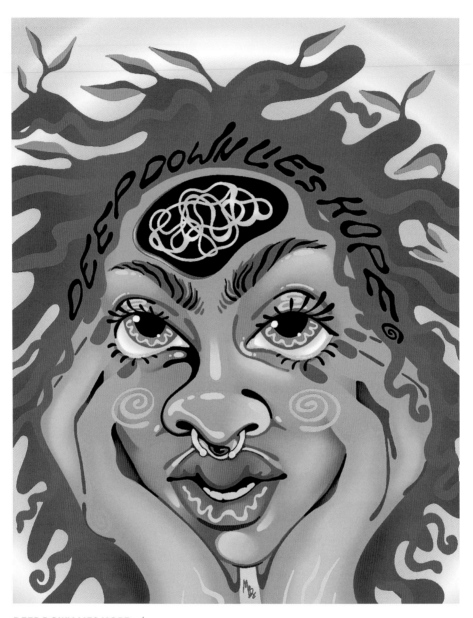

DEEP DOWN LIES HOPE | BY MITHSUCA BERRY

I uphold The Black Joy Project with a deep appreciation that, for as many Black people as there are in the world, there are that many ways to define and understand our joy. My work is committed to serving as an entry point both for this concept and for complicating everyone's understanding about the *full* context of Black life, without having to start with our trauma.

To hundreds and hundreds of people across all walks of life, I've asked the simple question: "What does Black joy mean to you?" The answer almost entirely boils down to one thing: we want to be ourselves unapologetically, with no hindrance and no external forces determining what that is. When I hear people answer this question in person and listen to them finally get to the root of their response, I sometimes get to see, in real time, them reckoning with the forces of anti-Black oppression *around the world*. That can be an overpowering and debilitating acknowledgment of how far we have to go. Yet the conversation that follows is so worthwhile.

We know it's complicated. Black joy is not an alternative or an escape. It coexists with our baggage and our hurt. It's the epitome of "yes, and."

It's yes to talking to a stranger for two hours about their depression and then afterward having them enthusiastically pose for a portrait in front of a huge mural of the word "healing." It's yes to attending the funeral of a loved one and then forming a second-line parade with the electrifying sounds of a brass band and crowds of people dancing their hearts out on the streets of New Orleans. It's yes to admiring your reflection in a mirror and also feeling unappreciated in the world for who you are. It's yes to staying up a little later than usual with friends to celebrate a win, knowing you have to go to a job that doesn't pay enough in the morning. It's yes to feeling good about choosing to move to a new place in hopes of a better life and being unsure of what will come next.

In addition to its ability to offer entry into our full, lived experiences and respite from our worst moments, Black joy offers a space for using one of the most radical tools to which Black people have free access: imagination.

Our ancestors, long before we were ever conceived or thought of, imagined our existence. Whether it was linked to their religious faith or the culture of their time, they knew that the children in their communities, and the children who'd be born in subsequent centuries, represented hope for a better day—*someday*. With each generation came renewed hope that their community's lives could be better and that,

though an ancestor may not see the day of liberation they dreamed of, one day it could happen.

The importance of imagination in the role of Black liberation still rings true today. It is the only way, in fact, that we can begin to create a world that does not yet exist—a world that loves and cherishes Black people as much as it loves Black culture(s). Imagination is the bridge between faith and the necessary actions to create the just world we know is possible. It is what connects that morning of believing I had to find a way out of my personal grief and sadness to building a community bigger than myself, *beyond* myself, that has inspired more people than I'll ever know to center joy in their lives for a moment and to let that drive them to action.

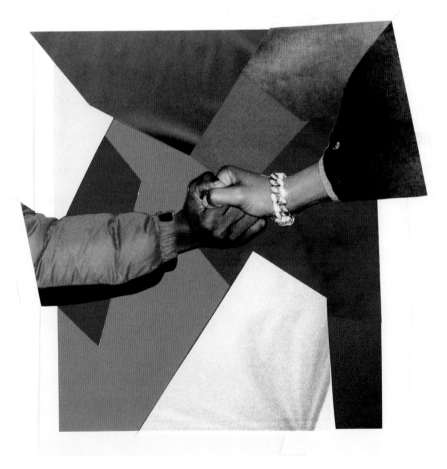

THE CREATION OF BROTHERHOOD | BY BRIA STERLING-WILSON

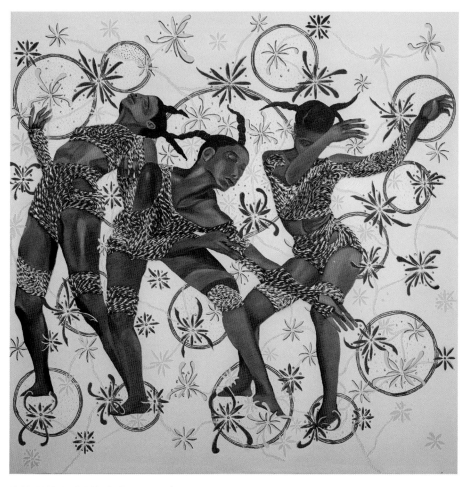

MOVEMENT OF MEDITATION | BY CECILIA LAMPTEY-BOTCHWAY

The Black Joy Project—both the initiative and this book—is not an answer key for fully dismantling all the oppressive forces that have plagued people of African descent. What it offers is a deep breath of sorts, which we all need to take regularly, so that we feel seen, renewed, and inspired. In the following pages, I bring together inspirational workers, conjurers, artists, and space-makers of Black joy from around the globe. In the visual images, you will find photographs, paintings, collages, and mixed media interpretations of joy from artists who both define their work directly through this force and others who fit in its spectrum. Some contributors are people I've known for years and admired; others are

people whose paths I first crossed in creating this book. Together, their work offers a look inside what Black joy around the world feels and looks like.

The following chapters are explorations of the themes and patterns as they relate to this special type of joy that I've seen rise to the top over the years of doing this work. They aim to offer food for thought and a deeper dive into different facets and purposes of this powerful force that exists within our lives.

In addition to the rich visual representations of joy, three textual contributors from Rwanda (by way of Holland), South Africa, and Zimbabwe (living in Australia) offer their interpretation in written form to give the reader not just insight into what Black joy looks like but context for where they exist in the world. These brief interventions are intended to further complicate your understanding of Black joy and how to recognize it outside of the obvious, toothy smiles we often see that oversimplify and contain it. All of our contributors have come together across time zones and geographic regions, but they're all in this conversation.

There's no one way or "right" way to experience this book. Read the sections that speak to you first or spend time with the images that stand out instead. You get to decide how you enter this conversation— and hopefully reengage with it, time and time again. May it lead you to revelations within yourself and, most important, with people around you about how Black joy serves us all and creates opportunities for us to share and build together. For now, I only have one more word:

Welcome.

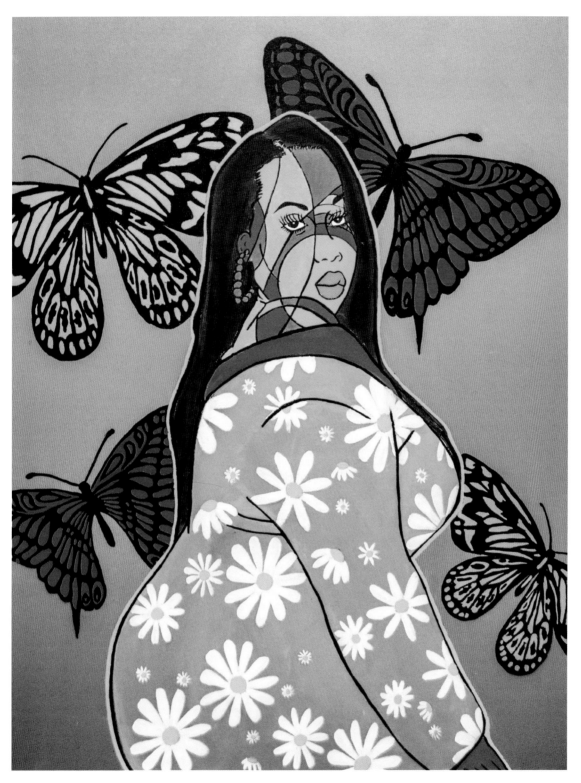

DAISY | BY JUSTICE DWIGHT

2

JOY AS A CHOICE

FOUNDER OF AFROLATINA NATURAL BLOG | COURTESY OF ANYINÉ GALVAN-RODRIGUEZ

There are times when we must choose joy in the face of the harshest conditions: In the span of dictatorships that have made life impossible for the masses while a small group benefitted greatly. In the echoes and "aftermaths" of colonization that still impact the world today. In the harm done and perpetuated within Black communities that create more margins within the margins. In the wakes of natural disasters that (re)surface inequalities. Through war, drought, famine, political unrest, hate, discrimination, persecution, violence, mass incarceration, and all the forces that directly work against Black people—systems larger than any one individual can effect on their own—that choice of joy has been available to us, always, some way, somehow. In the late bell hooks's words, "Unlike happiness, joy is a lasting state that can be sustained even when everything is not the way we want it to be."

It's important to acknowledge the *choice* of joy in our individual lives. On its own, choosing joy does not create the major shifts we need to fix the world's problems. This is where the power of awareness comes in. When we are aware of what is happening to us—the how and the why—then we gain agency. And with agency, we may be able to move differently, to *choose*.

This is no small task on the individual or collective level. It requires getting clear on what we do and do not have control over. It also requires us not looking away from our struggles. Because Black joy is not an escape. Rather, it is a way we fortify ourselves and our communities so that we can address issues and their impacts head on.

The Black world has seen its fair share of tyranny, violence, and exploitation over the course of history, especially in the last few hundred years. Africa as a continent has borne the biggest brunt of these impacts. Despite it being the richest continent in natural resources, which in theory would position the nations within it to be the wealthiest, those nations have been racked by colonialism, exploitation, and corruption.

However, it would be wrong and too narrow to characterize the continent that birthed humanity as rife with sorrow and disaster. Anyone familiar with Africa knows that its thousands of cultures, languages, traditions, practices, and styles create a continent that is overflowing with life and positive energy.

There is the pride and persistence of the Chébé in the Chad region with their ancient hair care rituals that continue to bring women and girls together in community. These women have continued an over one-thousand-year-old, time-intensive practice of harvesting small buds of a plant (Chébé, as locally known) and transforming it into a fine powder. They apply the powder to their hair over many hours of hair braiding, often in elaborate and specific styles that signal status, like marriage. They also consider the powder a great way to protect their hair from damage and to preserve length. All of this occurs despite the ongoing corruption, unstable government, and the other complex realities of one of the world's most economically poor countries.

Farther south, in Angola, the International Festival of Music from Sumbe, a.k.a. FestiSumbe, has held an (almost) annual celebration since 2002 that brings together some of the country's best musical talents, as well as performers from other parts of Africa and its Diaspora. Thousands of Angolans attend the multi-day event, which takes place on a beach in Sumbe, the capital of Angola's coastal province Cuanza-Sul. FestiSumbe is electrifying and has become an avenue to promote pride for Angolan music and culture. That it exists in the wake of Angola's two-decade-plus civil war, which ravaged the country, and began the same year the devastating conflict ended, is no coincidence. FestiSumbe is a moment of

MAMA JACKIE IN ALL HER GLORY, JACKIE'S ON THE REEF, NEGRIL, JAMAICA |
BY LAYLAH AMATULLAH BARRAYN

powerful jubilee that brings people of all ages together amid a nation still recovering and rebuilding from colonial rule and the strife that ensued from its independence.

And then in the Sahara region across the made-up borders of Niger, Mali, Libya, Algeria, and Burkina Faso, the seminomadic Tuareg people continue to cultivate their mind-blowing metal work and craftsmanship.

Some of the finest jewelry of silver, iron, and other metals in the world can be credited to the Tuareg. Instantly recognizable by their unique and intricate designs, their work is forged, to this day, in mainly ancient practices passed down through generations. These practices have persisted through the difficult subsistence of navigating an arid desert, among the many challenges that come from the conflicts in which the Tuareg exist.

However old these traditions, they did not exist in a vacuum. They emerged *even as* horrible, despicable things happened. The chaos and challenges roiling must always get tended to, obviously. But joy is still a choice we make. History bears this out, past and present.

Storytelling has been one of the most consistent ways we illustrate the power of choosing joy. A memorable example is in 1975 when the

A MIDSUMMER SWING À PLAGE HYDROBASE, NDAR (SAINT-LOUIS), SENEGAL |
BY LAYLAH AMATULLAH BARRAYN

KHALEEJI DREAMS IN BLACK BOYHOOD, DUBAI, UNITED ARAB EMIRATES |
BY LAYLAH AMATULLAH BARRAYN

ground broke, in the literary sense, and South African writer Miriam
Tlali published her novel *Muriel at Metropolitan* during the apartheid
regime. Tlali's short and semi-autobiographical novel is mostly set at
the main character Muriel's workplace, a booming furniture store called
Metropolitan Radio. This backdrop serves as an allegory for South Africa's
wider society—through the multiple languages spoken in the book, the
power dynamics of employees at the store, and Muriel's one-on-one
encounters with secondary characters, like the store's customers and
neighbors. As an iconic and seminal work, *Muriel at Metropolitan* reflects
the two worlds within one republic that Tlali describes in the book's first
chapter as, "The one, a white world—rich, comfortable, for all practical
purposes organized—a world in fear, armed to the teeth. The other, a
black world; poor, pathetically neglected, and disorganized—voiceless,
oppressed, restless, confused and unarmed—a world in transition,
irrevocably weaned from all tribal ties."

 Because of its often raw and unapologetic critique of South Africa
and its egregiously unequal society, the novel was banned shortly after its

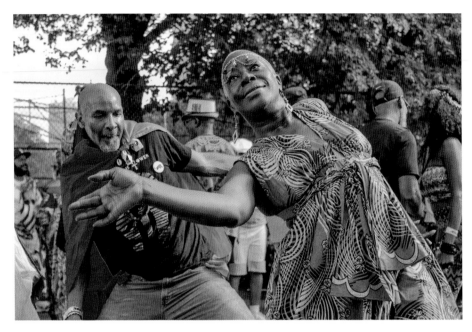

THE GET DOWN, THE GET FREE, BROOKLYN, NEW YORK | BY LAYLAH AMATULLAH
BARRAYN

initial publication, despite edits that reined in the critiques. It's no wonder. By the time *Muriel at Metropolitan* hit bookshelves, the apartheid system was a well-oiled machine and many Black activists had become political prisoners or were killed altogether. Nelson Mandela, renowned activist and South Africa's first democratically elected president, had been imprisoned for more than a decade on Robben Island, along with many other radical political prisoners. Decades after the first banning of the novel and then subsequent republications, it is still hard to find a copy in South Africa today.

Through *Muriel at Metropolitan*'s compelling setup, Tlali brilliantly weaves in elements of joy and resistance throughout the frustrating, hurtful, and enraging experiences that Muriel endures. In one chapter we are introduced to Anna, who is described as a very loyal customer and who loves the color maroon. In fact, she has an entire living room where every piece of furniture and décor is in that color, as well as everything she wears from head to toe. That can be interpreted as an intentional reference to organized rebellion. This character moves gracefully and with pride.

By the book's end, Muriel resigns from her job at the busy furniture shop with the plan to start a new job elsewhere. That job falls through because the white business owner does not set up the proper facilities of segregation as required by the laws of apartheid. The combination of her experiences at the store and then being left without work pushes Muriel to recognize her own power and the reality of how unjust the South African system is. She (re)claims her freedom by choosing not to participate in it anymore and seeks (presumably) a more liberated path.

L et's come back to the condition of dictatorships. Most Dominicans today, be it through personal experience, relatives still alive, or someone they know, lived (or died) during the thirty-plus-year violent reign of Rafael Leónidas Trujillo in the Dominican Republic from 1930 to his assassination in 1961. The violence of that era still echoes to this day. And even during that chaotic and bloody time of Dominican history, it would be naïve to say that joy was absent altogether.

The arts proved to be a space for this joy and resistance, notably in the voices of writers like Aida Cartagena Portalatin, who cleverly subverted the social norms of the day via her poems and other writings that spoke powerfully to her reality as a Dominican woman under a regime. Her coded and sometimes not-so-coded poetry spoke to a generation of Dominican writers hungry to express themselves despite serious limitations. Also worth mentioning during this time was the growth of bachata, a guitar-based music that emerged from mostly poor, Black, and rural communities and was heavily despised by Trujillo because it did not reflect his adamant commitment to a "civil" and "modern" (read: white) society. Bachata has been compared to the African American blues in that it reflects sorrow and pain but in a more upbeat rhythmic style, despite lyrics of heartbreak and woe. Bachata as a genre would eventually explode in popularity and become synonymous with Dominican identity and culture, even as it was heavily suppressed during Trujillo's rule. Around

the same period on the western part of Ayiti (or its colonial name of Hispaniola) in neighboring Haiti, an era of violence similarly forced many Haitians to find new ways to explore and express possibility despite heavy restriction.

In the opening of Edwidge Danticat's powerful reflection on art and exile, *Create Dangerously*, she offers insight into a defining moment in her life as a Haitian American through her retelling of a terrible moment in the horrific dictatorship of Francois "Papa Doc" Duvalier, who terrorized Haiti from late 1957 to 1971. It was a time in the small island nation where any form of dissent could lead to death among other violent penalties. In her introduction, Danticat describes the very public assassination of Marcel Nouma and Louis Drouin, members of a small guerrilla group called Jeune Haiti (Young Haiti) that formed in New York City to wage war against the Duvalier administration with the intent of taking down the dictatorship. She informs the reader that after many months of Duvalier's minions searching for the guerrilla group members and murdering many

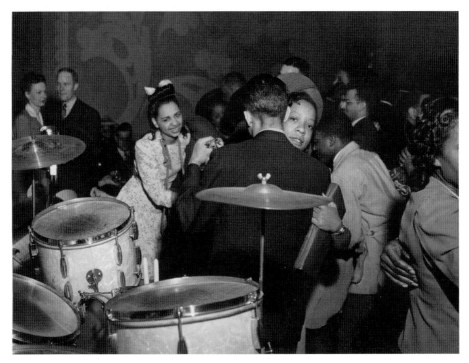

VIEW OF CROWD DANCING IN THE CLUB DELISA | NYPL

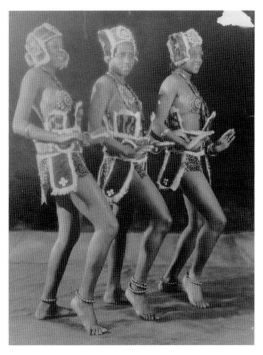

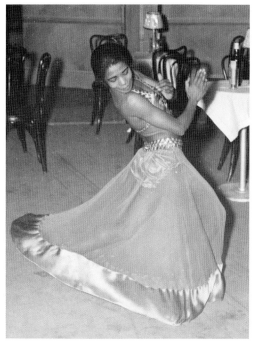

**THREE WOMEN DANCERS FROM ASADATA
DAFORA'S DANCE TROUPE** | NYPL

ZOLA KING IN THE CABARET SCENE | NYPL

of their relatives along the way, they finally caught up with Drouin and Nouma. Upon their capture, the two activists were brutally murdered by a firing squad while a massive crowd (including schoolchildren) watched. She tells the story to give context to the level of violence that anyone perceived as resisting the administration could experience. It was a life-threatening risk for Haitians to participate in any sort of activity that could be perceived as resistance. Even so, Haitians found another way. Many young people, though not exclusively, staged underground plays of both Haitian and non-Haitian writers as allegories for their existence under tyranny. They were secretive yet needed lifelines to affirm Haitians' own understanding of their current circumstance and artistic expression as a form of relief from it as well. However quiet the applause may have been after those performances, it could be safe to assume joy was present in them.

Unfortunately, Haiti and the Dominican Republic are not the only corners of the world where generations of Black people have

experienced dictatorships and their lasting aftermaths that often show themselves in forms of mistreatment toward certain groups of people and ways of thinking. However, what we can draw from examples like the Dominican Republic and Haiti are examples that creating joy in the midst of violence is possible. Did anyone's play or poem topple a dictatorship? No, but they provided the space to evoke feelings and moods other than fear, anxiety, and hopelessness. Memorizing and reciting lines from beautiful poetry and great works of theatre offered relief, however momentary, to feel less alone in their understanding of injustice and what is possible in the face of it. The quiet performances of these literary works in basements, the backs of churches, and other clandestine spaces cultivated communities of people who reminded one another of the power of the collective. It's that awareness that comes with choosing joy. These are a few stories among many of how Black people's resilience

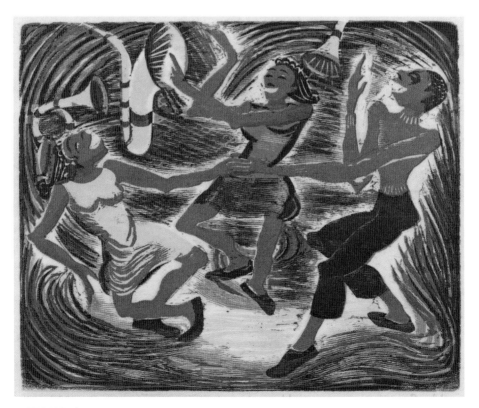

DANCING | NYPL

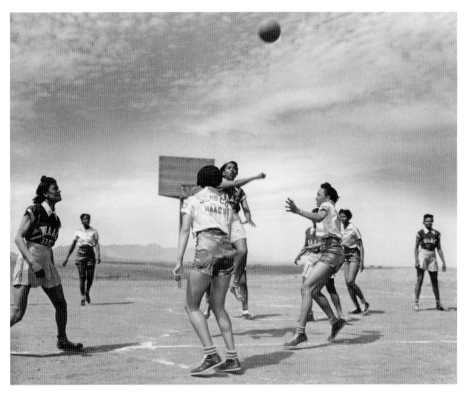

32ND AND 33RD COMPANY'S WOMEN'S U.S. ARMY AUXILIARY CORPS BASKETBALL TEAM | NYPL

illustrates creative ways to confront difficulty, not run away from it. Imaginative approaches to adversity can encourage those who experience it to get inspired enough to do something about it—to effect necessary change.

Hope often feels lost amid the many difficulties Black people must face. It's hard to conjure when you must wake up in the reality that not only can life be hard, it can also feel insurmountable. Danticat writes, "The nomad or immigrant who learns something rightly must always ponder travel and movement, just as the grief-stricken must inevitably ponder death. As does the artist who comes from a culture that is as much about harnessing life—joyous, jubilant, resilient life—as it is about avoiding death." Indeed, life and death are inextricably linked in the way that joy and whatever may be its opposite are, whether one has had to exist their whole life in one place or as an immigrant. During the time of the brutal

dictatorships across the island of Ayiti, people from the neighboring island of Jamaica moved en masse across the Atlantic Ocean into the land of the people who colonized them as newly formed immigrants reckoning with the tension of life and death that Danticat so powerfully named.

In June 1948, after the ratification of the British Nationality Act in the United Kingdom that granted citizenship to people all over the world living in British colonies as a deceptive incentive to recruit labor to rebuild post-World War II Britain, the *MV Empire Windrush* landed in England with hundreds of migrants from Jamaica and other parts of the Caribbean (about 802 of the ship's listed 1,027 passengers).

That group, today known as the "Windrush Generation," migrated to the land of the colonizer hoping to find opportunities to better their lives and those of the ones to follow them after finding limited options for making a decent life in the colonized lands they arrived from. Members of

JOLLOF + JAMBALAYA | BY JEREMY TAURIAC AND COURTESY OF SHANTRELLE P. LEWIS

this generation have established themselves as the integral members of British society that they have always been and are. Despite the rampant racism and discrimination they and the thousands of migrants from other parts of the British colonized world experienced, Black Brits went on to create social movements, collectives, publications, and spaces to both resist the second-class citizenship they experienced and to celebrate the cultures they took pride in and did not want to lose in this new land. An excellent example of this is the Notting Hill Carnival, meant to honor those important roots.

A three-day festival that happens every year on the last weekend of August and attracts more than a million people, the Notting Hill Carnival started as a response to an incredibly negative event and circumstance (much like The Black Joy Project).

In the decade following the arrival of the migrants aboard the Windrush, the districts of Brixton and Notting Hill became home to the largest population of Afro-Caribbean people in Britain. At the same time, Notting Hill was also a hub for the racist and conservative Oswald Mosley who led the Union Movement to promote propaganda around the idea that Britain was a white nation and needed to be kept that way. The movement led to violent encounters with Black Brits and migrants and, in 1959, Antigua-born carpenter Kelso Cochrane was murdered by white British people engaged in racially motivated attacks. Cochrane's murder led to uprisings calling for justice and an end to the discrimination that Black people in the United Kingdom were facing daily.

That same year, in response to the high tensions and upset, Trinidad-born activist and founder of the *West Indian Gazette*, Claudia Jones, organized an indoor Caribbean carnival in St. Pancras Town Hall. Jones's intention was to build solidarity between communities, ease tensions, and offer an opportunity to celebrate the various Caribbean cultures present in Britain and the long-standing style of celebration. For a few years after that first indoor event, inspired by Jones's carnival, wife and husband Pearl and Edric Connor (also Trinidadian) hosted a similar event in various halls around London. And in 1966, social worker and community

activist Rhaune Laslett organized an outdoor event for local children's entertainment intending to ease the ongoing racial tensions and to bring more Caribbean people into the fold. The key to that engagement was well-known Trinidadian musician Russell Henderson's agreement to participate in the event with his steel pan band. The signature sounds of the mallet hitting the many dents of the steel pan to create recognizable hollow notes activated the streets in a way that inspired people to join the organic procession that formed that day. That momentous transition from indoor to outside, led by Henderson's band through the streets of Notting Hill with one of the most recognizable sounds of Caribbean music, was the beginning of one of the most epic gatherings in existence today.

In an insightful article about identity and Notting Hill, Professor Adela Ruth Tompsett points out an illuminating moment in playwright Winsome Pinnock's 1989 work *A Rock in Water*, based on the life of Claudia Jones, where the character of Jones explains her reason for hosting the iconic indoor carnival of 1959:

> We've been wounded. It's time we began to heal. Why shouldn't we enjoy ourselves. Can't we be proud of what we came out of? It's hard enough to stay alive without punishing yourself trying to forget who we are. Try to see this carnival as a tribute, a way of drawing us together . . . We'll have our carnival because we deserve it.

Though Jones's words are dramatized, the sentiment is worth focusing on. Black Brits and migrants were experiencing persecution simply for being themselves. Yes, physically, but also emotionally and psychologically and on a daily basis in this new land they'd begun to call home. When Jones's character in Pinnock's drama asserts, "Why shouldn't we enjoy ourselves? Why can't we be proud of what we came out of?" she is posing the question of why Black people can't have a good time in the midst of violence and discrimination. She asserts the tangible option of joy and its power to not just celebrate but also offer healing.

**BECAUSE THE MACHINE WILL TRY TO GRIND YOU INTO DUST ANYWAY
WHETHER OR NOT WE SPEAK** | BY MCKINLEY WALLACE III

Today, the Notting Hill Carnival is known as Europe's largest cultural celebration that attracts more than a million people of African descent from the Caribbean, Africa, and the larger African Diaspora. Has the experience of racism and other forms of systemic and social hate been eradicated entirely by this special gathering? No. What it does offer, though, and what Pinnock's character of Claudia Jones points to is that Black communities get to take pride in who they are and where they come from. Our communities do get to enjoy their lives and the opportunities to do so get to be created by Black people (and allies when necessary).

IF YOU KNEW / LET IT BE US | BY MCKINLEY WALLACE III

The tradition of Carnival in the Caribbean and places like it, in part, comes from the adaptation of what was once slave masters' lavish masquerade balls to celebrate the arrival of Lent. Enslaved people were restricted from those events. However, as the saying goes, "There's always another way." Those same people denied access to celebration formed their own in a way that honored their own traditions and made room to mock the very people who banned their joy. The Notting Hill Carnival is but one of many moments in our collective history we've participated in and witnessed these moments of choosing joy, be it through music, dance, or the written word.

In a colonized society, language is one of the most political tools at one's disposal. In the South American country and former Dutch colony of Suriname, there are more than twenty languages spoken, though Dutch/Surinamese Dutch is the only official one. Sranan Tongo (Sranan), the language of the Afro-Surinamese, is the lingua franca of the nation and is the second-most spoken language in the country.

In the mid-twentieth century, Sranan was consciously used as a political tool via published works of writing. In the early 1960s, Suriname was under Dutch rule and building off the momentum of the previous decade. Its Black citizens were increasingly moving toward a political climate to achieve independence that necessitated the further development of a nationalistic ideal—one that included Sranan as a unifying force and assertion against colonial power and influence. Though *Soela*, a literary magazine, did not have a long life (seven issues; 1962–64), it continued a nationalist practice started the decade before, providing a platform for influential Afro-Surinamese writers to have their work published in a language outside of Dutch.

In 1962, after moving to Suriname's capital city of Paramaribo from Amsterdam, W. L. Salm published *Soela*. It was through that platform that the important emerging voices of Black women such as Johanna Schouten-Elsenhout and Thea Doelwijt could be heard as rallying cries for centering and promoting Afro-Surinamese culture as a nationalist project. Schouten-Elsenhout would publish several books in Sranan (most known for *Awese*, published in 1965). Doelwijt would later become an editor of the also short-lived, though still influential, *Moetete* magazine from 1968 to '69. It too served as a platform for these nationalist voices promoting the use of languages and cultural practices outside of those brought to the country by the Dutch. There is not enough written in the English language to truly get a sense of the full scope of impact these publications had, but it is safe to assume that it was no small feat to publish such works during colonial rule, in a context that only promoted the use of colonial languages that did not reflect the everyday lives of people who came from across colonized lands.

We know that in the 1600s during the enslavement of millions of Africans and people of African descent in places like Colombia and Brazil, people came together to form free communities deep in the jungle that not only offered safety but spaces to celebrate all kinds of occasions like the births of children. In Colombia's San Basilio de Palenque, the first free-Black community in the Americas, a dessert was created centuries ago that is *still* sold on the street today that goes by *alegria* (Spanish for *joy*). In a video interview for Great Big Story, a now-defunct media company that produced microdocumentaries about people and places around the world, Evelinda Salgado Herrera, a native of Palenque, reveals that this sweet creation was a tradition she'd picked up from growing up around her mother and grandmother who made it and other sweets all the time. According to the lore she grew up with, Evelinda says alegria was given its name to honor and transmit the joy of being the first town of free Black people into something that can be consumed.

It's very common to hear Black women in different parts of Colombia screaming out "alegria" and the names of other sweets they sell to signal their presence, much like an ice cream truck or street vendors in other parts of the world. These sweets are deeply tied to Palenqueras (women of Palenque) and their historic responsibilities and roles in the community. Of course, like life, the sale of these sweets is not all good. Colombia is home to the third-largest population of Black people in the Western Hemisphere (behind Brazil and the United States). Much like in other parts of the world, Afro-Colombians have suffered greatly under colonialism and its aftermath. To this day, many Afro communities in Colombia continue to be greatly impacted by inequalities like lack of quality education, shelter, and employment. As much as selling alegrias is a nod to an important history of resistance and freedom, it is also a lifeline to provide for communities that are still greatly in need. The condition of Black life is not all the way resolved, but it does not mean joy cannot be chosen or expressed on the way to that goal. It does not mean that joy cannot be a choice while working through difficulty.

In an interview with Junior, a former employee at an art gallery in Johannesburg, South Africa, where we met, he spent the first half of a two-hour conversation sharing with me how difficult his life was at the time. He spoke to me about the tension between his job that was not satisfying at all and his various dreams to make a better life in the big city. The reality of wanting better and not being in that space yet spiraled Junior down into a depression that it was clear he wanted out of. Eventually the conversation landed on the topic of joy, and although it was not fully possible for him to define what it meant for him in that moment, Junior did say, "[Black joy is] being with people that understand me; being with friends who get it. Being with my friend, laughing about situations and growing closer, I get hope. I feel like I'm not alone." When the conversation was done, Junior was tasked to pick a spot that may evoke joy for him in the Maboneng neighborhood of Johannesburg where

HAPPY NEW YEAR! | COURTESY OF ROMELIA CRUZ

we'd met up. As we turned a corner, a huge colorful mural with the word "healing" plastered across stood out, divinely. Unfortunately, I was still learning to use my DSLR camera and though we did not get a perfect shot, the moment felt perfect. Junior certainly chose to smile in the moment, both for the lens and, perhaps, for that moment of ease.

History has no shortage of examples of conditions that have felt and often have been insurmountable for Black people to survive, let alone experience joy, within. *And* we know they did. We are here today in part because of it.

In Black joy, there is a space created to make real the possibility of what other ways of being can be. An impulse to spin in a circle simply to enjoy the sun and let it kiss your skin can be an intentional practice. Through that moment of joy, we can create the opportunity to look at both ourselves and one another more deeply. It makes room to understand more clearly not only what brings us joy but also what takes it away. How to eliminate that force altogether becomes an idea because of that joyous moment. That sigh after a deep belly laugh that brings you back down to the present is a moment that can and should lead to action. Again, it is a practice that there are more ways to exist and be well than we've had before and currently have today.

In the spiritual sense, joy can bring us closer and in clearer connection to our guides and the forces many of us believe to be greater than ourselves. At its best it *is* a divine connection, a direct channel to affirm who and what you are in all its fullness. Living fully in one's truth is one of the best ways to honor and respect those who came before us. Black joy can be the doorway to that honoring. Much like faith—the choice to trust or have confidence in someone, something, or beliefs—to choose joy offers an opportunity to affirm positivity in the spirit as well as the body and mind. At its best, joy releases endorphins and serotonin that makes the body *feel* good. That is important too. In the *Self* article, "Black Joy Isn't Frivolous—It's Necessary," journalist Patia Braithwaite argues that "Joy . . . is nourishment. It's part of where some of us find the energy to continue thriving."

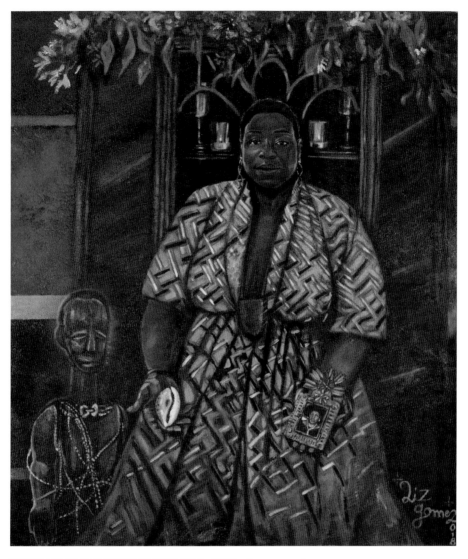

PORTRAIT OF ROOTWORKER TRACIE D. HALL | BY LIZ GÓMEZ

Of course, how joy manifests in the body is different for everyone, but it can often feel like a relaxing of the shoulders, unclenching of the jaws, and lowering of the tongue from the top of the mouth. It's a floating feeling in the chest, perhaps more of a hover like a hummingbird, excited and focused on enjoying the sweet nectar of a flower. It's the feeling you can get from watching a child's laughter and surprise after discovering a new food or activity they like. It can feel like a jolt of electricity shooting through your bones, orgasmic at times.

VALLEYS AND RAINBOWS | BY KALI MARIE

And the mental impact that joy can have cannot be forgotten either. Many of us inherit traumas that often affect us in ways that are hard to understand, not to mention the traumas we experience in our own lifetimes for various reasons, not excluding race. The combination of these truths can cause anxiety, depression, inability to focus, and so many others. What the experience of joy can create is a moment or moments to be present.

Much like love, Black joy is something we may never have all the words for, but when it's present, we can spot it. Words—language—are hard to find to fully represent what this vital force is. What is clear, though, is that Black joy can be—is—a portal to more loving and exciting ways of being, for the present and the future.

We get to live in a world where Black disabled, trans, nonbinary, and LGBQIA+ people are safe, sheltered, protected, and loved. In that possibility, then all Black people—all people—get to live in a world where we are safe, sheltered, protected, and loved for doing nothing other than sharing time and space on this floating rock.

On that road to that ultimate vision, choosing Black joy offers the space in our hearts to receive the truth that we get to live lives and have experiences that serve to soothe us, bring warmth to our hearts, and allow us to play for the sake of play.

This choice also acknowledges that because we exist in a world that is not set up to do right by us, we must forge other ways that will.

Over the last few centuries, we have seen movements rise across the Diaspora for the reclamation of our rights as beings. Most of world history, of course, spans much longer than the last five centuries, but these last few have been excellent examples of how we have come together through joy both for its sake and for the sake of a world that honors and centers it.

Throughout those centuries, we have had countless rebellions and resistance of enslaved people and the forms of violence and oppression that came with that. We've organized social movements to rise up on streets, in fields, on farms, in factories, on beaches, at restaurants, in

schools, in offices, in libraries, on planes, in governments, on screens, in music—anywhere and everywhere we exist.

Movements for Black freedom have taken shape all over the world. History is familiar with the civil rights movement of the 1950s and 1960s in the United States, which was in tandem with a similar struggle in the anti-apartheid movement of South Africa. History is familiar with the Pan-African movements that have insisted on the autonomy and inherent freedom of Black people. In the 1970s, along with the ongoing global protestations of the Vietnam War and the rights of queer people and women in the United States, Europe saw its own movements across the nations that make it up. Young people all over brought the empires that often forced them to migrate there to be held accountable. Black Brits questioned openly the distinction of their treatment and the injustices they faced daily. Similarly, in the Netherlands, young Surinamese people and members of other parts of the world that the Dutch colonized convened and organized to bring attention to that violent legacy and how it was still impacting them. Along with these major movements, there have been numerous instances on smaller scales that have impacted the power of joy and the importance of actively choosing it.

In the summer of 2019, a year before many floodgates would break open again, two friends launched a zine to explore a feeling and experience they'd created among one another and felt important to share with the rest of the world. Hailing from Côte d'Ivoire and at the time living in the United Kingdom, entrepreneur and creative Alice Gbelia partnered with Sanaa Carats, founder and editor of *33 Carats*, an online magazine all about hip-hop, culture, lifestyle, and fashion.

Gbelia's platform, Ayok'a (which means "welcome" in her native language), was created in 2017 while she lived far away from her home in the United Kingdom. She was interested in decorating her apartment with African art. After a mostly fruitless search, she realized there wasn't a space to easily access and buy the works for which she was searching. After that experience, she decided to create that space for people beyond herself to also get access to the vibrant art she was excited by

PERSONAL AND OUTER SPACE | BY JACQUELINE OGOLLA

GET LIKE ME | BY DESTINY MOORE

and eager to share. Though it did not exist for long, Gbelia's platform was successful in getting more African art into people's homes and amplifying the existence of Black and African art.

Together, with graphic designer Nadina Ali, Gbelia and Carats created their *Black Joy* zine. Pages of the zine are filled with interviews with a number of conjurers of joy, bright and colorful full-page messages ("Positive Vibes Only" and "Your Black Is Beautiful," to name a couple), equally vibrant artwork, and a celebration of this beautiful force.

As an entity, the zine brings together voices from Africa and the Diaspora in a harmonious way that shines a light on the efforts of Black artists to make claim of Black joy and its power. Via email, Gbelia invited me to reflect on The Black Joy Project, then only three years old. She was curious about what I had learned, patterns I noticed, the impact of the Trump administration I observed, and how my work with the project affected my mental health. From my responses, which she included in the zine, she put one of my quotes in big bold letters: "Black joy is best served in a group." Those words signal the understanding that like most power, it is stronger when combined.

The absence of stories that resonate with what one knows to be possible can make them question the storyteller. Ana's hands were softly tucked into the pockets of her wool coat. She stood under the shade of a tall tree in the winter that lingered in New York City one afternoon in the middle of May. With concern, she asked, "Por qué no conocemos cuentos de adas negras?" (Why do we not know stories of Black fairies?) The question of Black joy brought Ana Maria Belique right back to her childhood. Despite the difficulties of life in bateyes—communities historically built around sugar mills where employees of the mill live (most often Haitian migrants and Dominicans of Haitian Descent [DOHD], though not exclusively)—as a child she was still able to find joy. Her childhood was full of joy, she says, because despite the harsh circumstances, she never felt deprived. She

had a loving community and experiences of innocent childhood games. Today, Belique is one of the most visible activists within the movement for the rights of DOHD in the Dominican Republic. She is a leader of Reconoci.do, a prominent activist organization, as well as at the helm of other initiatives to promote the wellness and protection of the human rights of Black people, ultimately to create a more just Dominican society.

Formed in 2011, Reconoci.do came into being through young DOHD and Haitian migrants who were frustrated with the Dominican government and society treating them as second class. Their intention was to support other DOHD and Haitian migrants in becoming aware of their rights and learning how to claim them accordingly. Most of the movement's members are from bateyes where the quality of life is difficult and people are often lacking basic resources like clean water and steady electricity.

On September 23, 2013, the Dominican Republic's Constitutional Tribunal (the country's highest court) ratified Resolution TC 168–13,

FOURTH OF JULY | BY LEX MARIE

which retroactively denied Dominican nationality to anyone born after 1929 who did not have at least one parent of Dominican blood, under the argument that undocumented immigrants were considered "in transit," a status that was established to enable foreigners who had children in the Dominican Republic to claim citizenship for their child in their home country. It's important to note that the Dominican Republic granted citizenship to anyone born in the country except for people in transit. Almost a decade before the 2013 ruling, the Dominican Republic changed its Migration Law in 2004 and expanded the in-transit category to include nonresidents such as undocumented Haitian migrants in the "in-transit" category no matter how long they had lived in the country. Long before the early 2000s, unbeknownst to many DOHD and Haitian migrants, their children were wrongfully marked as in-transit on their birth certificates, typically for having francophone surnames (read as Haitian) or simply for being dark-skinned (through an anti-Black and anti-Haitian lens, they were not read as Dominican). That moment began the next chapter of denying DOHD and Haitian migrants their rights and any fruitful paths to citizenship.

What this meant in practice was another nail in the coffin to further anti-Haitian and anti-Black marginalization in the Dominican Republic. Thousands of people lost their citizenship or ability to fully claim it. Resolution TC 168–13 created the largest population of stateless people in the Western Hemisphere.

Since its founding, Reconoci.do has developed a national network of community organizers and worked in coalition with organizations like Movimiento de Mujeres Dominico-Haitianas (MUDHA), a pioneering organization in the movement; Dominicanos Por Derechos; and We Are All Dominican to lead the fight to eliminate the social exclusion and denial of basic human rights that DOHD and Haitian migrants have historically experienced in the Dominican Republic. This powerful network of activists has spent decades fighting for human rights and the acknowledgment of their place in Dominican society as fellow Dominicans.

In the ways they've taken to the streets, municipal buildings, public parks, and other areas to bring attention and cause change to their condition, members of Reconoci.do and other Dominicans with shared struggles have chosen joy too. Birthdays are an important celebration in the Reconoci.do community. The intention is to recognize the feat of seeing another year while navigating the unjust country known as home. On a member's birthday, a cake is usually brought to the meeting—and not just any cake either. If you ever had Dominican cake, then you know how perfectly moist and fluffy its texture is—the almost-too-sweet sweetness of the icing and middle layer with a punch of preserved fruit like guava or pineapple. On someone's birthday, a cake is cut, the birthday song sung, and well wishes shared for this next rotation around the sun.

And none of us are strangers to this choice of Black joy, whether we've understood it in those terms or not—whether in this English language or any other tongue we've learned to speak.

The thing is, we do need language. We need ways to articulate our world views so that someone or something outside of ourselves can understand or at least attempt to make sense of what's been expressed.

It's what legendary Ghanaian photographer, James Barnor, continues to come back to in his own understanding of photography's purpose to translate what's in your "mind's eye" outside of it. Translate your thoughts to reality. It's the key to the power of imagination—how when we conjure and create other ways to be and live in the world in our minds, that will lead to us believing that those worlds are possible and most important, at its best, end in us manifesting that world—not without its struggles.

It is not an easy task to make room for imagination when the world insists on challenging you in as many ways as possible through these webs of oppression we have inherited. By no means is the world we are currently in new or fresh. It sits on the bed of centuries of intentionally developed narratives and practices to justify the ways that hate manifests itself to oppress all of us.

Choosing joy can be more than a moment; it can be a way of thinking—a lens of supporting ourselves and one another through

Media I: "Aint I a Woman?" by Sejourner Truth
Media II: I See A Queen by Frank Morrison
Media III: The Life and Death of Marsha P Johnson Documentary
Media IV: Stonewall Then and Now by the Harvard Gazette June
2019

Speech Entitled "Ain't I a Woman?"
by
Sojourner Truth

Delivered at the 1851 Women's Convention in Akron,
Ohio
Well, children, where there is so much racket there
must be something
out of kilter. I think that 'twixt the Negroes of the
South and the women
at the North, all talking about rights, the white men
will be in a fix pretty
soon. But what's all this here talking about?
That man over there says that women need to be helped
into carriages,
and lifted over ditches, and to have the best place ev-
erywhere. Nobody
ever helps me into carriages, or over mud-puddles, or
gives me any best
place! And ain't I a woman? Look at me! Look at my arm!
I have
ploughed and planted, and gathered into barns, and no
man could head
me! And ain't I a woman? I could work as much and eat
as much as a
man - when I could get it - and bear the lash as well!
And ain't I a
woman? I have borne thirteen children, and seen most
all sold off to
slavery, and when I cried out with my mother's grief,
none but Jesus
heard me! And ain't I a woman?
Then they talk about this thing in the head; what's
this they call it?
(member of audience whispers, "intellect") That's it,
honey. What's that
got to do with women's rights or Negroes' rights? If my
cup won't hold
but a pint, and yours holds a quart, wouldn't you be
mean not to let me
have my little half measure full?
Then that little man in black there, he says women
can't have as much
rights as men, 'cause Christ wasn't a woman! Where did
your Christ
come from? Where did your Christ come from? From God
and a
woman! Man had nothing to do with Him.
If the first woman God ever made was strong enough to
turn the world
upside down all alone, these women together ought to be
able to turn it
back, and get it right side up again! And now they are
asking to do it. The
men better let them.
Obliged to you for hearing me, and now old Sojourner
ain't got nothing
more to say.

FOR US BY US—MEDIA SITE PLANS III | BY DESTINY BRADY

whatever it is we are going through on the personal level and, of course,
on the bigger scale.

There comes a moment when enough is enough. That point is
different for each of us, but when we get there, it's hard to come
back from—the feeling of rage and fear and excitement and a certain
assuredness that something has to change. *Must* change.

One of the most glaring examples of this urge is the civil rights
movement in the United States that symbolized in so many ways Black

people fed up with centuries-old practices, laws, and beliefs that stopped them from living fully self-expressed lives. And it was a continuation of the ongoing struggle that began from the moment Africans were forced onto those massive ships that continued through their descendants.

In her beautiful book, *The Three Mothers*, Anna Malaika Tubbs tells the story of a moment in the life of one of the most iconic writers of the twentieth century that is worth meditating on. Decades before James Baldwin became a world-renowned writer and figure in the civil rights movement, he worked with the U.S. Army to build an army depot in New Jersey. One night while living in Jersey, Baldwin went to see a movie and then planned to eat at a diner with a white friend after. Like clockwork, Baldwin was met by a white waitress after sitting down and for the umpteenth time was told that "negroes were not served" at the establishment. Baldwin and his friend stood up and walked out of the restaurant. Outside, Baldwin made his way to an even fancier spot with determination. He sat at the first empty seat he could find. Once again, he was approached by a white waitress who repeated the then-common phrase denying Black people service: "We don't serve negroes here." That night was different, and it set Baldwin off enough that it made him grab the water mug on the table he was sitting at and throw it in the waitress's direction. The angry crowd of white customers who witnessed what he'd done literally ran Baldwin out of the restaurant. He ran to save his own life.

This brief story highlights a feeling I personally have experienced and know many others—millions of others—have too. The Jim Crow system did not shatter with the mug that Baldwin threw against the wall that night, but that surge of having had enough of the system that denied him the simple right to eat at a restaurant pushed Baldwin to change how he was going to react to it moving forward. He was emboldened by the visceral act of resistance to stand up for himself and for what he understood was an injustice occurring in the lives of many like him. A rupture occurred that night in young Baldwin that would continue to open as he grew up to speak truth to power. It was a dangerous choice

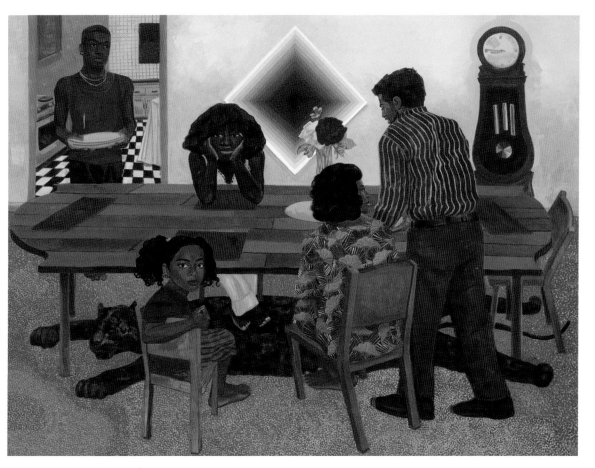

SOMEDAY | BY TAJH RUST

that could have cost him his life, but it was what he needed to validate his experience and those like it.

That similar urge has been present across front lines all throughout movements for Black life such as the civil rights movement and, most recently, in the waves of protests in the 2010s and early 2020s. In this more recent iteration of the movement, numerous images have flashed across timelines and screens of people voguing in front of barricades of armed police ready to cause them harm. All kinds of protest songs and chants have been created for the moment while also invoking classics such as "We Shall Overcome" and, at one point, the consistent recital of Assata Shakur's famous words, "We have nothing to lose but our chains."

Baldwin's personal tipping point has been felt across the Black world to this day and throughout time. Today, we see it in the uprisings after the

release of videos of Black people being murdered by police, the waves caused by the #MeToo testimonies, the insistence on eradicating a racist Christmas celebration through Blackface in Holland, the shutting down of an LGBT+ center in Accra. Unfortunately, the list of the many ways and moments that we have been pushed to the edge feels endless—to choose resistance.

In an ideal world, nonviolence would be the most effective way out after being pushed to the edge as described earlier. The truth is,

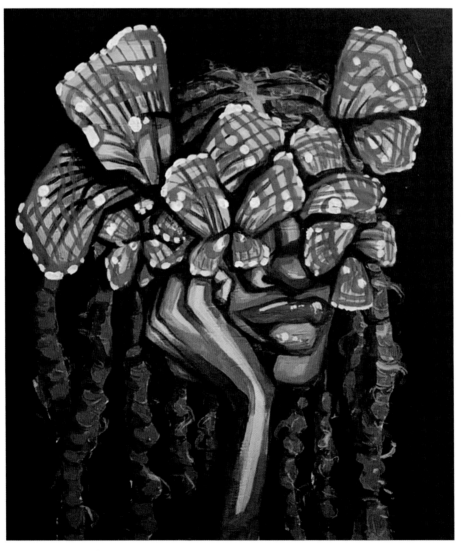

FLUTTERVISION | BY NYALA BLUE

sometimes fire does have to be fought with fire. Think of the uprising at New York City's Stone Wall Inn led by trans and queer people of color in 1969. What is also true is that the goal is not just to eradicate every form of oppression with joy as an anchor, it's also about what happens in the wake of that vision. When we choose to resist through Black joy, we are choosing to create new spaces and uplift those that may already exist to fight back.

Storytelling is one way that we can choose joy as a form of resistance. The Nairobi-based podcast *AfroQueer* is an incredible example of a space that amplifies joy while also not shying away from what does not bring it. What's special about this platform is that it has created opportunities for queer Africans to tell their own stories on their own terms from across the continent. Launched in the summer of 2018, the podcast offers twenty-nine episodes across four seasons that bring listeners on a journey to hear firsthand insight on all kinds of topics, from the history of Pride in South Africa to the legend of a queer nineteenth-century king from the Buganda region of Uganda. West of Uganda, a child of Central Africa is also hard at work on telling important stories.

Marie Pierra-Kakoma, best known as Lous and the Yakuza, is a Congo-born artist who also spent her childhood and teen years in Rwanda as well as Belgium due to wars and their wakes. Her work is very intentional around centering Black people—Black women, especially—in a way that visualizes them with pride in who they are and what they look like. In an interview with *Dazed* magazine, Lous said, "For me, it's important to have a beautiful representation of a Black woman—someone who's not ashamed of her skin tone." In her decision to showcase Black women, and particularly dark-skinned Black people, in a light of pride, she's also accepting all that comes with those experiences. The "yes, and," if you will. She's also making the active choice of joy as a means to shine a light on reality as it truly is.

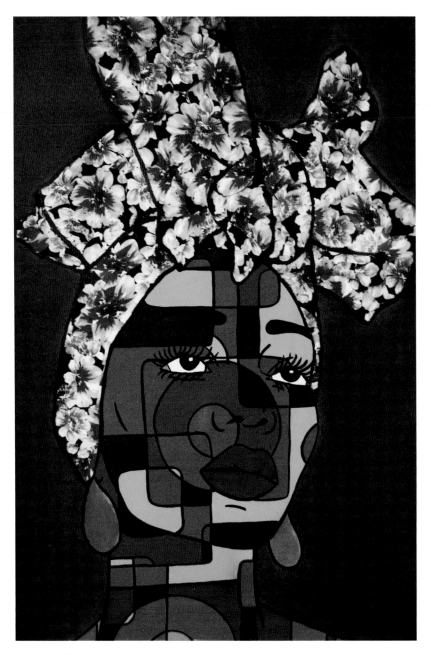

INDIGO | BY JUSTICE DWIGHT

In her song "Solo," Lous explores solitude and its ability to be both confining and liberating. She explores the importance of learning to love time alone with yourself to heal yourself through inner work and also find the good parts of life, of living. She's not evoking utopia but rather an invitation to be in the full harshness of our realities and then show how there is joy and power present there. This sentiment is present in Lous's

upbeat bop, "Dans La Hess," whose title and lyrics refer to "the struggle" that is living a life of poverty and difficulty. The tempo of the song speaks to this larger sentiment of choosing joy and moving toward another way. In the song, Lous describes how bad her situation is and why it's not working for her, and she cleverly inserts into the chorus a line affirming that when her first album debuts it will free her of that condition. There is hope embedded in the song, and the up-tempo beat transforms what would otherwise be a depressing moment into something else. We get to dance in the middle of this struggle and affirm that there is a way out.

When we accept we are in a world that is actively set up to destroy the lives of Black people, then we can discuss how actively choosing joy is a way to resist all those forces. How critical it is to consider alternatives for tackling the very systems that threaten to take our lives daily.

The creation of a movement via music to uplift voices.

The writing of books to push imagination while holding a magnifying glass to reality.

The slicing of cake and passing it around after an hours-long meeting to strategize a new plan to address unconstitutional rulings.

Resistance and joy go hand in hand, fist in fist. In fact, when we choose joy in the face of obstacles, we are seeing reality clearly, yet being brave enough to imagine something better: a world fit for us, not the other way around.

MUNGANYENDE HÉLÈNE CHRISTELLE

When I think of Black joy, I think of the Kinyarwanda[*] word for "more than one" or "multiplicity": ubwinshi. Ubwinshi is an indication of quantity, but it is more than that. It means both quantity and destination, like a deep well that you can sit in.

On the edge of Lake Kivu,[†] children like me are born in a state of ubwinshi. We are curious, rebellious, and because we are born at the water's edge, we see everything in life as fluid. The mythology around this lake's origin is that a witch was kidnapped by the royal court and gave birth to the lake via orgasm. Thousands of years of volcanic activity have caused our birth water to be combustible. Quite literally. From the deep, fresh water of the lake, clouds of gas can suffocate livestock and people. I came to understand how expansive the world is in that water. My understanding was like its own birth, happening in three acts: first (screaming) like amniotic fluid, then (screeching) like holy water, and later (crying) like the swell my family and I crossed to flee to Europe and start a new life "in the abroad."

In this foreign home, I found myself hiding under tables to hand draw portraits of grown-ups who visited our living room to discuss grown-up things with one another—sticky things that I overheard but could not begin to understand. Under those tables, I tried instead to capture the faces of grown-

* The national language of Rwanda.
† One of the East-African Great Lakes.

ups as side portraits. Looking at an auntie or uncle in profile meant not seeing them for all that they really were, which made their horror stories less real. Except for their eyes, because the eyes always speak, even from the side. When I would crawl out from under the table and they would remember I was in the room, I would see their full expressions again, startled at my drawings.

Meanwhile, I found ubwinshi in clothes. I wore my brothers', and they wore mine. There were no "boy clothes" or "girl clothes," so none of it made me feel like I was doing something wrong, until mounds began to grow on my eleven-year-old chest. I was given a pair of Hello Kitty pajamas from my favorite uncle. I excitedly walked into the garden in my new pajamas and felt my new nipples poking through the pajama shirt. I noticed the startled faces of my parents and that of my uncle, who looked to the ground with his hands folded.

I found ubwinshi in words to embrace myself with too. I write of a home to wrap my tongue around, to say all that has been left unsaid or left behind at the waters' edge. I know of words to multiply myself with. Ubwinshi is not only a quantity but a destination—a deep well that you can sit in.

In those first months "in the abroad," the grown-ups talked about returning home on the regular. At their kitchen counters and around cardboard-boxes-turned-coffee-tables, they sipped hot bottles of Leffe Blond that had been left outside of the fridge for too long, forgotten because of the heated political discussions that would ensue on long afternoons. We were too busy imagining freedom.

The homeland danced on the lips of the people who gathered on our couches every other weekend. The conversations were all invested in the political turmoil of our home countries: who would carry out the next coup; when the next prison release of such-and-such would take place; which vintage African president we should criticize most for ignoring the voice of young people. On afternoons like this, we kids made it our mission to rush between grown-ups' legs—in and out of the kitchen to steal yet another sambusa or chapati, avoiding a reprimanding tap on our greasy fingers. Our

mothers and aunties walked up and down the kitchen and living room area serving hot plates of food as they collected empty bottles and displayed their cooking skills with pride. Despite the distance between us and home, those dishes would come very close to the food that we were used to eating. And when we swallowed a bite of isombe, ubugali, or boiled cassava, we would picture ourselves home in our backyards of Kigali, Lomé, and Dar es Salaam. All of us shared but one collective goal: getting through our first winter here.

As a child I believed in magic in an unbridled way. I saw magic in all the things I had no explanation for: magic was why I could fly in my dreams, why a wound hurt less when my favorite auntie kissed it, why a chicken kept running when its head was cut for slaughter, why birds found their way home at the beginning of spring, why my parents escaped death through the eye of a needle in wartime. But I was called to womanhood early. That first winter came and went, and my life became filled with adult experiences. Words like "luck" (for family) and "sin" (for my body) came and took the place of magic. Magical thinking became a false belief and imagining freedom a thing of superstition.

Over the years, I've learned that the way people envision the future is often influenced by the limitations people know from their past, especially if that past was exposed to trauma. What is the Black experience outside of the white gaze? Womanhood outside of sexism? Queerness outside of homophobia? Being African and of Africa outside of neocolonialism? These are questions about the future whose answers seem so distant at times. Trauma is not an identity. Yet, it is sometimes difficult to look beyond the comfort of habitual pain. We sometimes carry the weight of our trauma for so long that we don't know who we are outside of our suffering.

Black joy starts at the borders of our traumas. As resistance workers, we have to envision the day after the revolution before we know what the revolution is actually working toward. The revolution in itself cannot be the goal. Future-thinking is the audacity to dream. What makes this mindset a challenge is what it demands of the stories we tell ourselves, about ourselves, to be postrevolutionary and self-evidently free, which then poses the next question: Who do we want to be when we finally get to freedom?

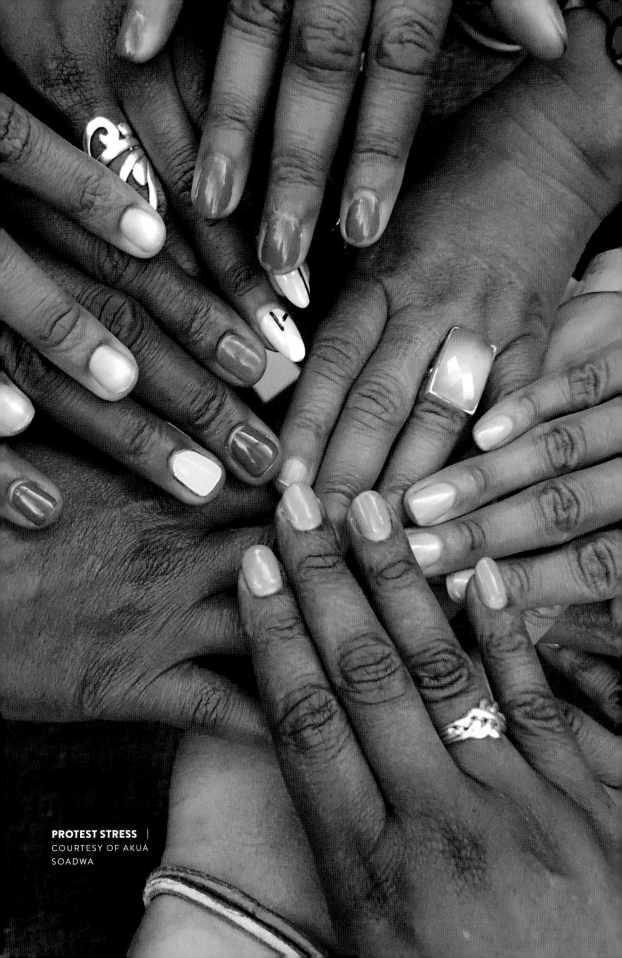

PROTEST STRESS |
COURTESY OF AKUA
SOADWA

3

YES, AND . . .

COCONUT GIRL | BY RUKAYA SPRINGLE

We can hold two truths at once. That joy exists alongside pain is not a contradiction. There is not necessarily a "brighter side," but rather a reality and how we decide to engage with it. Black joy is a kind of *yes, and* to this challenging reality. In improvisational acting, "yes, and" is a foundational principle that requires an actor to accept what is happening in a scene (that's the "yes") and then add information to move the accepted knowledge forward in some way (that's the "and"). "Yes, and" is about building a scene from nothing, off the top of your head, alongside others. This strategy of performance uses our full imaginations. It is what actor, healer, and creative producer, Cloteal L. Horne, described in a conversation I had on this topic with her as a practice of "transformation that evolves into a new reality and shifts the circumstance." Imagine two actors pretending to be on a playground full of children running around. They are having the time of their lives, soaking up the sun on their brown skin. One actor turns to the other and asks, "Can you see the finish line?" The second actor smiles, now panting. "Yes, and when we are done with this marathon, there will be so many snacks!" A simple example but one that speaks to the power within our reach to cause significant change in the tangible world.

This principle can be applied beyond the world of acting and used as a tool when combined with joy. If we first consider improvisation in regard to life, it is something that Black people do all the time, whether it is through the legal and systemic restrictions that force them to innovate and improve their lives—like the birth of hip-hop in the Sedgwick Projects

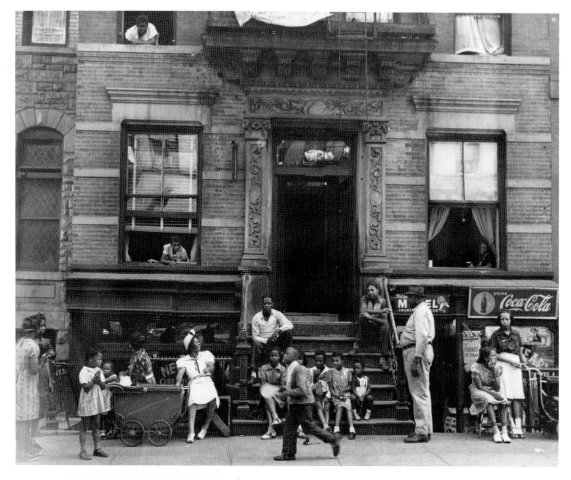

HARLEM TENEMENT IN SUMMER | NYPL

of the Bronx—or the decision to hide grains of rice into cornrow-styled hair in the long journey into forced captivity.

The "yes" in "yes, and" calls for the acknowledgment of a situation or circumstance as it is at that moment in time. That recognition then leads to an opportunity to shift it in some way: the "and." By accepting that the world is messed up, that there are systems historically in place to harm, limit, and kill Black people altogether, then the space opens to change those conditions accordingly. This, of course, is much easier said than done. And it takes more than only some people using this lens. This principle is also linked to imagination—the creation of what does not yet exist to address what already does.

Imagination is one of the most radical tools Black people have access to and, as with joy, it is something that cannot be taken away. Like improvisational acting, it takes practice to develop and strengthen the skill to create shifts (often on the fly) that lead to necessary change. These skills help both to navigate the complexities of this anti-Black world and to make the reality that serves us best that much more real.

In the eleven years (1866–1877) immediately after the Civil War and the signing of the Emancipation Proclamation that freed millions of Black people in the United States, the country entered what Congress named Reconstruction. It was a time when Black people who were legally freed from bondage (unless a crime was committed, as per the Thirteenth Amendment among other exceptions) and the country at-large had to reestablish what the nation looked like. In this new era, Black people built and grew their lives in ways that had never been possible before. It was an era with a record number of Black politicians, business owners, and professionals. Many free Black people forged new paths toward (re)building their lives in a complicated nation. It was also an era of experimentation and artistic expression, as Black people all over the country figured out what this new status would look like for them. Of those many people, one was a queen.

Born in Maryland four years before Abraham Lincoln's Emancipation Act of 1862 that freed enslaved people in the District of Columbia, William Dorsey Swann spent the early part of his life in bondage. It was in the 1880s, when Swann was in his twenties, that he appeared in newspaper articles that described private parties he'd organized with fellow Black queer folks in the D.C. area. The parties got media attention at the time for being raided by the police. We can thank historian and writer Channing Gerard Joseph, author of the biography *House of Swann: Where Slaves Became Queens—and Changed the World*, for discovering those newspaper clips more than a century later and unlocking a valuable piece of (queer) history for the world. Joseph uncovered Swann's indelible mark on history as the first documented and self-proclaimed "Queen of Drag" or what we today call a drag queen.

At a time when Black people in the United States were reestablishing themselves as newly freed people, Swann and his community gatherings were incredibly transgressive by any standards and definitely those of the late nineteenth century. Swann and his crew existed at the margins of the margins, so it was there that they created their "yes, and." Their "yes" emerged despite not embodying what both society and Black communities considered appropriate at the time and even perceived as a threat toward societal progress. Joseph's scholarship describes Swann's parties as "particularly significant in light of nineteenth-century attitudes toward masculinity." Swann and his community in D.C. came together, often at high costs, knowing they could be thrown into jail or publicly humiliated. That they would still be willing to live their truths, fully self-expressed, is a sign of how much it mattered. Those gatherings that Swann and his friends created for one another served as the early seeds for what has become a long history of Black queer gatherings and spaces

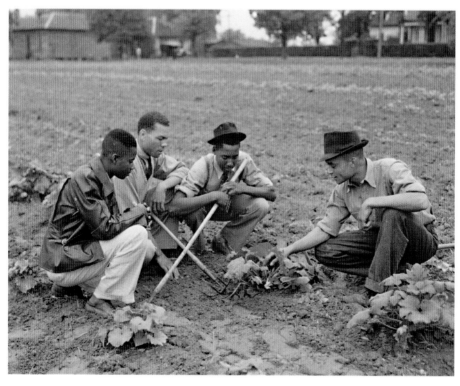

FORT VALLEY NORMAL AND INDUSTRIAL SCHOOL, EXPERIMENTAL GARDEN | NYPL

that celebrate the TLGBQIA+ community in its fullest. It has led to spaces like today's ballroom scenes that offer lifelines for people all around the world who still are not fully loved and respected as much as they should be in broader society. Swann's parties offered moments of Black joy in a really specific way. It was not an escape or an opportunity to look away from the realities of the world. It was the opportunity to say *yes*, the world is not as it should be, *and* to choose joy as a valid option toward addressing what is not working. For Swann and his comrades, it was *yes*, the world may not love us . . . *and* that does not mean we cannot love ourselves.

I t's important to accept that to make change requires one to be with the world as it is in its fully complex and violent state. It means facing said challenge or obstacle head on. Confrontation with what is impeding our joy opens space to figure out ways to free ourselves and, if not, at the very least make progress toward that goal.

Many, if not most, of us already make the daily decision to step out into the world despite knowing that it will not love us back in all the ways we deserve or in the ways it should. What Black joy offers is the hand to hold through that journey.

In a beautiful description of the various beliefs that Malcolm X (born Malcolm Little) and his siblings were raised with by their parents, Louise and Earl, scholar Anna Malaika Tubbs paints an image of a young Malcolm learning the power of growing food. Passing down skills like gardening nurtured the family teachings about self-sustainment—both for survival and as a tactic of resistance against the forces working against them. According to Tubbs, Malcolm loved growing peas and seeing their journey from garden to table. During the gardening process, after the hard work of tending to his plants, Malcolm would "lay by his peas, looking up at the sky, watching the clouds pass and think about his dreams. Here he found tranquility."

It's important to acknowledge that the backdrop of Malcolm and his siblings' lessons on growing their own food was one of incredible violence toward Black people. During that time, the Ku Klux Klan (KKK) was at an all-time high in its membership and mission to terrorize people across the United States; Jim Crow laws also made it so that the Littles and millions of other Black lives were heavily restricted in their mobility, both by the laws of the day and the violent practices of everyday individuals and terrorist organizations like the KKK. Further, Malcolm's parents were race people, especially his mother Louise Little, who was a devotee of the radical Black activist Marcus Garvey. Garvey was a charismatic leader who championed Pan-Africanist beliefs in uniting Black people around the world through the founding of the Universal Negro Improvement Association and the establishment of chapters throughout the African Diaspora in the Caribbean (started in his native Jamaica), South America,

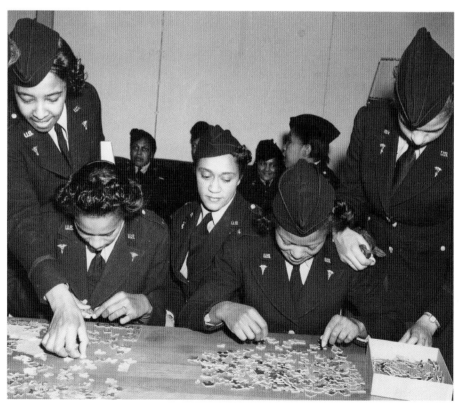

WOMEN'S U.S. ARMY CORPS MEMBERS WORKING ON JIGSAW PUZZLES | NYPL

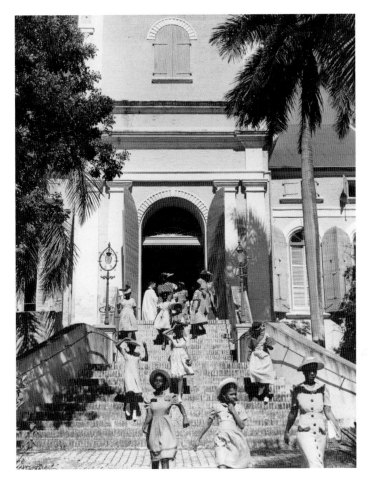

VIRGIN ISLANDS, DECEMBER 1941 | NYPL

Central America, the United States, and Africa. The chapters served as outlets for people to gather, organize themselves and get more acquainted with ideas of Pan-Africanism. Louise was also raised in her own Black radical traditions on her home island of Grenada as a result of the legacy of resistance to white supremacy there.

As Garveyites, the Littles were part of a huge movement in the early twentieth century that promoted the ideas of Black nationalism and autonomy—ideas that were seen as valuable exit routes from the legacies of slavery, patriarchy, classism, and the general sense of second-class citizenship. The Littles understood that in the process of building community and movement to take down the violent forces harming millions of people every day, there also needed to be space to accept that reality while moving toward a different one. A *yes, and,* if you will.

Malcolm, and I imagine other children of his childhood era, had moments of sitting in the sun quietly dreaming as they lay next to seeds they'd planted and cared for. Each literal seed planted was a contribution toward a life that was less reliant on systems that insisted on taking their lives away. They dug their hands into soil to grow food in the ground of a country that saw them as less than valuable. Perhaps the landscape did not change entirely, but seeds were planted that eventually blossomed.

The story of Malcolm's family is also a great example of a meeting point of different parts of the Diaspora because his mother, Louise, was of Caribbean heritage and his father, Earl, was African American. Like many other Black community organizers of their era, before it, and after it, their work coincided directly with the movement for Black lives in other parts of the United States and, of course, all over Africa.

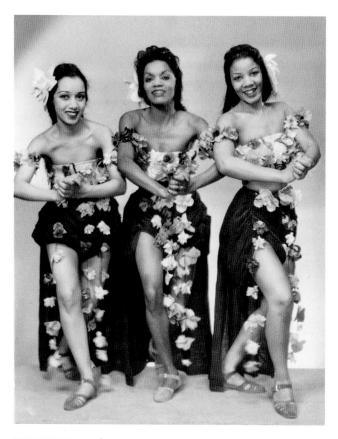

THREE WOMEN | NYPL

On a large, wrinkled piece of white paper, torn at the edges from hands holding it up high during a protest, the words *"Why do I get beaten 4 being femme and perceived as gay? #ENDSARS #QUEERLIVESMATTER"* forced anyone who could read them during that march (and across the internet) to engage with the violence that too many TLGBQIA+ Nigerians face daily.

Queer Nigerian activist Matthew Blaise held up this striking sign during the #EndSars protests in major cities across Nigeria in the fall of 2020. This movement was sparked by a viral video of a young person being murdered by members of Nigeria's now-defunct Special Anti-Robbery Squad, a division of the police force. Young people, who make up the majority of the nation's population, took to the streets to call out a history of police violence, among other related issues of inequality in Nigeria that they'd grown tired of. The uprisings came on the heels of a summer of protests in the United States after the murder of George Floyd months earlier in Minneapolis, Minnesota. Both protests spoke to an explicit exhaustion from unjust policing practices and systems.

Blaise and many other young Nigerians were signaling to fellow Nigerians and the rest of the world that there was no way to address a history of police violence without addressing the ways it has impacted queer people. Of course, the persecution of queer Nigerians and Africans in other parts of the continent is deeper than the violence inflicted by police. *And* it would be one-dimensional to describe Blaise's life and others like them as simply sad or depressing. What is also clear from social media posts and other forms of public sharing is that these lives contain joy. This is evident in clips of dancing solo and with one another, in poses of confidence in crop tops and short-shorts, in hugs between friends and chosen family. Black joy is *always* in tandem with oppression and discrimination.

Part of getting through is first seeing the world as it is. It is anti-Black. It is transphobic. It is classist. It is homophobic. It is sexist. It is ableist. It is set up to serve the insatiable appetite of white supremacy and the many heads it bears. Even for those who live incredibly privileged lives, these

forces can never be fully escaped. In some form or fashion, they will confront you.

One of the very first people to engage with The Black Joy Project was renowned Kenyan, immigrant, speaker, organizer, and performance artist Mwende "FreeQuency" Katwiwa. At the time, Katwiwa was living in New Orleans doing work with Black youth and performing their art. While catching up with Katwiwa and inevitably talking about The Black Joy Project (which was only a few weeks old at that time), I asked them, "What does Black joy mean to you?" There was a pause. Katwiwa found themselves stumped. They shared that they had learned how to write about and speak on Black pain so eloquently, quickly, but had not had the same readiness to articulate Black joy. As we went around a small circle of their friends talking about Black joy, they continued to be stumped. It would take some days before they could get back to me with a response. They had to take some time to work through what caused that pause, that difficulty to give language to a force they were no stranger to but could not easily find the words for. Eventually they did. *The feeling of home and happiness rooted in the love of yourself and your community despite everything that tells you otherwise.*

In a conversation with Katwiwa a few years later, they expressed how that question catalyzed their thinking around joy and pushed them to make it more of a presence in their life and work. Was it a life-changing question? Perhaps not, but a *shift* did occur. There was an acceptance that yes you can proficiently articulate Black pain *and* as much energy can be contributed to expressing joy.

As many brilliant minds have expressed clearly before me, there are levels to Blackness and the ways that white supremacy impacts our lives—not in the sense of an "oppression Olympics" but rather in the acknowledgment of the existence of the "isms" (race, class, gender identity, sexuality, religious beliefs, etc.) and how they impact us differently. Though, for example, I am a queer Black person from an immigrant family, my lighter skin affords me privileges, as does my status

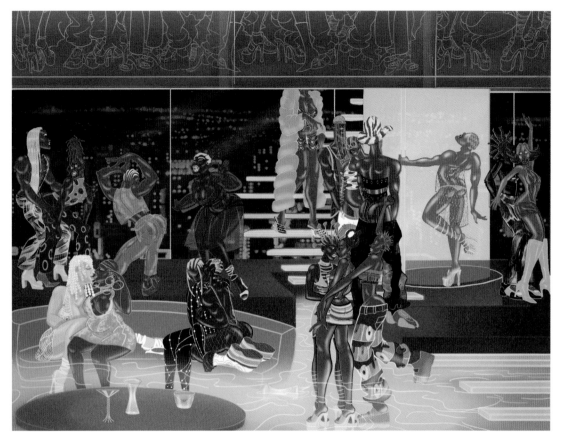

CLUB OASIS | BY TERRELL VILLIERS

as a citizen of the United States. These are important factors to consider when thinking about who gets to experience Black joy and whose joy needs protection.

In the discussion of African descendancy and the African Diaspora, Black people from around the world are often roped into an incredibly complicated conversation. For example, who gets to be included in these categories of "African descendant"? And within those categories, is there room for difference and variance? The answer, of course, albeit not the most comforting, is that it depends. It depends on who you are talking to, where you are talking, and when. Some people who are viewed as Black in one part of the world may not identify as Black themselves, and the inverse is true too. In some places, like Holland, Black can be a political

identity that forms a huge umbrella. In other places, such as South Africa, it's a more distinct identity with specific entry points. And of course, the people who are viewed as Black anywhere in the world regardless of circumstance should be most lifted up as they will bear the most brunt of the forces working against us—their joy will often be most threatened.

What has risen to the surface from observations through this work of Black joy is a broadness around Black identity that has its own distinct markers but offers room for many. It is particular to people of African descent and principally uplifting not just those with African ancestry but especially people who phenotypically look Black. It's the people who, whether or not they had a hard time articulating what Black joy means to them, have ultimately come to some form of defining the role of that force in their own lives because of how they've been forced to navigate it and often denied their full humanity.

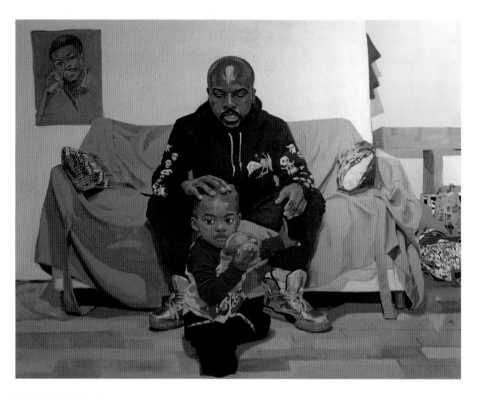

THE FREEMAN | BY TAJH RUST

In the fall of October 2017, a former colleague and brilliant mind Shakira O'Kane invited me to serve as a photographer for a small group trip she organized to Havana, Cuba. As a Dominican American, I've always been curious about life on neighboring islands in the Caribbean. Cuba, in particular, is interesting because I have had little firsthand experience with Cuban culture or people, outside of occasionally meeting Cubans in the United States. Its tense history with the United States makes it a compelling place to learn about too. Having a direct channel to get firsthand insight on daily life was irresistible. Plus, any opportunity to speak Spanish in a place where it is spoken widely is exciting.

I wasn't sure what to expect from this trip, other than knowing we were there to learn. What I experienced was a people who fought hard for their daily survival, situated amid obvious inequality, be it old dilapidated housing, barely stocked public supermarkets, or an always-present heavy surveillance of the people. I found the obvious conflict between governmental rhetoric of harmony and the difficult reality of everyday life hard to reconcile.

First and foremost, it's important to state how Black the population of Havana truly is. It was evident not just in the people I saw on the streets and packed into public buses and taxis. It was also in the cadence of the Spanish spoken that echoes West Africa; in foods like moros y cristianos (black beans and rice) cooked in homes and restaurants; in the strong presence of Lucumí, a traditional African spiritual practice handed down through the centuries; and in the percussion of salsa heard around the way.

One morning on that trip, our small group, led by Shakira, loaded onto a charter bus in a big, mostly empty Havana parking lot. We had planned to tour the westernmost region of the island with a local tour guide and translator, but because the translator was sick that morning, I was the only other person who could translate from Spanish to English. Nervously, I made my way to the front of the bus. Though I had never been to Cuba before, I found myself translating a day-long tour of one of its most visited regions.

We stopped at all kinds of places that day—rest stops to look at trees with distinguished trunks reminiscent of potbellies (barrigón); smaller cities like Pinar del Río and the giant Fidel Castro-commissioned mural depicting supposed life in prehistoric times in the Viñales Valley; and the round and lush green mountains of Los Jazmines that looked like the ones from the classic Super Mario games—before heading back to that large, mostly empty parking lot.

Along the way that day, among the many topics of discussion throughout the tour, we talked about African spiritual traditions still existent on the island and the roles they play and have played in society. We made connections between those practices in Cuba and the ways that similar practices showed up in the United States and other parts of the Diaspora. There was awe in several moments of the connection between our experiences and excitement in the ability to recognize them. We talked about daily life, we laughed, and we also took in some of the harder realities Cubans face: the poverty; the lack of access to quality basic human needs like affordable groceries, unstable shelter, underpaid labor; and everything else that comes with inequality.

During one of the quieter moments in between sites that day, I got to speak to our guide—I will call her Yocelin—about what her life was like. Admittedly, there was some hesitance and shyness because outside of sharing this tour responsibility, we did not know each other. It took a little prying to get her to talk a bit more in-depth with me about life in Cuba. I also imagine she may not have fully divulged all her truth, which is understandable, considering the potential risk of speaking out to a foreigner who would not be around for potential repercussions if things ever got messy. The conversation was warm, though. She talked about enjoying her life with her loved ones and the opportunity to interact with people like ourselves on these tours. Eventually, I asked her what joy meant to her, and she said, "To see my family do well. To feel good internally. Many things."

During the brief time I spent in Cuba, I saw the continuation of a pattern I'd seen elsewhere around the world when the powers that be do

not support people's needs. I saw the consequences yet again of only a handful of people having more resources than the masses—a system that makes us pay simply to exist and which raises impossible expectations for any individual or household to maintain any type of stability.

And: that golden word. *And* there was also so much joy present. It was on the dance floor in the packed club as people burned holes into the rug to salsa, merengue, hip-hop, and all those Afro-influenced sounds. I saw it in Shakira's partner's face when he talked about the love that existed in his family and in the walls of his small family apartment in Old Havana, which was full of love despite its dwindling state. I saw it under the neon lights at a fast-food spot on the corner that served hot tasty fried food near that same apartment. I saw it in the Lucumí initiates dressed in all white walking around the city in a calm and focused pace. I saw it in the lovers' embraces along the Malecon in Havana.

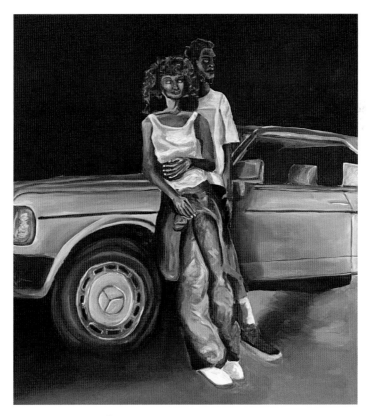

RIDING ON LOVE | BY BECCA BROWN

At the start of the summer of 2021, my uncle Pupo, my grandmother's brother, was diagnosed with stage four of a rare form of lung cancer. This diagnosis threw my family into a tailspin. Quickly, our lives shifted to sharing the responsibility of supporting Pupo, picking up the medicine he needed and taking him to see specialists at the hospital where he would eventually spend the next few months. There wasn't much we could do besides show up.

On a random morning right before the COVID-19 pandemic started, I found myself in the East Liberty neighborhood of Pittsburgh in the garden section of a big-box hardware store up the street from the century-old, two-story brick home that houses my first-floor apartment. It felt like a lucky day because there were plants at prices that were affordable and I had some extra cash. I bought a medium-size plant with waxy dark green leaves that looked like raindrops poking out of a thin sugarcane stalk. I named her Susie, as in Susie Carmichael, the most badass toddler on the legendary, animated television series *Rugrats*. My partner's sister later gave me a painting she made of Susie as a gift. I sat the plant in the corner of the small front room in my apartment, right under the painting. Susie's presence made me feel good because it was another source of life at home to connect with. I didn't have the greenest thumb, but Susie gave me hope and some comfort.

Black joy feels good, no matter where we summon it. Yes, we recognize it in a smile or a laugh. But where else does it show up? We must see it in the moments and spaces where we experience the most persecution and tension with the forces attempting to steal our joy. It's in the deep sigh of relief when you've paid your bills for the month after not knowing where it was going to come from. After living in an area that a government or those with power have designated for you and your

community to reside in whether it can provide all the necessary resources for survival or not.

It's also in that experience of hugging people you love after being gone for too long because of incontrollable circumstances like needing to find work elsewhere or somewhere safe(r) to be yourself. It's there at the airport when family members have traveled long distances to receive a relative who has been away earning money in a low-paying labor-intensive job in someone's house or in a factory to send back home.

It's in the person's relieved heart for not being misgendered, stared at, or harassed for being themselves walking down the street, particularly in and among Black communities.

It's in the strategies, visions, and dreams of abolitionists who vie for societies that are free of police systems and laws that continue a legacy of dehumanizing violence toward anyone, particularly Black people.

Black joy must also be tended to.

At some point during the madness of the pandemic, Susie didn't make it. I came back after being away for at least a month and I'd forgotten to water her properly. Her leaves had fallen off, and the sugarcane stalk–like

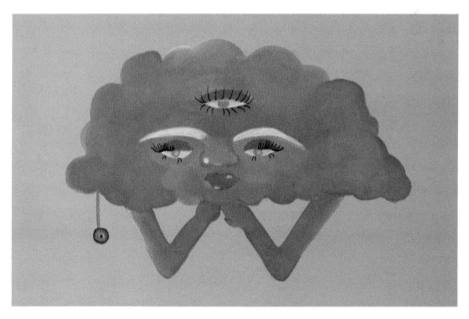

HIGHER SELF | BY ZIANA PEARSON

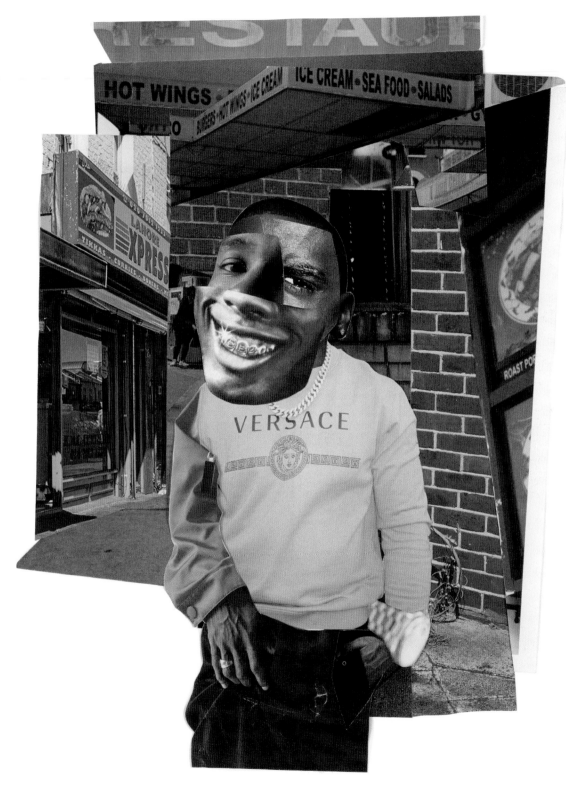

CORNER STORE | BY BRIA STERLING-WILSON

stem had shriveled. I thought maybe it was best to get rid of her since she seemed so far gone. I called my mom, my go-to green thumb, and asked her for advice. She told me not to give up on it and to just water it some more. So, I did that and placed her outside. I went back to New York, again for an undetermined amount of time.

I spent most of that summer in New York trying my best to write while tending to family needs, a big chunk of which was supporting my uncle. Pupo passed away early that fall in September. The inevitable result of a terminal illness is still hard to deal with when it comes. Once again, in less than a decade, my maternal line lost another loving relative. Pupo did not leave many material things behind, but he did leave that warm feeling of love in the hearts of many of the ones who knew him. I returned to my apartment in Pittsburgh a week later to catch my breath. To grieve for a moment to myself. To clean my altar, bring it fresh flowers, water, and white candles.

I was getting reacquainted with the house when I opened the back door in the kitchen and was pleasantly surprised. A burst of long green leaves were coming out of Susie's pot! From the shape and size of the leaves I knew immediately it was some type of wildflower. After taking in the pleasant surprise, I lifted the plant out of the larger plastic pot it was sitting in. The leaves looked like they were reaching for sunlight, and I wanted to support them in that. When I lifted the pot, all the water that had pooled at the bottom from a summer of rains poured out of the drain holes. That budding wildflower made it through all those intense hurricanes-turned-tropical-storms that swept across the United States that summer and was still standing. Growing in fact. So, I wrote down in my notebook:

Forgotten outside
Surprise burst of green of life
There soaked in bucket
The wind blew fiercely, you bloomed
freed from your cages

This poem is a reminder that life is like that too. Haven't you tried to keep something alive that seemed like a good deal but in the end did not make it? And haven't you been surprised by what can rise from the very place where you lost something you loved? How many storms have you weathered that did not knock you down? At the moment I lifted Susie's pot and placed it on the rusty fire escape, a strong wind blew. There was an affirmation in those winds that carried love and the power of existing more freely.

That's what I want for us. This is why we need to address all that does not bring us joy in the world because it holds space that more joy can exist in. This is why it's so important for us to have mental health, shelter, food, safety, and all the basic human rights wherever we reside in the world so that we can have a strong foundation to hold existences full of joy. A house cannot stand long without a strong foundation. That base of a quality daily life demands that each of us have access to clean water sources, a home that does not just contain places to rest, relieve ourselves, and make food but also a sanctuary where we can seek refuge and share space with people we love. That base involves access to doctors and medical facilities that provide critical aid and support through whatever health issues and conditions we may be working through. This is why we have to understand the connection between the persecution we are experiencing around the globe. What steals the joy from some of us steals the joy from all of us.

In 1970, the literary icon Toni Cade Bambara edited a groundbreaking collection of Black women's writing called *The Black Woman*. In that collection, Bambara has an essay she titled, "On the Issues of Roles." In the piece, Bambara is critical and weary of not just gender roles affecting our identities and relationships to one another but, more important, the lack of internal work to get clear on who one is and how being in practice of that person is where the revolution begins. The type of revolution that looks real and concrete shifts in who we are deeply on the inside to ensure that we can usher more of that world outside of ourselves into being. Bambara concludes the essay by asserting:

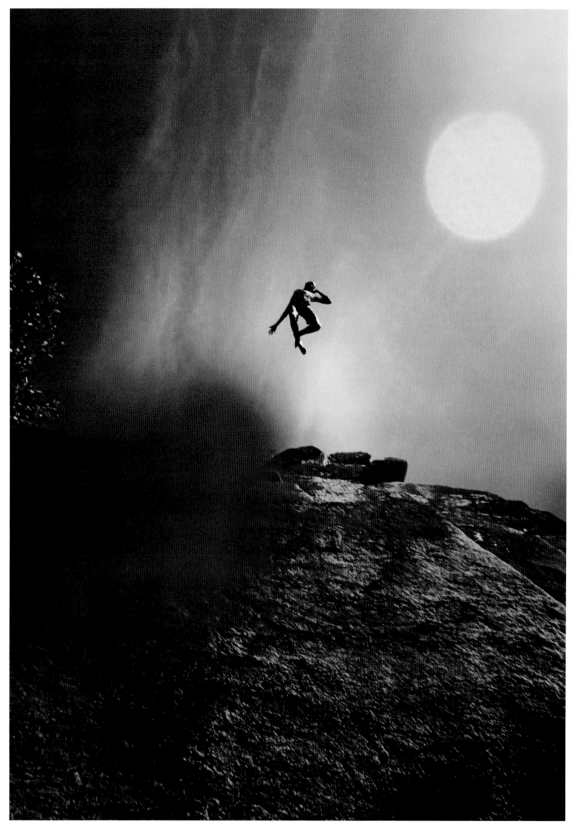

CIRCA NO FUTURE NO. 8 | BY NADIA HUGGINS

STAND IN YOUR DIVINE FEMININE | COURTESY OF AKUA SOADWA

We've got time. That, of course, is an unpopular utterance these days. We'd better take the time to fashion revolutionary selves, revolutionary lives, revolutionary relationships . . . If your house ain't in order, you ain't in order. It is so much easier to be out there than right here. The revolution ain't out there. Yet. But it is here. Should be . . . ain't no such animal as an instant guerrilla.

Tending to Susie, she taught me that sometimes we're going to be shiny and full of potential, and sometimes some of that may seem to be gone when we haven't been nourished in the ways we need. That is not a sign to give up. It means digging deeper and letting go and allowing what comes next to come forward.

Susie's form when she entered my life is not how she is now. Her soil has become a garden for not just one wildflower but two. New life has emerged from the soil I had been planning to discard altogether. All of this takes time, of course. Time that Bambara told us is not needed but necessary if we are committed to being the change we want to see. If we are committed to ridding the world of what is stealing our joy, we can enjoy all of life's depth and beauty. To bloom fiercely.

A nd fun is political, because imagine if we had images of Africans who were vibrant and loving and thriving and living a beautiful, vibrant life. What would we think of ourselves then?" In her TED Talk that has been played almost one million times, filmmaker Wanuri Kahiu shared these words in describing the importance of the artistic movement and community she was a part of creating known as AfroBubblegum. On a website dedicated to this initiative, they describe themselves as, "storytellers, clothes makers, graphic designers, musicians, lovers of life, joy harbingers, beauty mongers, [and] hope sayers." Its mission is to create "fun, fierce and frivolous African art," as a reminder to African people that they too are more than resilient, they are people with cultures and histories of joy too.

83

Too often when the topic of Africa and African peoples is discussed, a gray cloud practically enters the conversation, distorting the diversity and dynamism evident across the second largest continent in the world. More often than not, people associate Africans with stories of struggle, abject poverty, disease, and corruption. And while that is present in some places, it is biased to leave out the ways that joy is cultivated across a continent with a population of 1.4 billion people who speak thousands of different languages and span more than three thousand ethnic groups that speak them.

In that same TED Talk, Kahiu asks about the impact of having a joyful lens or the space to create to uplift this force to counter the tired and reductive narratives of who African people are and for Africans to see themselves that way too: "Would we think that maybe we're worthy of more happiness? Would we think of our shared humanity through our shared joy?" Initially, Kahiu describes the work of AfroBubblegum art as not political, not intentionally, but Kahiu is clear about what happens when people who are marginalized make art and how it becomes political because of its nature.

In 2018, Kahiu released the film *Rafiki*, a love story about two women in Nairobi, Kenya, and their journey to that love. Though it received a relatively positive response outside of Kenya, it was banned by the Kenya Film Classification Board (KFCB) because of the same-sex love themes of the film and what an episode of the Nairobi-based *AfroQueer* podcast reported as ending on too positive a note. The KFCB said that it did not reflect the "realities" of the harshness of TLGBQIA+ life and offered too much hope. It made queer love too normal.

And there it is. Consistent with the rest of the world in terms of its homophobia and resistance to affirming a world that is truly welcoming of all forms of life and love, Kenya is a difficult place to be a TLGBQIA+ person but there is also joy present, both literally and imaginatively, as Kahiu demonstrates in her film.

"[AfroBubblegum] is the advocacy of art for art's sake. It's the advocacy of art that is not policy-driven or agenda-driven or based on

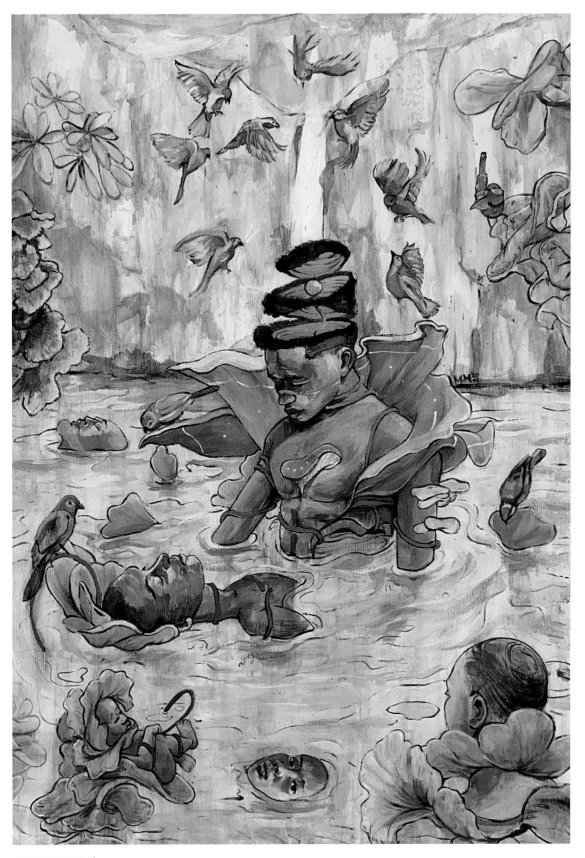

RESURGENCE | BY MARK MODIMOLA

education," Kahiu explained in her talk. She clarified that AfroBubblegum is very much driven by the importance of creating space, in tandem with the realities of everyday Africans, and stimulating imagination. Kahiu's point is that imagining something new or different simply for the sake of imagining it is enough of a reason to do artistic work, because in that process, people can expand the possibilities of their lives. To me, this opens up ways to make connections through the shared experience of joy. For example, the power of art, though it can be experienced solo, is most often created for an audience. In the shared audience experience, a common ground around joy can be established. And it can grow.

Unfortunately, it can also be crushed.

In 2018 after much heavy lifting and legal battles with the state of Kenya, the *AfroQueer* podcast reported that, in hopes of being nominated for an Academy Award that year, Kahiu successfully sued the KFCB and secured the right to screen her film for seven consecutive days, which allowed her to comply with the Academy's rule for nomination. This also marked historical precedent as it was the first time a gay-themed film was screened in theatres in Kenya. *AfroQueer*'s Aida Holly-Nambi reported that hundreds of people attended the first screening at around 10 A.M. on its premiere day. There was joy and hope in the air.

Did Kahiu's film completely shift Kenyan society and eradicate all forms of hate toward TLGBQIA+ people? No. However, it did something that cannot be undone. It created hope and proof of what joy can come from imagination and what can happen when we dare to see the world, both as it is and what it can be.

I n the small town of Spartanburg, South Carolina, lives Faith, a plus-size model and tattoo artist. In an episode of the acclaimed HBO reality series, *We're Here*, Faith has been recruited to perform at a one-night-only drag show in her hometown to help foster community and create more safe space for the town's TLGBQIA+

residents. Like other conservative places around the world, Spartanburg is not the most welcoming of people living outside of the status quo. The drag show is intended to shake that notion up.

In the episode, Faith appears as a flower bud waiting to be nurtured, as a cover of Bonnie Raitt's "Make You Feel My Love" plays in the background. Faith is then "watered" by her Drag Mother, Bob the Drag Queen, which leads to her "blooming" into a sparkly and shiny flower. Faith then points to her partner in the audience and invites her onto the stage, where she lovingly holds her hands under bright stage lights in front of everyone. There, in the very town that made it difficult to navigate as her full self, Faith uses joy as a vision of another possibility—an imagined one that made her and her partner's love more palpable. They share a slow dance during her performance as Faith musically declares her love for her partner, gifts her with a giant bouquet of silk flowers, and then lands a small kiss on her lips to mark the end of the performance. In the crowd, the camera pans to her tearful mother beaming with pride behind her blue medical-grade mask.

After the performance, backstage, Faith is surrounded by family and friends who are admiring her look and praising her. After lovingly embracing her partner, Shaniqua, Faith turns to her mother and asks if she understood the message in her performance. "I got your story, baby. Yes . . . She blossomed into the most beautiful individual ever. I just want you to know you are *loved* among *everybody* and we adore you!"

Faith is but one life among many in that small town, but what is evident in her experience on this episode of the show is what happens when we support and are supported to create and imagine spaces of joy in the name of causing important shifts. It's the shift that Bambara demanded in her groundbreaking essay: an internal change we must make time for that will lead to necessary changes outside of ourselves. Are Faith's family and friends trained warriors in this ongoing war against hate? Perhaps not entirely, but the love they were tasked to demonstrate has fortified their ability to take on more of that battle.

WHILE I'M ALONE | BY BRIA STERLING-WILSON

Through the lens of "yes, and" Black joy serves as a tool to reshape a circumstance or at least the engagement with it—whether it's improving the quality of a relationship between a mother and her daughter as they navigate her queerness in a small conservative town or finding the sustenance to continue a deep fight with corrupt policing. This lens offers the opportunity not to escape from difficulty but rather to create an imaginative armor to wear inside the confrontation necessary to eliminate it altogether.

Like the improv principle, this view of Black joy takes practice to get comfortable with and utilize fully. And it must also be said that we've been here before—whether doing the catwalk in big ruffled dresses at secret drag gatherings or while learning to plant literal and figurative seeds in gardens that sustained the bodies and imaginations of an activist-to-be as he and his family resisted the injustice that surrounded them. And also like in improv, there will be silliness and mistakes in the "yes, and." Not every imaginative or creative idea will be useful or right in inciting the best changes. And that is okay too. What's more important is being in the practice of it so that when it is needed, it is within reach.

4

FINDING HARMONY

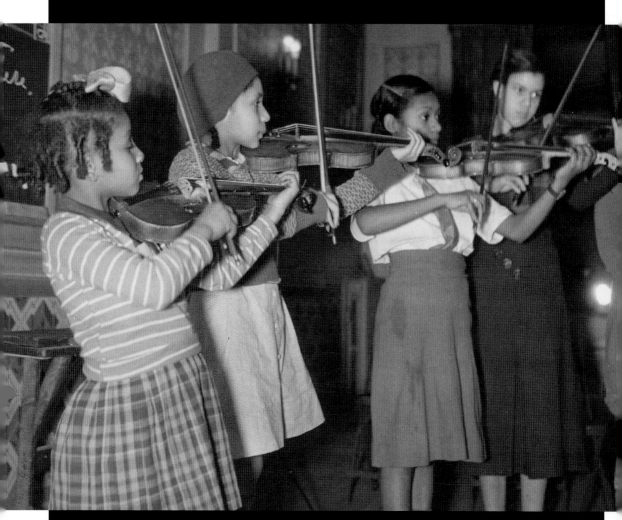

In a choir, a singer can take a breath without stopping the song. It continues, in fact. And when the singer or singers have taken that breath, they can rejoin the song and relieve anyone else that needs one too. The harmony stays unbroken this way. Black joy can be used as an entry point into understanding our everyday lives and Black lives that differ from our own, both in our struggles and wins.

Black joy is a space for harmony because there is room for all of us in it, in all the ways we exist. It can help us rise above white supremacy, the anti-Black world it nurtures every day, and divisions across geography, nationality, and identity. This applies to divisions that anti-Blackness creates within us and that can prevent us from embracing the complexity of Blackness.

In the work of bringing Black people together in a deep sense of connection, we need to cultivate more opportunities for those necessary breaths—or moments of rest—that allow for rejuvenation and also make room for everyone to be seen and have their individual moment(s), even among the collective. Trust is a huge component of this as it is crucial in building bridges and loving connections. Part of what allows beautiful harmonies to exist when choirs sing are the rehearsals, which build confidence and help establish trust among the singers. The singer who takes a breath, for example, has to know that the rest of the choir will keep going without them, and the choir has to know the singer will jump back in to relieve someone else who needs to breathe.

In this model of aspirational harmony, it can feel like not all of us are able to take a breather or that, if we do, the song will end without us. The world has provided long receipts for the baggage and labor that a

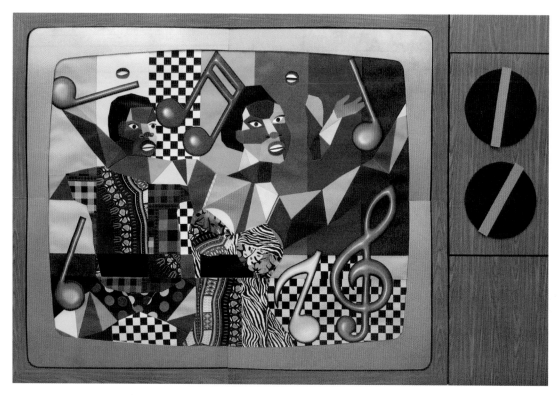

DANCE OFF | BY DERRICK ADAMS

person takes on the more intersections they exist at, be it race, gender, ability, class, etc. We are not all moving on the same level or with the same amounts of responsibility, yet we all need, deserve, to breathe. And not little breaths either. We all deserve full, deep breaths that replenish our bodies. Remember, this is also a physical experience. A strong choir is aware of each of the singers that make it up; it makes room for those varied voices in service of ensuring a stronger collective sound, collective song.

The issue isn't about whether collective living will work; the issue is how committed we are to these bigger goals of liberation. To make things more complicated, there isn't agreement among everyone of what freedom or liberation should or does look like. What if the goal is not to get a piece of the pie but to imagine and lean in to more ways to exist? At its best, music can allow both the singer and the listener to transcend. For a moment, you can exist beyond that space and time.

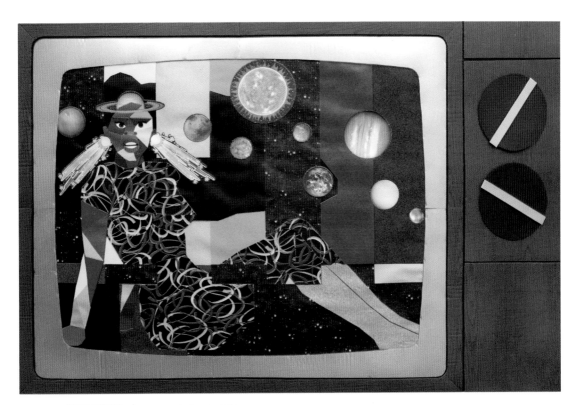

OUT THERE | BY DERRICK ADAMS

In a conversation I had about harmony and its link to pleasure and joy with poet, designer, and musician Willie Kinard III, they exclaimed, "It has to be pleasant! Otherwise, it doesn't work. Unrelated benefits in tandem produces something unexpected in nature: safety. With repetition, it produces trust. Trust and safety and continued exposure produces just that: pleasure—where one can enjoy and not have to think or work or worry."

There is profound meaning in Kinard's thoughts on harmony and how it bears on the power of joy achieved in a collective sense. Their words speak to the function of harmony as a producer of things that feel good. But in Kinard's interpretation, harmony also produces a sense of safety. And that makes sense. After all, isn't joy also a call for safety? For us to be ourselves without the worry of violence or disruption?

Community and relating to one another can be like a harmony too because we show up this way in other areas of life already—whether it be

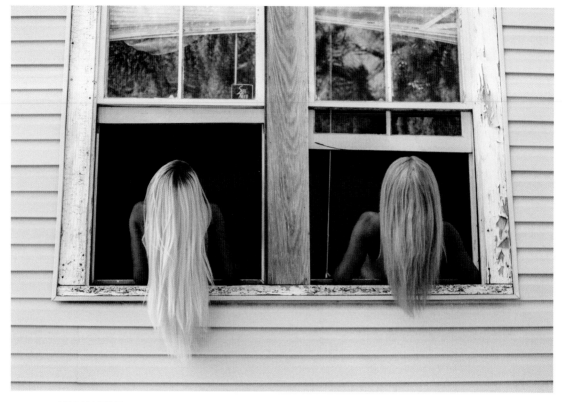

FOR NAKEYA | BY EMERALD ARGUELLES

neighbors coming together to support a newborn child when they may
not have all the essentials or the baby's guardian(s) need rest to opening
up our homes for others who need somewhere to stay (if there is room
or not) to sharing meals to setting up Susus (lending circles for financial
support), and on grander scales, forming aid efforts through small
collectives to provide support during times of crisis. This is happening
in Black communities across the world, and that serves as a point of
conversation for all of us, albeit complicated.

In mid-October 2017, seven writers and I flew to Brussels and
Amsterdam to represent the United States at the Read My World
international literature festival, which is based in the Netherlands. The
festival is an annual event that draws writers, creatives, and people
who appreciate the spoken and written word from all over the world
to be in community around a selected geographic region. That year's
theme was "The Black U.S." Our cohort was led and cocurated by social

creative entrepreneur Shantrelle P. Lewis and author Maurice Carlos Ruffin. Along with our small cohort, almost one hundred artists and creatives participated, most of whom were Black Europeans. Europe has approximately eight to nine million Black people, including more than seven hundred thousand in the Netherlands. The Dutch participated in the gruesome West African slave trade and were arguably some of its cruelest participants. They colonized the region of South America we recognize today as Suriname as well as the Caribbean islands of Aruba and Curaçao, and their descendants were key architects of the apartheid system in South Africa. With that history as the backdrop, I was excited to come together that week in Europe with fellow creatives in the name of Black arts and culture.

It was an incredible experience to meet other Black people from across Africa and its Diaspora who were living outside of those countries and navigating the world in ways that paralleled each other. There was a camaraderie in a shared understanding of what it meant to live *somewhere in between*. In between the colonized land and the land of the colonizer. In between multiple languages. In between multiple cultures.

Throughout the panel discussions and performances during the festival, a recurring pattern became apparent. There seemed to be tension between the ways that Black Dutch folks understood themselves and the ways that Blackness was understood in relation to them in the European context. There was a recurring articulation of white Dutch society's insistence on filtering these Black experiences and cultures via largely corporate America's construction of what it means to be Black in the United States via popular media like movies and TV shows.

I observed this resonance in other parts of Europe with a tendency for white people to distance themselves from their violent history and then project that distance onto one another and people of color who also call those countries home. A distinction is created that draws hard lines between the complexity of Blackness and whatever makes it easier to compartmentalize histories of violence and muddy that institutional

memory. This was particularly clear from an anecdote that producer and podcast cohost Anousha Nzume shared during one of the conference's panel discussions.

Dipsaus is the leading Dutch podcast, started in 2016 to tell the stories and express the interests of people of color in the Netherlands and hosted by three women of color: Anousha Nzume, Ebissé Rouw, and Mariam El Maslouhi. During the conference in 2017, Dipsaus hosted its first-ever English-language episode with acclaimed poet, essayist, and novelist Morgan Parker and me as guests. During that fruitful conversation, Nzume shared an anecdote that illustrated so well this pattern that became increasingly evident during the conference and generally being in the Netherlands.

While discussing Blackness and what that meant to each of us, Nzume shared that growing up in the Netherlands, the first Black family she remembered seeing on TV was the Cosbys, from the popular American sitcom The Cosby Show. As it was for many in the United States, The Cosby Show in the Netherlands was groundbreaking and affirming to the Black community. The Cosbys were upper-middle class and professionally successful. The parents were caring and loving to each other and to their children, and they were fun. The kids were good kids, a bit mischievous at times but harmlessly so. The parents were always one step ahead and parented well. There was an extended family of grandparents and close friends who were equally loving and fun. No problem ever arose in an episode that couldn't be resolved by the end. In the 1980s, The Cosby Show was a ratings juggernaut and aired around the world, including the Netherlands.

For Nzume, seeing a family like that on TV in a country that was so starkly white and that provided little representation of Black daily life was a game changer. It convinced her that there would be room to tell the stories of Black Dutch families. She was unfortunately wrong. Using her background in media, she pitched that idea for years to no avail.

What became clearer from that anecdote was the litmus test being used to determine one's Blackness. The measure was strictly based on

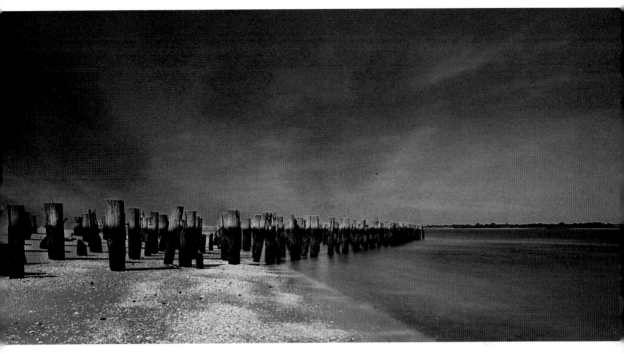

ORANGE AT DAWN | BY BRENDA A. GATES

the most visible and disseminated representations of Black people—on Black Americans, in particular. In the Dutch context, those depictions are often used against Black people to "distinguish" them in a very anti-Black manner that ultimately erases them or discounts their experiences altogether. *Those* depictions are Black and the Black people in the Netherlands are not *that*. Nationalist techniques of division are used to imply hateful distinction and an erasure of nonwhite experiences. It was a singer in the choir that was not being allowed to breathe fully.

What is also clear is that as many Black people exist in the world, there are as many ways as possible to define *being* . . . to define being Black. What the powers of white supremacy and the raggedy branches of that tree often cast a shadow over is this important complexity that cannot be held fully within the narrow frames we have been squeezed into for too long, as was evident in Nzume's story. We have existed much longer than those frames have and without romanticizing the world before colonization, it is worth noting that there was more room for our multitudes because there wasn't always an incessant need to paint with such broad strokes to justify a particular form of racial oppression.

As in most harmonies, singers work together across different segments to sing a song. There are altos, sopranos, tenors, basses, and the mixes of those vocal ranges that all comprise the elements necessary to make music, collectively. Sure, a song can be sung by only one of those sections, but in that divided performance, there is a richness and texture lost. It also creates more of a burden and a pressure for that single section, not just to sing but to sing well. The harmony loses a certain depth without all the parts of a choir. And we know the difference between a good song and a great one.

Black people are not a monolith. We have many facets that together build all kinds of structures depending on when, how, and where we exist. That complexity cannot be tamed or boxed in and is hard for the world to

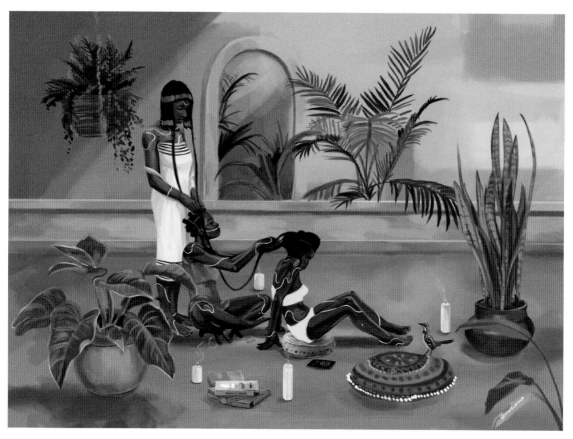

HAIR DAY | BY MARK MODIMOLA

hold. It is difficult for many to wrap their brain around the idea that what you understand and experience to be true about one Black person is not—cannot—be true about all Black people. This is where the danger lies in the attempt to filter any one Black experience through another.

Yes, we have similarities and ways that our cultures inform one another, but our distinctions are also what make us beautiful and something to appreciate. That's where the beauty of harmony in a choir's song enters the room. There is a "yes, and" with which we can approach the ways we are interconnected.

It doesn't take much searching on the internet to find examples of "diaspora wars" where Black folks are engaging in often unproductive arguments about differences—not for appreciation but often to prove some type of false superiority or inferiority. It's not hard to find lines being drawn to distinguish Black people from one another to further divide across sexualities, genders, economic classes, geographic regions, etc. However, our coexistences on this floating rock as different forms with a bond through our ancestry is essential to highlight and not brush over. It's distinctions like the sounds when isiXhosa is spoken in South Africa and how that hits differently from the cadences of creolized languages in the Caribbean and the thousands of tongues and dialects that exist across other African countries. Seeing the harmonies offer us entry points through joy to acknowledge our existences more as notes within various but connected songs and not flat, unrelated sounds.

It would be a lie to say that all the examples mentioned are always full of joy and everyone gets along accordingly. In the *practice* of building a great harmony, there are mistakes made, notes missed, frustrations, anger, and everything that comes with building something that has value.

The East African nation of Rwanda is no stranger to the complicated process of building something that is worth sustaining. In the spring of 1994, a plane carrying then President Juvénal Habyarimana of Rwanda was shot down; it crashed, killing the nation's leader. That incident ignited one hundred days of terror and genocide that resulted in the massacre of

almost one million Tutsi people, one of the two major ethnic groups in the region. The Tutsi were killed largely at the hands of Hutus, the other major ethnic group. The two groups had become rivals over time as a result of long-standing colonial rule by Belgium and Germany and the colonizers' exploitation of Rwandan ethnic divisions.

In the wake of the genocide, Rwanda's government took several deliberate steps to begin putting the country back together. One of those methods was the tradition of Gacaca, a practice that outlawed colonial rule and required both the perpetrator of harm and those harmed to come together. In that process, the harm doer told the truth about what they did, while the harmed shared the impact of the actions. The intention is for those harmed to come to a place of forgiveness and to create a new opportunity for coexistence.

It was an ambitious task to have the Tutsis and the Hutus try to reconcile using Gacaca, as this was not a simple feud. The level of violence perpetrated by the Hutus made it clear that they were trying to exterminate the Tutsis all together. Indeed, Rwanda's efforts to facilitate reconciliation and peace shows us how complicated creating harmony can be, especially in the face of atrocity and devastating violence. But the reality is that today both the harm doers and those harmed are still both in the same country, side by side.

Almost thirty years later, the process of reconciliation is not complete and has not gone without heavy criticisms from all kinds of people in places across the world. However, I highlight this example because of the strides it has made. There are many stories in Rwanda of people who killed a neighbor or someone they didn't know at all confessing to that act and having the survivors of that violence reach a place of forgiveness so that they can all try to move forward. An entire generation has come up in the wake of the genocide, and like many young people before them, they have been influential in (re)building an imperfect nation. However, there is much to be learned about a possible harmony in the aftermath of such terrible violence.

Harmony is not about any one individual. It's about the collective joining together to make a pleasing vibration. The "collective" piece is critical. It allows room for a person to rest while others go on and for the resting person to return with more energy and focus—having taken a necessary moment for themselves. The space to do this is sometimes hard to find among the pressures of daily life, professional responsibilities, family obligations—the list goes on. But it's easier to make space to rest, as part of a collective, than it is as a soloist. Black joy operates this way as well.

Harmony in music and dance, and the way it's shared in today's social media landscape, is strong evidence of how congruent Black joy is culturally—be it afrobeat, taarab, reggaeton, amapiano, soca, house. All reflect both visceral and intentional ways of moving the body as well as expressing life, dreams, and difficulties faced as Black peoples.

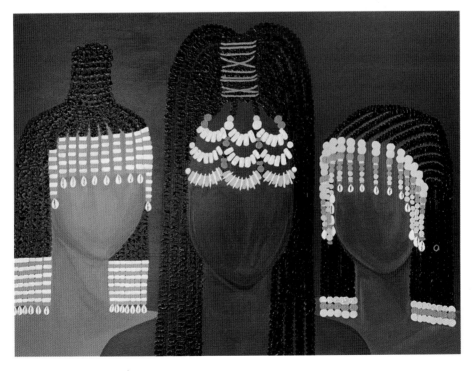

BRAIDS AND BEADS | BY SIERRA CLARK

In my conversation with the *Dipsaus* podcast team back in 2017, I shared how growing up in an immigrant family of multiple generations in the United States felt kindred to the three cohosts' experiences in the Netherlands. There was similarity in the ways that Black people there too often lacked enough creative autonomy to present the fullness and complexity of their lives, yet they were constantly bombarded with racism, homophobia, and sexism in popular media or through exchanges in their daily lives.

We also laughed a lot together about funny remarks and thoughts on pop culture, and we shared warm, familial hugs. Much like the inevitable laughter from a funny story, we found joy in our exchange because we conjured it together. The five of us on that stage represented three continents and four distinct regions of the world *and* were able to come together around being Black. I allowed that deeply good feeling we

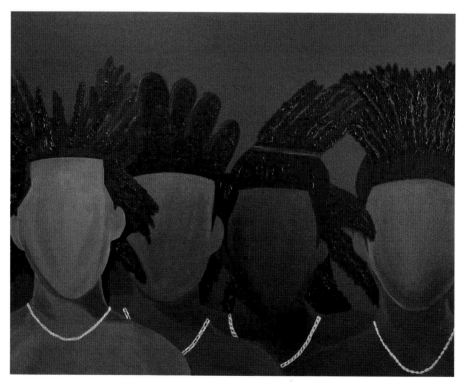

FLORIDA WATER | BY SIERRA CLARK

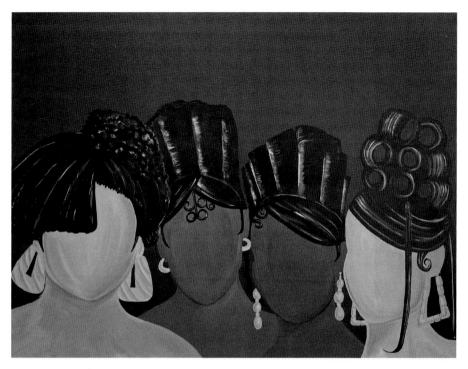

LADIES FIRST | BY SIERRA CLARK

conjured to be an avenue of insight into one another's lives. I used it to push back against unfair comparisons, to better embrace the beauty in our differences. In practice, it was a demonstration of this nonmonolithic existence we all knew to be real.

I came away from the whole experience more curious, inspired, and ready to reckon with some questions more in-depth: What would it look like if I didn't jump to assume or think I understood someone just because of the way they look and everything I've been taught about that? As a Black person what does it look like to listen first when another Black person is expressing an experience I am not familiar with? How could that expand and complicate my own understanding of what it means to be Black in the world?

On one of the last nights of that trip to Amsterdam, a group of us from the U.S. cohort found ourselves on a bench outside of the hotel where we were staying. In the short time we sat there, we kept noticing handfuls of Black people walking down the street wearing stylish, all-white outfits. After a few more people passed, someone in our group stopped one of the people clad in all white and asked where they were going. A white party—as in the dress code was to wear white, of course. We weren't dressed for the theme, but we followed the crowd anyway. After a few minutes' walk, we found ourselves in the lobby of a club that was bumping loud music. We made our way into the spot, and it was clearly the right place to be.

It felt like an appropriate ending to that trip to wind up at this party that happened to be within walking distance of our hotel. It was fitting to find ourselves in a room with all kinds of Black people dancing to music across genres that our cultures have influenced. The sounds of Dutch (among other languages) stringing along Afrobeat, hip-hop, R&B, and other rhythms that were impossible to stand still to as they burst through the speakers. We knew the songs, though we may not have heard them all before. We understood our place in that choir of Blackness, even though we may not have joined it before. We had the opportunity to enjoy the spotlight or centering of a Blackness that was not ours but was kindred and offered insight into a space we were unfamiliar with.

It's incredible to think back on how much joy there was on that dance floor. How we picked up moves from the people around us and busted out the ones we'd come to the Netherlands knowing. These social spaces are not intended to catalyze revolutions or major social shifts, but they are garden beds overflowing with the potential for those occurrences. Was that a perfect space? Was it free of misogyny and homophobia and all the -isms that often plague our world? No. But we all took a collective breath and, together, felt the world was full of possibility.

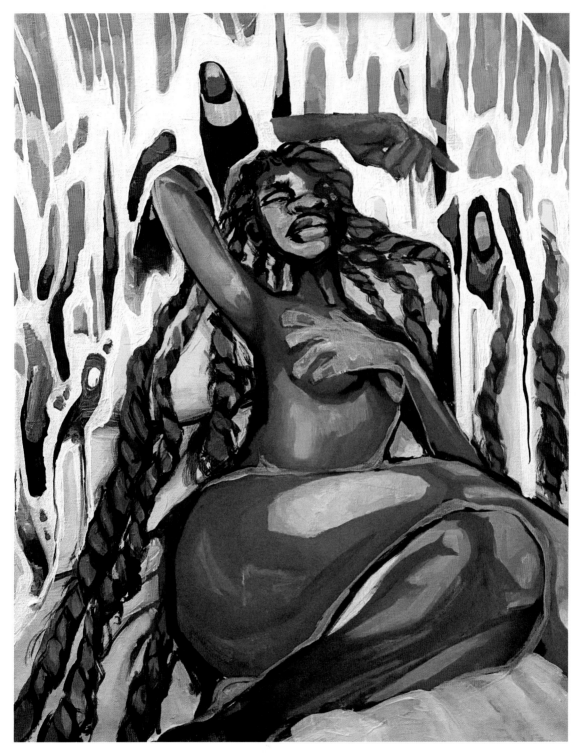

LOVESLIDE | BY NYALA BLUE

Black people outside of the United States learn about American Blackness in a way that is not as true in the reverse. Part of this is because the U.S. empire has outsize global influence, and so Black American culture gets exported and consumed around the world. As a result, there is an inaccurate dichotomy between Blackness as it is understood in popular U.S. media and the realities of Black people everywhere.

Let's go back to what harmony is: a merging of simultaneous sounds to create a key element of music. Those sounds occurring at once are often not the same, which is what makes it impressive to hear in sync. The sounds come from voices, instruments, etc.—the point being that there is typically some*one* or some*thing* behind them generating those notes. We don't have to study music to appreciate a song or how it comes together—but we do have to approach music with the intention to experience it in the fullest possible way. The same is true of Black joy and with Blackness in general.

Discord, however, is what we are often fed in our daily lives. This informs how we see our lives' meaning, our own self-worth. *Discord* is the story we often take on when we wrongfully compare ourselves to one another or to cultures that seem different from our own.

Black people around the world have gathered in community across differences and similarities in lived experiences for centuries. At times, that has manifested as conferences and consortiums. Other times, it has been concerts and art-related events, convenings of community organizers and political protestors who congregate on front lines, etc. There have been so many ways that we have come together, not to distance ourselves because of our differences but to see where we share solidarity *because* of our distinctions, and even sometimes *despite* them. That is something worth holding on to.

One voice singing alone can be heard, but a chorus of voices can be heard much louder and for longer. In that moment of voices coming together, there is a transformation. The song takes on a new form as well as possibly new meanings. The melody might change. It might hit a

different resonance depending on how the singers are listening to one another, or to the audience, for that matter.

Joy offers an opportunity for transformation. In conversations around making change, we most often hear calls for reform to make things better, but not necessarily change them. Transformation, then, is a much harder task. It requires going back to the drawing board to create something new altogether. This type of shift I have found to be more real in the moments that we can connect with one another genuinely and understand how our lives are interdependent.

Our qualities of life should mean more than what we can do to improve the qualities of life of others, namely, white people and white-affirming spaces. We don't even need to speak the same language to make this happen or even live near one another. Social media has been a great example of this type of attempt at harmony.

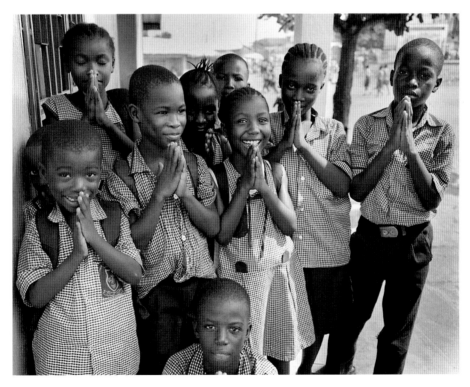

SCHOOL KIDS PRAYING, FREETOWN, SIERRA LEONE | BY ARTEH ODJIDJA

TikTok trends have often circled around the world both through short dance routines and funny refrains, but there are also pockets where creators embrace our differences to come together, rather than apart. One great example of this is shadow work specialist, holistic healer, and public speaker Tevin M. of TikTok's "Gullah Grits TV."

Hailing from a small Gullah Geechee community in South Georgia, Tevin was already rooted in a culture steeped in the experiences and practices of a diverse set of Black/African histories. What I have witnessed Tevin do via their social media platform is engage with the Black world in such warm and joyful ways. That has ranged from learning and practicing the isiXhosa language, the traditional East African dance Eskista, cooking Dominican food, singing Haitian songs, and practicing several other diasporic traditions through a Black queer and spiritual lens. Through engagements with other viewers, speakers of these languages, and practitioners of these cultures, Tevin has built a community that fosters curiosity and embraces a type of Blackness beyond what may

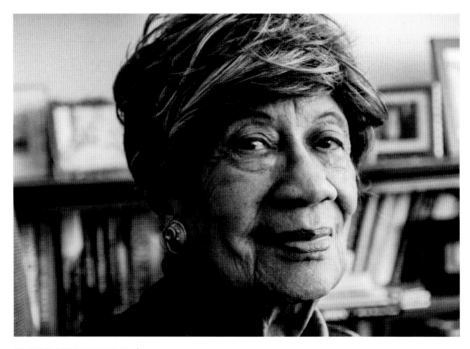

GLORIA RICHARDSON | BY JAMAICA GILMER

be familiar to them. This is largely happening through *doing* as opposed to simply *talking* about it. There is an active commitment to hold all this complexity in a way that brings Tevin more joy and is tangible in their popular videos.

In those conversations had in the Netherlands, it was also clear that though many of us may not have explicitly had certain conversations with one another on stage or in the audience, it was not the first time we'd engaged in them. What we are doing through these interactions is cultivating another way of being. Tevin does this too through their work; there is a clear understanding of the kindredness in the many Black cultural and spiritual practices they choose to engage with and make their own. Tevin's development of community around this speaks to my time in the Netherlands by illustrating the kinetic power of making connections in real time that acknowledge bonds already there. We both get to see and be with more singers in the (aspirational) harmony.

Like the beauty of a stained-glass window, joy cannot be found in homogeneity or uniformity. The goal in using Black joy as an entry into understanding both our similarities and differences is to build stronger solidarity to address the forces that aim to take all of us out in one way or another. History is evidence that when these types of connections are made in effective ways, the ground begins to shake with possibility. A quaking that causes fear and more violent attempts to snuff it out.

5

COMMUNITY BUILDING

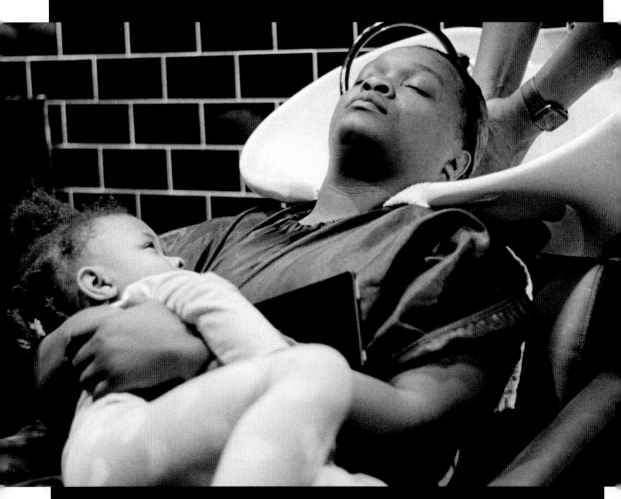

If words and phrases had shapes, "Black joy" would be a circle. It is a continuous connection.

There's something about a group of Black people experiencing joy together that hits a little different. For one, the joy seems to become exponentially more palpable. Each person brings their own spice to the situation. Second, it is an undeniably powerful force to see and to feel our ability to connect, coming from a place unanchored to harm or trauma. Joy, in its purest form, presents an opportunity for the deepest connections, which in turn can set the foundation for later addressing the harder parts of our connected, collective existences. Oftentimes, that begins with establishing a physical space for joy.

There was dancing, conversation, and enough food for almost a hundred people at an event one night. The impetus was loneliness. It started in 2016 when writer, legal advocate, and cohost of *The Cheeky Natives* podcast Letlhogonolo Mokgoroane invited a few people to celebrate the Christmas holidays at their Johannesburg apartment. Mokgoroane opened their home because they understood that for many Black queer people in South Africa during the holidays, they must choose to either stay away from family or minimize themselves to be around them. Mokgoroane wanted to offer a loving space to their guests and to encourage being their full selves in community. It was a queer Christmas celebration. It was *Queermas*. For Mokgoroane, Queermas invokes Audre Lorde, Alice Walker, and the proverbial kitchen table. It is a practice of Lorde's famous statement, "Without community there is no liberation."

That is the heart of Queermas—to commune around food and to openly be in one's queerness unapologetically.

For so many queer people around the world during holiday times, it can be isolating and lonely because of being shunned from family or for fear of harm for living in their truth openly. The invitation was for guests to show up in their fullness with the understanding that it may not be possible at home. Many attendees responded with positivity, and some shared it was the best holiday they ever had.

In the first year of the celebration, guests were only asked to come as they were. What was intentional about this space was safety, and during the event it was made sure that preferred pronouns were asked of each guest. Each person was also asked if they consented to pictures taken of them, as some people kept a lower profile for safety.

After the first couple gatherings, Queermas began to grow and Mokgoroane and other coordinators provided the main dishes and asked people to bring salads, dessert, and other accompanying dishes. The first time the event was hosted in an outside space was in 2018, with about fifty guests.

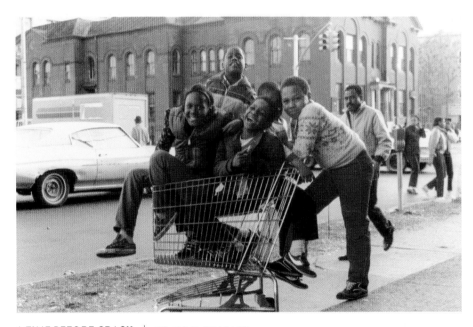

A TIME BEFORE CRACK | BY JAMEL SHABAZZ

What started as a small gathering to relieve loneliness bloomed into an annual event that, by 2019, hosted about a hundred people. That same year, a doctor who runs a queer wellness center in the city volunteered to provide all the main food, including a braai (South African style of barbecue). People played games and enjoyed one another's company through dance and conversation.

Mokgoroane describes Queermas today as being "about chosen family. We unfortunately cannot choose the families we come from, but we are fortunate in creating families for ourselves that will accept us for who we are." For Mokgoroane, this has expanded their vision and imagination about what else is possible to provide shelter and resources for TLGBQIA+ folks. During the pandemic, like most things, the event moved online. This created an opportunity to have guests from outside of South Africa participate, and people were really touched by the space.

Queermas is also important for the ways its reach has been extended beyond one night. After one of the annual gatherings, someone who attended reached out to the event's organizers to ask for support with housing. The organizers and a few others came together to support this person in need and, after about six months, got them a job and a stable place to stay. There was a trust built from that space of joy that allowed for leaning into the community for support in areas of their life where joy was not present. There was a vulnerability and sharing of labor that allowed them to help a member of their community who was in need in ways that set that person up for success and not a temporary fix.

To form those types of spaces and forge the bonds that community requires means also offering oneself fully and openly to ensure that everyone else connected can and will do the same. That's what is required of a Black joy community, or rather a community that honors and cultivates Black joy. When we look back, history shows us beautiful and complicated examples of this community in practice. One of the biggest gatherings of Black and African peoples in contemporary history happened in an era where the odds of making it happen worked against it. But joy prevailed.

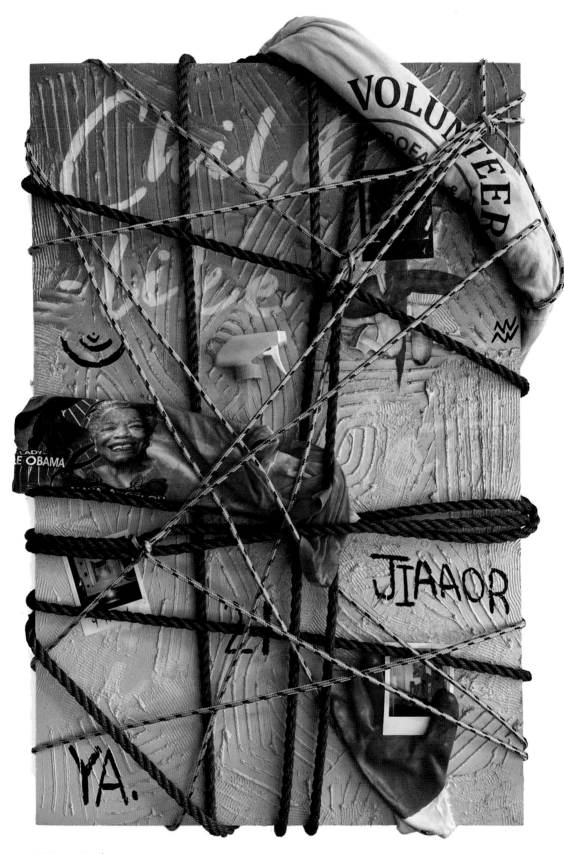

CHILDLIKE | BY WALTER CRUZ

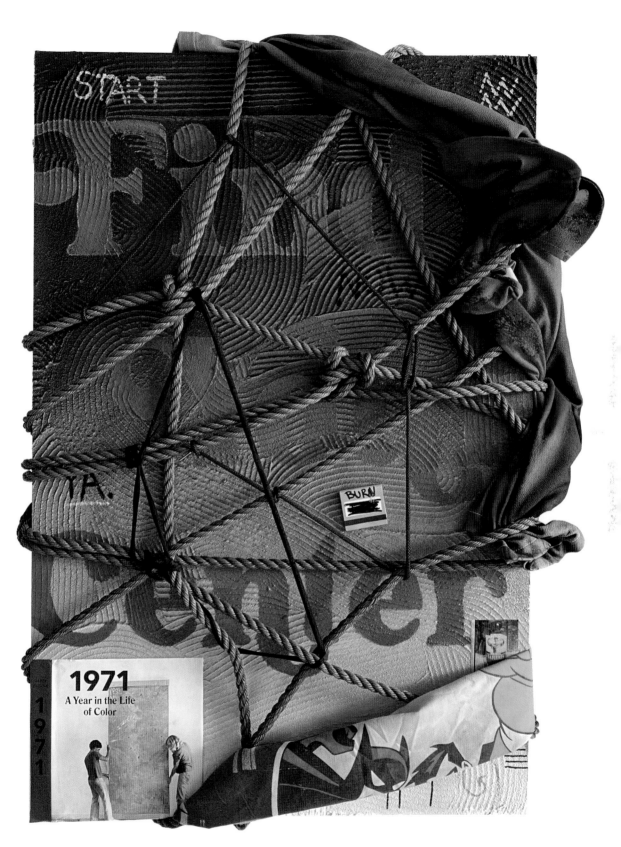

FIND YOUR CENTER | BY WALTER CRUZ

By the late 1970s, many newly independent nations around the world had emerged from the chaos of European colonization. There was a global atmosphere of both excitement for possibility and the disappointing reality that there was still a long road toward a world where all people were truly free, safe, and protected. The United States celebrated its bicentennial in 1976 and was still living in the wake of those two centuries that established the foundation of a shaky house of independence. Across the Atlantic, Nigerian people were still working through life after a brutal civil war. The nation was also preparing itself to host one of the largest international gatherings of Black people in Africa in the twentieth century: The Second World Black and African Festival of Arts and Culture, most remembered as FESTAC '77.

The festival was originally scheduled for 1971 as a follow-up to the First World Festival of Black Arts in 1961, hosted in Senegal by President Léopold Senghor. After major cuts from the host's budget, heavy criticism from many Nigerians about the amount of money being spent on a project largely focused on foreigners (millions were spent), and a change in power after a coup that was preceded by civil war, the massive international gathering of Black and African people came to life.

"For 29 days, Black people from everywhere—from Africa, Europe, African-America, South America, Canada and the islands of the seas—testified to the . . . presence of Blackness in the world." These words, from the May 1977 issue of *Ebony* magazine, are what famed journalist Alex Poinsett used to describe the participants of FESTAC '77. From January 15 through February 12, 1977, more than fifteen thousand Africans and people of African descent from over fifty-five nations gathered in Lagos, Nigeria, to celebrate, share, and be in community around varied cultures and art forms. They convened to (re)claim space, significance, and influence. Thousands came together to create and reimagine a Blackness that was defined by people of African descent on their own terms, more expansively than ever before. The almost month-long international festival ended with an impromptu thirteen-piece band performance by Stevie Wonder, who had traveled to Nigeria,

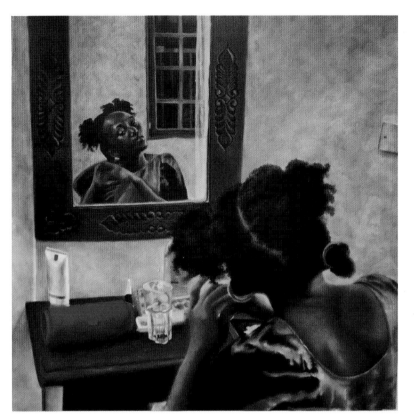

EVENING ROUTINES | BY APRIL KAMUNDE

independent of FESTAC, with interests in connecting with Africans who shared his (dis)ability.

Renowned artist dancer and theatre instructor Bob "BJ" Johnson (1938–1986) attended FESTAC as a member of the legendary jazz musician Sun Ra's "Arkestra." Johnson was a young faculty member of the then-emerging Department of Africana Studies at the University of Pittsburgh, where he taught dance and theatre arts workshops. Johnson also danced with some of the best companies of his time, including an international tour with Katherine Dunham's company and under Alvin Ailey. It was through Sun Ra's invitation to be a part of the U.S. cohort—which comprised more than four hundred artists including Audre Lorde, Alice Walker, and Paule Marshall—that Johnson was able to join a delegation of Black artists and culture makers hailing from all over the United States and ranging in age from children to seasoned creatives in their seventies.

Throughout his experience in Nigeria, Johnson kept a sporadic journal and took many pictures to document his experience. What is clear from his personal writings is how profound an impact FESTAC had on him—being immersed in a place where he saw what he recognized as the "archetypes" of the faces and mannerisms he'd come to love and recognize as familiar back "home" in the United States among the Black communities he'd grown up in. From Johnson's archive, it's clear the experience left a deep mark on the artist and his ability to better understand what it meant to be in the African Diaspora and how that all came to be. His experience of FESTAC affirmed him in his dedicated artistry to promote Black consciousness and liberation. Johnson attended much of the festival's programming and spent time in the "FESTAC Village" with artists from other delegations to learn new dances, music, and perspectives, as well as attend local events outside of the official festival venues.

The truth is you also don't have to understand and make sense of everything to give love and respect. What's most important is allowing yourself to be fully self-expressed while giving that space to everyone else. Your understanding of others is your work, not the person being who they are. Often, we may be generous with sharing and explaining who we are, but that's always a choice—never an obligation.

That's what made that unprecedented gathering and the many like it that occurred in the late '60s and throughout the '70s special. On the level of the artists and contingency members, there was a generosity present because of love, excitement, and a yearning to build bonds despite the heavy hands of colonialism and white supremacy. There was an understanding among this massive gathering of artists from around the world that this wasn't supposed to happen, not under the forces that very much still had their hands in myriad cookie jars that made life incredibly hard to live before, and to various extents even after, "independence." Among many injustices, the apartheid system in South Africa was still thriving as well as an active resistance to it. FESTAC was occurring in the foreground of much political and social turmoil

FOR OUR LOVE | BY YANNICK LOWERY

across the continent and other parts of the world and yet, by any means necessary, almost twenty thousand people of African descent from across the continent and the Diaspora came together for intellectual and artistic exchange in the name of defining oneself for oneself.

Can we recreate this powerful and complex event or the era of festivals it existed within? Maybe, but what might be the more important question is what would it need to look like today? Out of the many archives and public records (in English) for this event, there are barely any recorded perspectives and insights from queer people (with the exception of brief mention in an Audre Lorde biography written by Alexis

TAIWO AND KEHINDE | BY STEPHEN TOWNS

De Veaux). Considering one of the important frameworks to come out of the movements for Black life in the mid-2010s, it would be imperative to organize a gathering that publicly and pridefully uplifts TLGBQIA+ people. What we can also do is look back at what worked well to move and imagine forward.

We get to imagine the world we want to live in and the lives we want to live in it. This level of imagination requires no limits, and that is where the difficulty often lies. We may feel limited in what feels possible because of the experiences and circumstances we have had to navigate based on our identities at the intersection of Black. However, we must remember that so much is possible because it has been. FESTAC almost didn't happen because of so many serious obstacles; yet, with commitment and persistence, albeit different from its original vision, the festival came to be. And it is real, hard work to manifest a vision. Even the oppression we experience was envisioned and worked toward to make real, consistently over a long period of time.

Those fifteen thousand–plus participants and the more than fifty thousand mostly Nigerian packed-beyond-capacity audiences throughout this epic gathering had a curiosity to see what these events could mean and what the Black world really had to show for itself. Do we need a FESTAC 2027? It's something worth considering. In the meantime, today there are gatherings that become whole communities and that push for a world that ain't so steeped in hate.

On the morning of Monday, October 26, 2015, a teenage Black girl named Shakara was sitting in her math class at Spring Valley High School in Columbia, South Carolina. According to her teacher, Shakara was asked to put her phone away and refused. After this exchange, the teacher called in a school administrator who then called in "School Resource Officer" Ben Fields to have Shakara removed from the classroom. Reportedly, she was being defiant because she was on her phone and was not doing what

the teacher asked of her. Instead of defusing the situation, the teacher escalated the problem by effectively calling law enforcement on a Black girl. That cop, who had a reputation for being rude and disrespectful to students, grabbed the entire desk and chair combo of a seat that Shakara was sitting in, lifted her, slammed her to the ground, and then dragged her. This occurred all while a classroom full of students watched, mostly in horror, and the teacher stood by and did nothing. After being assaulted, Shakara was arrested and taken away. A classmate of hers witnessing the violence was daring enough to record the incident and speak out.

"I had to do something" is what Niyah said to a reporter that night on a local TV news broadcast. That's all Vivian Anderson needed to hear from her downtown Brooklyn apartment. Hearing Niyah's words broke Anderson's heart. Right then and there, she decided she needed to take a bus down to Columbia to find these girls and offer them some love. "I just wanted to give them a hug," Anderson has said about that impulse. So, she called some close friends and shared her plan to head down to Columbia and offer some support to these young girls. Anderson has always said she just wanted to give them a hug and let them know they weren't alone, but everyone around her knew it was always about something bigger.

Those few days in Columbia turned into weeks that turned into spending more time regularly in South Carolina than in her Brooklyn apartment for the #EveryBlackGirl campaign she started to raise awareness about Shakara's case (and girls like her). That campaign led to her hosting the first EveryBlackGirl conference for Black girls in the Columbia area. There is intentionally no spacing between the words in EveryBlackGirl to signal the mission to be a stand and support for *every* Black girl. No one is left out. The conference was intended to create a space for Black girls to play, be around people their age, and to celebrate them and the women who have supported them. It also served as spaces for middle- and high school-age Black girls to have healthy discussions with one another and adult Black women. This gathering was for Black girls and the people who stood for them.

Intergenerational gatherings are important to building community in Black joy. It's an opportunity to share knowledge and understanding, both from elder to youth and youth to elder. Of course, across our cultures and the places we live this has been a long-held value. We see it in homes where children live with their parents and grandparents (with extended family too, like aunts, uncles, and other relatives). It's in religious spaces like masjids, churches, and temples and in schools where teachers are part of the students' communities.

Historically, in countries like the United States and South Africa where extreme forms of racial segregation exists, intergenerational

MARY HAD A BABY | BY STEPHEN TOWNS

community has also been mixed across class lines. The restriction of land ownership or even of home rental made it so that working and middle/upper-middle-class Black people often lived side by side one another, if not in close proximity. It would be inaccurate to say that it was or is a completely harmonious experience; however, if we consider that part of what builds and sustains community is proximity to one another, then it becomes clearer why closeness often is a strength to sustain it. This is not to say that if we aren't physically close to one another, it is impossible to have community. Rather, with distance between us, it becomes more important to be intentional about maintaining said bonds. And if we acknowledge how far and wide Black populations are in the world, then it is more evident how joy is part of community building.

SUNDAY AFTERNOON | BY BECCA BROWN

Developing a community that is linked by or based in joy is not always smooth and can require giving something up or sharing it. That is the work of dismantling oppressive forces. It requires sacrifice in some form or fashion. That can look like sharing resources, such as knowledge around attaining financial stability or cofunding efforts that support those with fewer resources. It also means valuing people that aren't as well-off financially. Often, people experiencing poverty are treated as less than or not as valuable. And this happens *within* our communities. Part of the unlearning toward the life *after* the revolution(s) is to value one another simply for being and not for what we can produce or offer.

In a similar vein, and ironically, ageism can sometimes prevent connections between generations. Young people have much to offer but are not always heard. Elders have lots of experience to share but are not always appreciated. Both groups feel shut out and unable to engage with the other, even though they need each other.

In what can be perceived as superficial but clearly makes a real impact are spaces like social media. TikTok in particular has proven to be a platform where some of these communities can foster Black joy across age and class lines. One solution toward promoting communities of joy is to continue spreading it on private and public digital platforms. The more people see Black joy online, the more they may be encouraged to connect to Black joy in real life.

This brings me back to Vivian Anderson's organization, EveryBlackGirl. Anderson was so serious about the work helping girls like Shakara that she set up a conference for it in March 2016. The Black Joy Project was invited to set up a photo booth to encourage joy outwardly and to capture this moment with so many beautiful spirits in one spot. The conference was a success, despite challenges, and it offered a day of all kinds of workshops, honoring community leaders, and support from Black people of different walks of life, coming together in the name of uplifting Black girls.

That conference was the beginning of making EveryBlackGirl, Inc (EBG) the force that it is today. There have been almost a dozen conferences since the first one that have impacted the lives of hundreds

of Black girls and Black youth, as well as the adults who support them. EBG has brought much-needed support, resources, and spaces of joy and healing for these young people through intentional programming and outreach over the years. EBG has also done collaborative work

#TEAMUS | COURTESY OF SYREETA GATES

like cohosting back-to-school events to provide young people in public housing with book bags and other necessities for the start of school.

The Black Joy Project has had the honor and pleasure to be a part of this EBG journey. Most often it has been through photobooths that offered participants a moment to play and relish in their joy and for some to consider it intentionally for the first time and allow themselves to experience it fully for the few seconds they stood in front of a step and repeat. I asked many of the EBG conference participants, "What does Black joy mean to you?" to keep that conversation alive and to also show you don't have to have a lot to make joy that lasts. What's always most important is being in community with people committed to conjuring that joy in the first place.

In 2016, as part of AfroPunk Brooklyn's "Activist Row," the then New York City chapter of the Black Lives Matter global network shared a tent with The Black Joy Project as part of an effort to engage with the public about local and national issues. That weekend, The Black Joy Project partnered with talented photographer Dominique Sindayiganza, who has a deep passion for portrait work and noncommercial photography. Dominique and I had no idea what we were getting ourselves into other than knowing it felt like the right thing to do and an amazing opportunity to learn more about Black joy and interact with beautiful strangers. The

intention was to get more insight into how others understood Black joy and to create a visual record of it in a way that went beyond pictures taken quickly on an iPhone or a standard DSLR camera as had been the case throughout The Black Joy Project's life up to that point. We decided we'd set up the space and just see what would come of it while also sharing in the responsibility with the Black Lives Matter chapter to offer attendants of the festival some key political education.

A few days before the festival, I found myself hunting around New York City for an oversize frame to use for the photo booth setup I envisioned. I eventually hit the jackpot at a thrift store where I found a huge, ornate wooden frame spray-painted in gold with dark red corners for twenty-five dollars. I had no shame in riding the busy subway all the way to the Bronx with the oversize frame in tow.

That week I was also able to get a few yards of wax print fabric from a shop in the garment district that I thought could be a great fit. Did I already say I didn't know what I was doing? Not knowing can't be in the way of getting something done. That is called learning in the name of growth. We had plans to grow that weekend! No matter what came our way.

SELECTIONS FROM THE BLACK JOY PROJECT AT AFROPUNK PHOTO BOOTH 2016 + 2017 |
BY DOMINIQUE SINDAYIGANZA

The festival coordinator working with us had communicated in advance that the tent we'd be sharing with our comrades was ten feet by ten feet, but I wasn't exactly sure what that meant. It sounded like a decent size in my head.

Early on the morning of the first day of the weekend-long event, I met with Dominique and some of the other comrades to set the tent up for the day. What a shock to find that not only was the tent relatively small, we'd have to use about half it to do the photo booth. No time to panic, though. We didn't know what to expect of the day. All we knew was that we were committed to making it the best day we could and getting as many people as we could to engage with Black joy. Also, considering this was only eight months into the first full year of the project, I hadn't thought to formalize it in the sense of creating a logo or other types of branding. My twin brother, Walter, a professional graphic designer, was able to throw together a simple banner that got printed the day before to draw attention to our section of the tent.

By early afternoon that day, the line was as long as the eye could see. People were interested in getting their pictures taken and excitedly curious about what this project charged with Black joy was about. We made it a point to talk to every single person among the hundreds in the line that day. We met people from all over the United States, the United Kingdom, Canada, Brazil, South Africa, Nigeria, and everywhere else that people had come from to be a part of the music festival in this overly populated park in Brooklyn. It was an exhilarating experience to see a real-time affirmation of that saying that if you play the drums, the dancers will come. The line didn't stop until the closing of the day's performances on both nights.

And it wasn't all laughs and smiles. Some people struggled with how to express joy, especially for a photograph. Yes, they could define it in their own words and talk about it with me or friends and family they came to the booth with, but in terms of expressing it for a photo, it did not always come as easily. For some people, self-consciousness seeped in—insecurity about what they looked like and who would see them. For

others, their typical expression for a photo wasn't necessarily joyous. We noticed that more often with men and masculine-presenting people. In some of those moments of awkwardness or discomfort, my comrades and I would make them laugh, shout out compliments, and gas them up to bring that joy to the surface. Portraits were shot individually, in groups, couples, and families. In a few cases, people who didn't know one another too well came together for a photograph. Every person was also asked to write down their definition of Black joy. I was curious to extend this simple question I'd been asking people for months to this group of excited festival goers. So many people offered their definition that the team ran out of the printed slips prepared for the weekend and started ripping scraps of paper up to hand out.

What I also witnessed throughout that weekend was people connecting with one another in line. Some started by complimenting each other's outfits, and others smiled at each other. There were people who joined in singing along to whatever song was being performed at one stage near the tent. And the hugs. So many loving hugs and embraces full of gratitude for having that space. For amplifying the importance of Black joy.

SWIMMING #1 | BY ALABI MAYOWA

By the end of the weekend, we had hundreds and hundreds of portraits and as many definitions of joy. I was astounded. I had not imagined the photo booth would draw that many people to it. What I particularly loved was how the booth also shared in the opportunities created by my comrades and me to build with people seeking to get their portraits taken and offer them some key political education. This was done in tandem with a "Carnival of Consciousness" where various small games and interactive activities were created as a more creative way to engage the public with heavy topics such as state-sanctioned violence and white supremacy.

One highlight of that experience was having the legendary Nikki Giovanni pose for a portrait. She was filming part of a documentary about her life that summer and was hosting parts of the festival too. Giovanni made it her mission to get to the tent where the New York City chapter of Black Lives Matter was set up because she said she felt it was one of the most important things she could do that weekend: encourage us to keep going. That was another moment of affirmation that the project was moving in the right direction. Never in a million years did I imagine an icon like her would find her way into this corner of work in which I'd found myself. I was so thankful.

KEEP YOUR HEAD TO THE SKY | BY ASHANTÉ KINDLE

To forge bonds that are necessary to have authentic community is not an easy task if you are committed to its longevity. It requires a level of vulnerability and accountability that is often a challenge to sustain in a way that is equitable for all involved. What joy offers in the process of fostering community is an opportunity to further those needed bonds or establish them anew. It's a type of glue in the ongoing DIY project of healing and resistance necessary in the dismantling of harmful forces to be replaced by ones that offer less harm or something else altogether.

Black joy that creates community can differ from the one that sustains it. Perhaps the former can show up as more lighthearted or surface as a means of entry (like a music festival) whereas in the latter, it can look more elaborate and deeper in its forms of expression (conferences and campaigns). Nonetheless, it all serves as means to set up the environments we have always needed for our survival and thriving. We have always needed one another and forces greater than ourselves to get through the obstacles and major challenges thrown our way, both as individuals and collectively.

What community can and needs to look like all depends on who is intended to forge that space. And there is room for all the variations of joy. The challenge is figuring out where those types of joys belong and the best ways to cultivate them in a healthy and safe manner.

In community that is fostered and sustained by Black joy, there is space to lean both into the shadows and into the sources that offer us reprieve to continue that shadow work.

Bob "BJ" Johnson along with thousands of other artists, creatives, scholars, and community leaders were forever impacted by both the reality of a rare moment in time that made space for a joy that could be heard all day and all night for almost thirty days. Countless participants' testimonies in various publications that covered the festival describe the meeting of instruments, bodies, hearts, and minds on sidewalks, on roads, on stages, and in festival housing that came together in ways that had never happened before in the name of sharing, collaborating, and coming

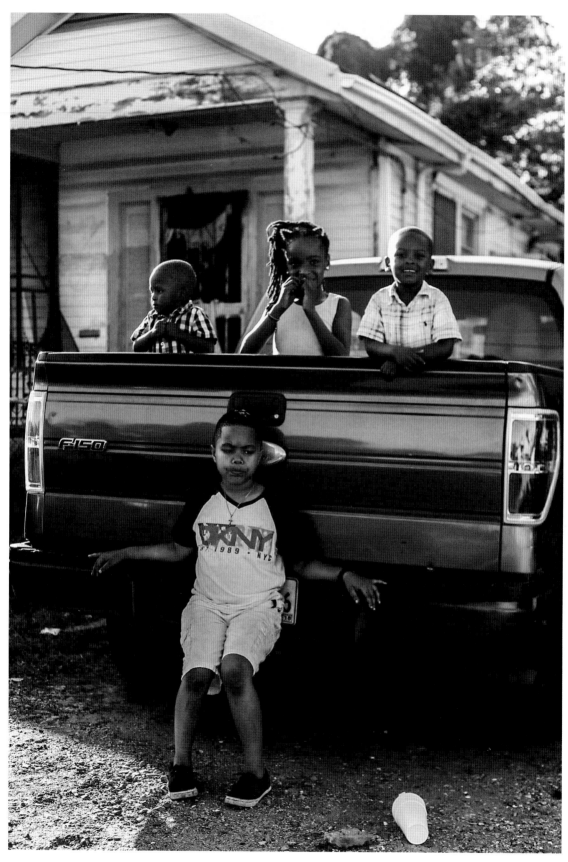

BEYOND BOURBON STREET | BY EVA WOOLRIDGE

together for something greater than themselves. Many initiatives came out of that major festival, one of which was an international collective of Black artists intending to continue this mission of working collectively to form a stronger global community committed to fostering and preserving Black art.

After my first photobooth experience at AfroPunk, The Black Joy Project held photobooths over and over again to much love and excitement. There is something exciting about having your picture taken when the purpose is simply joy on your own terms. We saw that excitement consistently from participants and how much a moment could lift their spirits, which was preserved for them to revisit as much as they'd like to in the future, perhaps in a moment where they weren't experiencing joy.

Although special and vital, Queermas is not unique in terms of a Black queer space created by Black queer people for Black queer people as a lifeline for those who need it most. In an interview, Mokgoroane made it a point to emphasize how their gathering was directly linked to a similar gathering that started before it in the township of Kwa Thema outside of Johannesburg, known as "Matoko's House." And that gathering is similar to another space in Kisumu, Kenya, known as "Paula's House" that offered young queer Kenyans in the mid-2000s a safe space to commune and be themselves.

These are all gardens that plant and nurture seeds of hope and possibility. We clearly are not yet there in terms of true liberation for all Black people and therefore all people. Continually, we see reports from across the world that Black people are still being violently and systematically harmed for being themselves, especially when they are not a cis-heterosexual person. The injustices are still pervasive.

The communities that have existed, do exist, and will need to exist are vital to our ability to authentically generate the version of the world, of life, where the foundation of our experiences is joy and love. And there is ample space to *heal*.

LETLHOGONOLO MOKGOROANE

I have been feeling anxious and scared. I have been feeling uncertain about the world and when I am not uncertain, I grieve.

With so much loss, unrest, uncovering, and uncertainty, I return to the words of English literature and Black Studies professor Christina Sharpe. She writes, "Here there is disaster and possibility." These words have stayed with me. Globally, Black lives seem to matter little—in the vaccine fight, the fight for equality, and the fight for our lives. Black lives are not prioritized. Black queer lives are not admitted as grievable losses. We are disregarded and pushed to the margins. The COVID-19 pandemic has shown us this and so much more.

I am situated in South Africa. South Africa has an amazing Constitution, which promises a better life for all. But in reality, this country is rife with inequality. It is a country where students have protested for free higher education. A country filled with high rates of unemployment. A high rate of gender-based violence and considered one of the rape capitals of the world. This beloved country is a country with a crippling healthcare system, insufficient social security, and rolling blackouts. Electricity has become a major problem in South Africa, with the day filled with more darkness than light. As the years go by, the cuts are more frequent and for longer periods. It means that people should think about finding their own source of electricity, entrenching the deep-seated inequality that already exists. The result is that many of us remain in darkness, which translates into decreased productivity and loss of income for many of us.

With all of this, I ask myself: where can I find joy and what does it look like? Black joy for me right now is possibility. As the American philosopher and gender theorist Judith Butler has written, "Possibility is not a luxury; it is crucial as bread."

Possibility starts with hoping that there is better. Hoping for a better world. Hoping for real freedom. Hoping that we begin to dismantle dominant cultures so that we can create a new world where the future is queerness's domain. Possibility, like queerness, is a structuring and educated mode of desiring that allows us to see and feel beyond the quagmire of the present. Possibility lets us know that the here and now is not enough and it allows us to reject the here and now and insist on the potentiality or possibility of another world.

Possibility isn't always about the big things like abolishing the prison industrial complex and the police or eradicating poverty or fighting to access free universal healthcare for all or fighting queer and transphobic legislation.

Possibility is when I allow myself to believe that touch will be something that I will have in abundance. It is believing that someday we will be able to gather in all our queerness and celebrate that we as Black people and as queer and trans folks have survived. It is hoping that one day queer and trans people will not be slain for living out our truth.

I'm beginning to realize that my joy is in thinking about what is possible for me, for my queer and trans family across the world. Possibility is keeping me here right now. It is helping me imagine better tomorrows.

Alongside possibility is community. One thing that I have learned as a result of the pandemic is creating closeness and connection in the virtual world. We have seen book festivals with some of our favorite authors happen in our living rooms. We have seen academic conversations become open to all. I've had the best conversations with authors I never imagined I'd speak to through The Cheeky Natives, a literary podcast that I cohost. I have spoken to Saidiya Hartman, Kiese Laymon, Carmen Maria Machado, Robert Jones Jr., Akwaeke Emezi, and many more. Online communities have also grown. We have seen Black queer and trans people create spaces to hang out, to

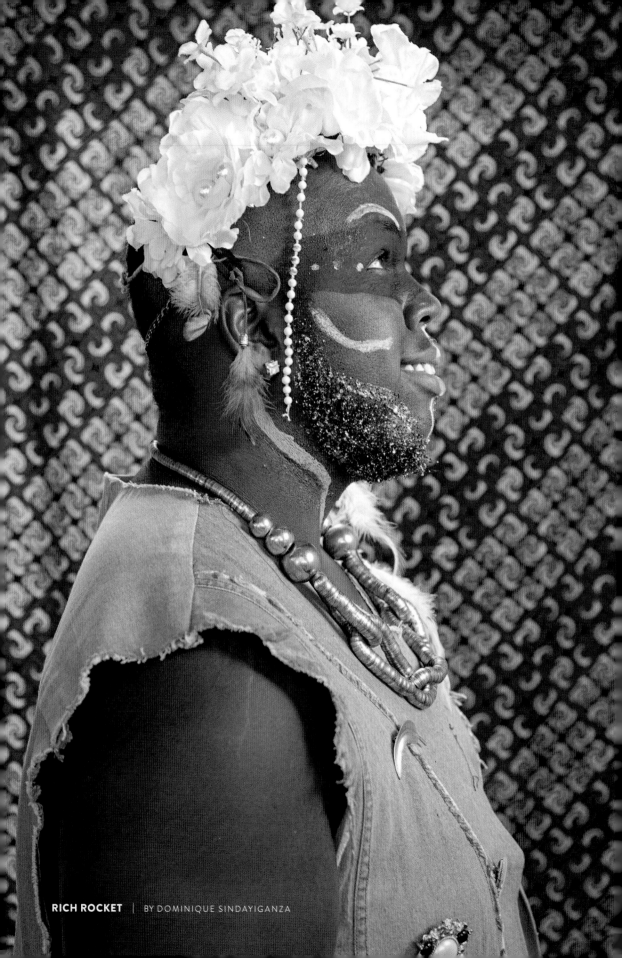

RICH ROCKET | BY DOMINIQUE SINDAYIGANZA

laugh, to reflect, to share, and to be in relation with one another. That has been beautiful—for us to know that we do not have to be alone. We have one another.

Community is vital. Community can be nourishing and in the uncertainty of the world, community can be a lifeline.

In holding on to possibility and community, I often wonder if Black queer and trans joy is in (re)membering the names of the people whose lives were cut short because they dared to exist in their fullness. I wonder if Black queer joy is naming their histories, shouting their names continuously, and ensuring that they are not forgotten.

I wonder about this a lot—what Black queer joy looks like for the dead, known and unknown. Is it perhaps me wearing a skirt with printed names to sign a book to become an advocate (barrister) at the oldest bar in South Africa? To declare their lives matter? Is it me writing about them and naming their deaths as hate crimes, hate murders, and unjustified killings? Is it that? Or is it perhaps that their lives touched someone and their memory will remain? I wish I knew the answer to this question. I wish I knew what Black joy would look like for them. Perhaps in truth, it would be being alive, communing with loved ones and enjoying their lives. But that is not possible. So, for now, I have to live in the possibility that my life will be long, fruitful, and effective and that our collective work will make the death sing louder and never be forgotten.

Black joy is possibility and community. Black joy feels more and more like coming home to oneself, reclaiming parts of yourself that have been pushed to the margins. Black joy feels like the quest for healing—that healing that will settle deep in the bones, the one that nurtures the soul, the joy that tugs at the heartstrings.

Black joy is the possibility that one day all the trauma that sits in the body will be released and the body will learn healing like a language it has always known.

6
WE CAN BE LIKE MOSS

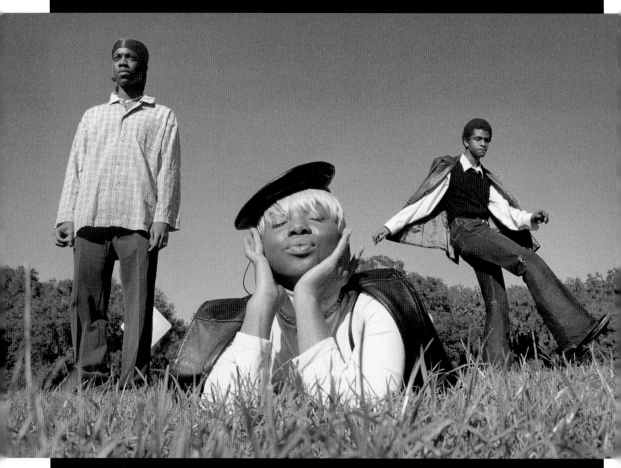

UNTITLED | BY GEOFFREY HAGGRAY

Thrives along crevice
sage, coral cracks concrete
calmly forest floor
sprouts sprinkled life forms commune
unity at the edge

Moss is one of the oldest forms of life on the globe. It has survived more phases of this planet's evolution than most of what is alive today. It has existed throughout much of Earth's history—hundreds of millions of years, to be exact—and was key in establishing the natural world we are in, where other life forms could live and thrive. It is a plant so small that it sometimes can be ignored or missed altogether, but its impact cannot. It can survive in extreme conditions and still hold on to life.

In *Gathering Moss*, Robin Wall Kimmerer, scientist, professor, and citizen of Potawatomi Nation, talks about her journey to find the history and traditional indigenous understandings of moss and its purpose. In that journey, she encounters a lot of difficulty finding historic evidence of its presence and uses. However, she continues to hold on to the traditional notion that every plant and being has a role and responsibility on the planet that is reciprocal and serves the well-being of the community. She ultimately discovers that moss has been a very multifaceted plant used for all kinds of purposes, from baby diapers and women's menstrual napkins to sponges to clean dishes to insulation for boots in cold weather

to a disinfectant for wild salmon to a healing ingredient for illness. It has also existed by many names in indigenous languages, though there is only one to describe it in English. (There are more than twenty thousand species.) It's a plant that has always existed almost as a detail on the planet, one whose absence is very much felt. Its existence has not always been well-recorded by the largely white male anthropologists who did not give it much attention, outside of uses they observed by other men, such as padding in a weapon. Its history and historic uses have been somewhat lost over generations because of the forced assimilation that indigenous people have undergone in the Americas and the ways that has affected ancestral knowledge of the plant. Still, moss is very much alive on the planet serving its many purposes. Moss, like nature, is a resilient plant that refuses to cease to exist and one of the best examples of resilience we have. This can offer some insight into how we, those of the human experience, can organize ourselves in the commitment to living liberated lives. In the seminal anthology, *Black Nature: Four Centuries of African American Nature Poetry,* poet Camille Dungy brilliantly highlights this relationship when she writes, "Recognition of the connectivity with worlds beyond the human is revealed as necessity of spiritual and physical survival."

Moss is a plant that Kimmerer affectionately calls "the coral reef of the forest"—lifelines that offer all kinds of support and sustenance to the many beings within and in proximity to it. Moss exists in colonies and its success is tied to each of its members, or stalks. It's a relationship that Midcoast Conservancy Land Steward Skye Cahoon describes as one where an individual stalk would dry out if it stood alone. The stalks exist in a tight community that depends on water to live and so each stalk plays a role in distributing that necessary moisture to ensure the survival of all the stalks. Kimmerer believes this plant species challenges the overly accepted ideas of Charles Darwin and his belief in the "survival of the fittest."

No one stalk being stronger or better means it lives longer than the rest. They are dependent on *one another.* That communal aspect is

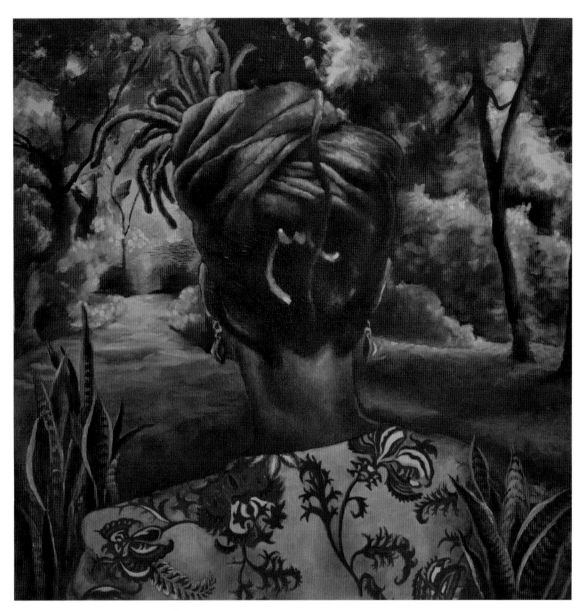

ON TO THE NEXT | BY APRIL KAMUNDE

what gives moss its powerful force of resilience. Moss's way of being illustrates how notable poet and teacher Ross Gay describes joy: "not being 'happiness,' but joy being the way that we manage and create and study, how we be together and take care of one another, how we carry our sorrows together, and how we carry each other's sorrows. How we carry each other. And in this way remember that we are each other." Each stalk within a colony of moss is unique, but all are key in its survival and its healing in moments of drought or severe lack of moisture.

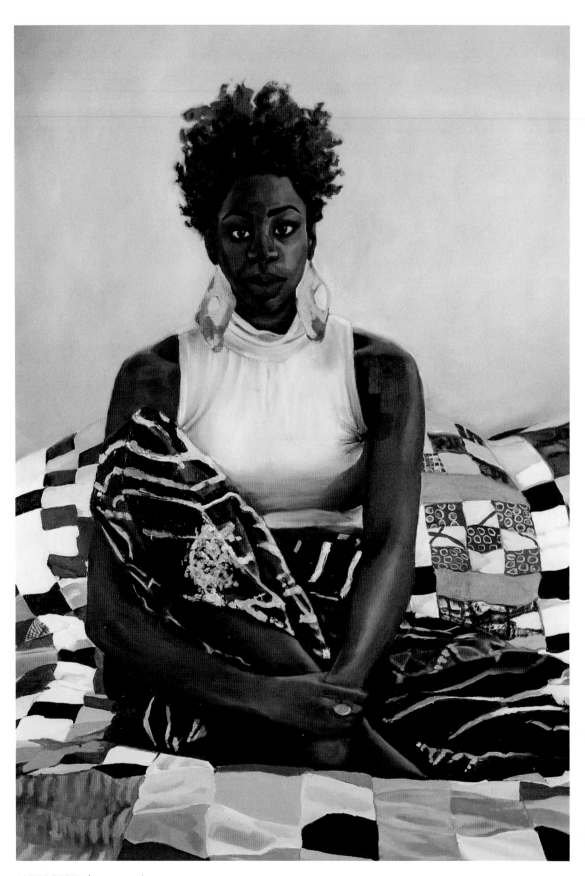

ALE EREGBU | BY LIZ GÓMEZ

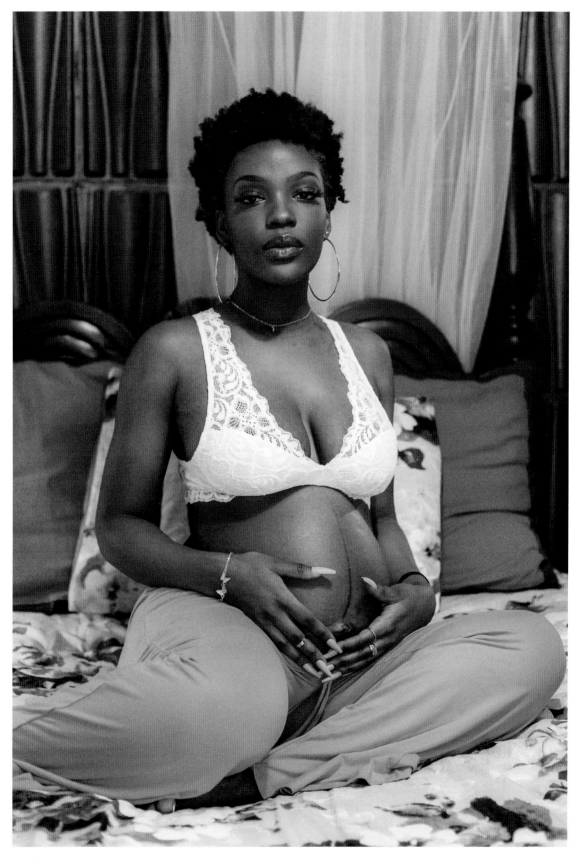

GISÈLE | BY EMERALD ARGUELLES

When moss is around, all kinds of good is possible. It grows in natural environments like forests and jungles, and it can also exist along edges of concrete sidewalks and the foot of fountains. Wherever you see moss, let your eyes wander farther out, and almost for certain you will see more moss growing near and around it. Resilient communities thrive in all kinds of conditions and climates.

In cities, you can find moss crawling and sometimes sprawling along old stone walls and bricks, in the small holes evenly placed on the covers of manholes, at the metal edge of the gutter on a corner, in the cracks and crevices growing as an added layer of grout across concrete tiles. Pittsburgh in Western Pennsylvania has great examples of this. In more suburban and rural areas, you can find it growing on forest floors, along rocks (often over them), spread across the north side of trees, and on and on. There are many types of moss and each serves its own special purpose. Each is important and vital to the survival of this planet. It is one of the oldest inhabitants of Earth. There are lessons and wisdom to be gained from paying attention to such a long-lasting and consistent conversation between moss and this planet.

We are like moss in that way. Constantly sharing resources, clumped together and spread out, in some places supple and other places in need of more hydration and nourishment. We know what it's like to either occur naturally in a place or be forced onto it, learning to survive either way, and thriving whenever possible. We know what it's like slowly, consistently, over time to focus on attaining what we need to live more quality lives. That's what I saw in the emerald-colored moss that insisted on growing at the edge of a sidewalk, so fluffy it looked like the velvet on those popular sofas in so many people's living rooms and offices. That lushness is something that we can connect with and insist on becoming.

In early May 2020, at the height of the COVID-19 pandemic's first wave, my twin brother, Walter, and I found ourselves on a Zoom call with a group of Black people. We had been invited by our friend Mikey to a small gathering to share how we were doing and to give any wisdom that could help all of us to be better armed in treating a sickness we had a name for

but no full understanding of yet. People shared all kinds of stories that ranged from moments of triumph despite the chaos to difficulties they were experiencing from the sudden thrust into isolation/heavily restricted social interactions.

What I remember most from that exchange through screens was the discussion of herbal remedies. What knowledge of nature-based healing had we used or learned about in the early weeks of facing this new illness? What did we already know about treating afflictions to the body that we could use now? What traditions were passed down to us that served our relationship to Earth—that could help us fight this beast claiming more and more lives?

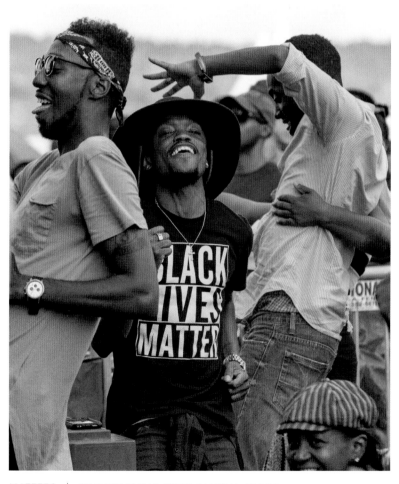

MATTERS | BY CHERISS MAY, NDEMAY MEDIA GROUP

Our sharing of those recipes, teas, tinctures, oils, practices, remedies was also a conjuring. We were doing as the people who came before us did. We came together in times of crisis and made space to be with what is and then determine what will be done, what can be done, what must be done. A healthy relationship to all life forms on this planet was a part of what moved that gathering forward. There was a direct connection between the life in the bodies we wanted to protect and the life of the plants that could make sure we made good on that goal. Like moss, there was an understanding in the interconnectedness of our being(s) and how sharing resources was key in our survival as a whole.

We understood and believed in the power of plants and nature. We *felt* the power of those remedies as we made them, and so did our loved ones who received the healing they provided. It was evident in the many calls my family, and others like ours, received when one of us was experiencing symptoms of what was more than likely an undiagnosed

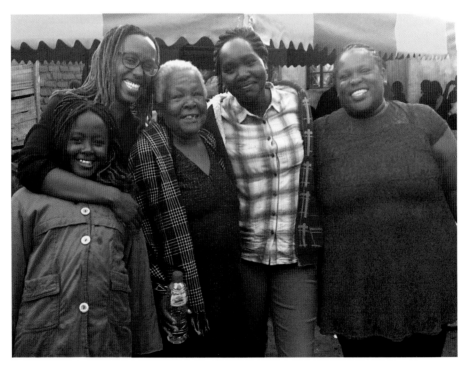

FAMILY | COURTESY OF MWENDE "FREEQUENCY" KATWIWA

COVID-19 case. They patiently explained how to mix thyme, olive oil, and garlic to promote better breathing and clearer lungs. It was evident in the daily tea of apples, red onions, lemon, and ginger we made and served. Recipes that we hadn't had to use in some time but rolled easily off tongues with faith and confidence in the potential of their healing powers. Recipes handed down from one generation to the next.

That summer, a few months after Mikey's call, consultant, writer, public speaker, and media personality Aaryn Lang hosted a series of Instagram live conversations titled, "Ms. Aaryn Lang Presents," as a demonstration of what transformative conversations can look like. The conversations covered a broad range of topics, which spanned from Black trans women in the arts to how white people need to support one another to navigate their privilege. In the first installment of the series, Aaryn spoke with partners Ericka Hart and Ebony Donnley about the state of the world at the time and their insights on how to make sense of it. Much was discussed in this more than one-hour exchange, but how it ended was particularly powerful.

Toward the end of the conversation, Aaryn shared that she and her mom talk to each other a lot about how the ways in which Black people are treated are not one of "people to people." She says that rather, "When you look at it human to beast, you get it." Aaryn suggests that to understand the functions of white supremacy and all the oppression tied to it, you must understand what we are taught about the relationship between humans and animals. Between humans and life outside of our species.

Lang goes on to assert, "People all over the world feel an inherent superiority in human beings . . . until we can see animals as inherently deserving of a life outside of our control on this planet, we are going to struggle with this [white supremacy]." Lang pushed for listeners to check in with their relationship to this planet and *all* of life on it. We must understand the reality that we are coexisting on this rock floating in space. Together.

Listening to Aaryn, I heard the message of indigenous people around the world—the people who have historically been closest to the earth and its preservation. We must understand our relationship to all that is alive on this planet. That is a foundation we can build on because many have done so before us. It is how we are still here to talk about it, experience it, live it.

It has been clearly established by scientists and historians that our species of human originated in what today is understood as the continent of Africa. There has been debate about where exactly on the continent this beginning can be pinpointed to, but it is generally accepted that the origins of humanity are from this part of the world. And though a term like "Black" is relatively new to describe those original people, it is safe to say that from the beginning our species has had to understand the functions of nature to survive. Black people have had to understand the functions of nature to survive. This has played out both in the physical sense of tending to the land and in the spiritual sense of making meaning of its purpose(s) and roles in our lives.

When we fast-forward a bit and look at the history, for example, of Maroons, Cimarrones, Palenqueros, Quilombolas of the sixteenth to nineteenth centuries—independently free Black and often formerly enslaved people throughout the Americas—it's important to note how key their relationships to the terrains they were either forced to cultivate or had to learn to cultivate were all means of survival and vehicles to establish societies outside (at times alongside) colonial structures. It was the ability to navigate rivers, to contain the knowledge of forests and jungles and the properties of the many plants and animals of those landscapes that provided stability in these free Black communities.

These rituals and practices of the Maroon communities across the colonized western world were directly derived from practices found along the Gold Coast and other parts of West Africa (and beyond to other parts of the continent). That is to say that skills like fishing, farming, and other necessary practices of survival outdated the very rebels who used them across the colonized western world. They have existed for centuries and millennia. We must be with the truth that though "Black"

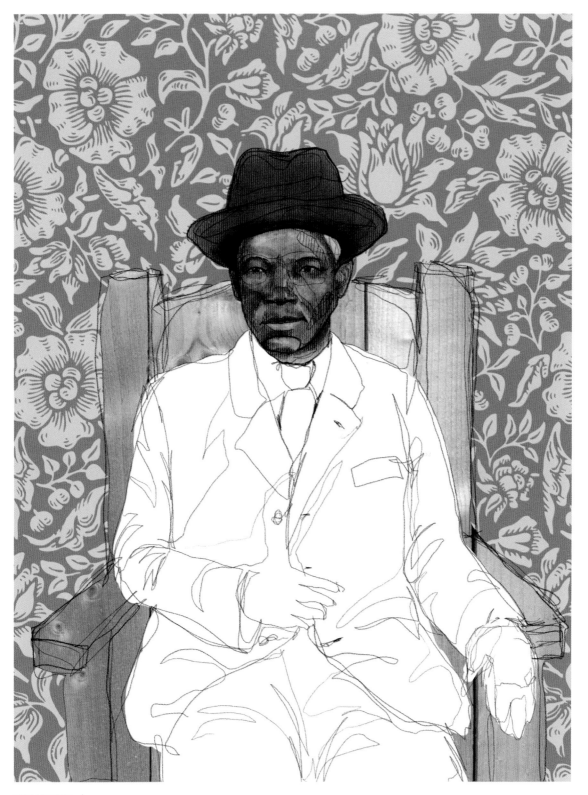

PAPA TOTO | BY ANGIE BOUTIN

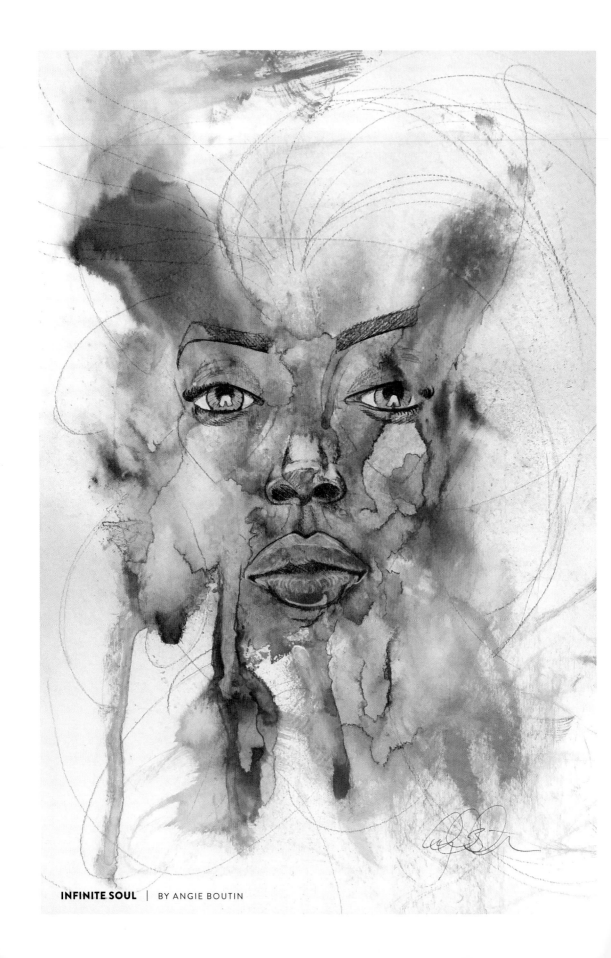

INFINITE SOUL | BY ANGIE BOUTIN

and "African" are relatively new terms to describe our existence, the roots of the species we are at-once denied from and told we are part of are in the land we now call Africa. Those first peoples had to understand their relationship to all the other life forms existing at the same time as them as a means to survive and to live well. They learned how to swim, how to work with the various functions of plants, the behaviors of animals, the significance of changes in weather, and so on.

What does this all mean today though?

It means we must give attention to where these practices can serve us *now*, where we must shift accordingly in the practice of becoming better, and ultimately, how those practices of resilience can be better shared and preserved.

Resilience is the ability to persist despite whatever challenges or difficult circumstances one may face. Moss has survived for so long because of its ability to adapt and, in a way, never give up. Moss is a rootless plant that depends entirely on its stalks to absorb the needed water and moisture that ensures its survival. Even if only a few stalks can take in those necessary nutrients, it is enough to keep the rest of that colony alive. And the colony will contract in moments of drought or extreme weather like freezing temperatures, but it will not shrivel entirely. It will not die. And when the rain comes or a condition that allows it to regain its moisture arrives, the plant will expand again and become that lush velvety green that is so beautiful to admire.

Unlike moss, Black peoples and cultures around the world *have* deep roots. We possess the resilience of the plant with the bonus of deep foundational knowledges and practices that inform who we are today and, of course, who we can become. Black peoples and cultures the world over are no strangers to contracting in times of difficulty to preserve what little they may have to see a brighter future. And they are no strangers to the instances where they can expand and thrive when the conditions are right for it to be so. In those instances of expansion is where joy has a home.

In recorded and oral histories throughout time, Black people have migrated across massive swaths of land, established empires, built

universities and educational institutions, endured enslavement (and at times participated in its administration), created countless eras of design and architecture, written literature and music, led rebellions against oppressive states, fought wars, founded cities and communities, invented numerous ways of existing in this human experience, created religious and spiritual practices, cultivated and preserved the natural world, and the list goes on. Through all of it, the will to exist and to thrive did not go away.

Like world history, global Black history is incredibly complicated and filled with all kinds of overlaps and contradictions. What is clear, though, is a consistent presence of persistence and resilience that has often extended beyond the lifetimes of any individuals or collectives who stood for change. These are the many "stalks," if you will, that have expanded and contracted in service of sustaining the entire community.

Throughout the mid-twentieth century, the world witnessed the independence movements of colonized people around the world, which certainly included the revolutions and establishments of new nations across the African continent and Diaspora. Of course, these movements and endings of colonial reigns were not made possible by any one individual but rather, like those closely growing stalks of moss, collectives, unions, and organizations that formed with many members committed to this goal of revolutionary independence.

At times, these battles and conflicts were with the white colonial forces and others in power. At other times, the conflicts existed from within Black communities and nations. What is true is that in all of those cases were *struggles* that required rebels and revolutionaries alike to be persistent in their dedication to make change. This required battles on all kinds of fronts, some of which were, of course, physical, and others, spiritual and mental.

There were the ancient Egyptians who wrote down stories and texts for burials to accompany the dead into the afterlife as ritual for ascendance more than five thousand years ago and enslaved Africans under the Arab slave trade that led revolts as early as the seventh

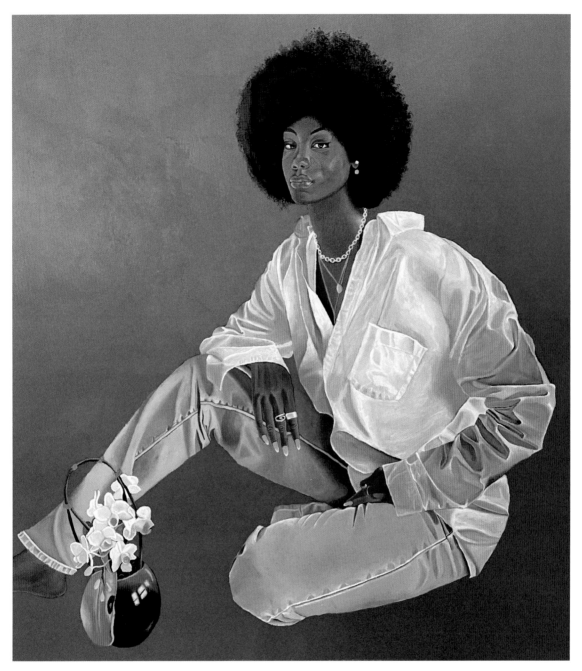

GRACE | BY WESLEY GEORGE

century. Africans also traveled beyond the bounds of the shores of the
continent to what Europeans would later call the "New World" as early
as the ninth century. By the thirteenth century, Timbuktu was the capital
of the Mali Empire, one of the most influential empires in history, and
served as its central hub for religion, trade, and politics. By the fifteenth

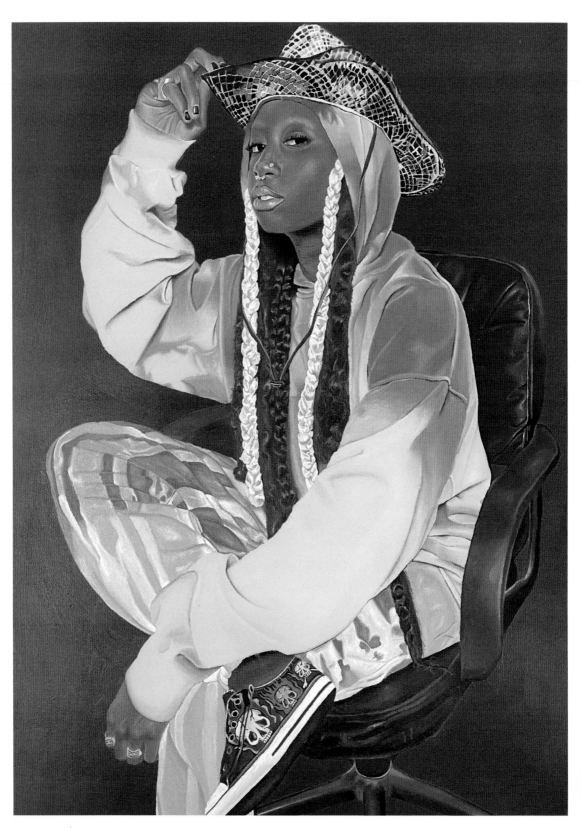

OPHELIA | BY WESLEY GEORGE

century, when the rumblings and ultimate establishment of a new system of slavery led by Europe's greedy monarchies was formed, Black societies and civilizations had already been well-established and proven to thrive on their own volition. And we know that many Africans who were forced into chains and labor fought back and resisted this system that would thrive for the next few centuries. They would rebel, create new freed communities, and determine ways to exist within these new societies and systems. Some would join with the indigenous peoples in these new lands and create new cultures, significant ones like that of the Garifuna in the late eighteenth century. And by the early years of the nineteenth century, Haiti would lead the greatest uprising of enslaved people in recorded history to create a ripple effect still felt today.

By the end of the same century, many of the biggest nations that grossly profited off the forced labor and dehumanization of Black and African people would see the legal end of enslavement. Throughout the twentieth century, the world would see Pan-African gatherings with various intents, ideas, and actions to connect the struggles between Black people the world over (though there was never a fully unified or consistent vision for what that work could look like) in service of elevating people of African descent out of the spiritual, mental, and physical bondage they were committed to transition from. And many also stood in solidarity with people of color around the world touched and devastated by similar effects of the systems that hurt them too. And that work continues into the twenty-first century in all its complexity.

There are Black people who are working and preserving the land as well as honoring its role in their lives, in the name of liberation all over the world. This preservation work is the continuation of ancient practices, their evolutions, and intentional means of retaining land in the name of sustaining healthy Black futures. An incredible example of this work today is found on an eighty-acre plot of land northeast of Albany, New York, in the town of Grafton.

In 2006, a Black-Jewish family who lived in the south end of Albany struggled to find fresh food to feed their children. Their neighbors asked

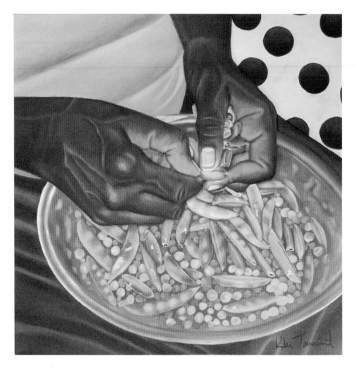

PEAS | BY KIKI TOUSSAINT

them to start "the farm for the people." Over the course of the next four years, the family worked the land and built an infrastructure on their eighty-acre plot to prepare for what would become Soul Fire Farm in the fall of 2010. More than a decade later, the farm describes itself as an "Afro-Indigenous-centered community farm committed to uprooting racism and seeding sovereignty in the food system." Soul Fire operates "with deep reverence for the land and wisdom of our ancestors; we work to reclaim our collective right to belong to the earth and to have agency in the food system."

Today, the farm has a reach of almost two hundred thousand people annually via educational and training programs as well as "reparations and land return initiatives for northeast farmers, food justice workshops for urban youth, home gardens for city-dwellers living under food apartheid, doorstep harvest delivery for food insecure households, and systems and policy education for public decision-makers." It exists both as a place to sustain life via food production and to spread ancestral knowledge

of liberating practices. Fortunately, many initiatives like Soul Fire Farm continue to pop up all over as more communities get clear on the importance of our relationship to nature and its avenue(s) to freedom. They keep a seed of hope alive—a seed of ancient cultures that cared for the land and the people who existed on it.

And it's a seed that revolutionary and leader of the Liberation Front in Cape Verde and Guinea-Bissau Amílcar Cabral links in a famed 1970 speech on National Liberation to culture. Cabral argues, "Just as happens with the flower in a plant, in culture there lies the capacity (or the responsibility) for forming and fertilizing the seedling which will assure the continuity of history, at the same time assuring the prospects for evolution and progress of the society in question."

When you listen to indigenous people around the world, you are present to the importance and sacredness of understanding why one's connection to the natural world is a stone in the path to imagine and ultimately create a world that loves Black people and, therefore, all people.

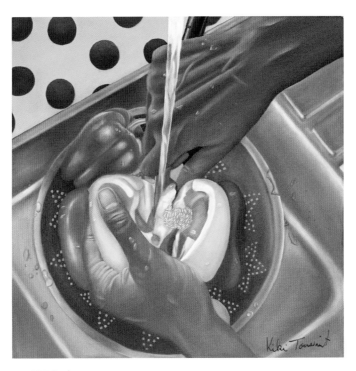

PEPPERS | BY KIKI TOUSSAINT

In Milton McFarlane's late 1970s account of Maroon history in Jamaica, *Cudjoe the Maroon,* he describes a culture that, as a means of promoting community, organized itself in a way that assigned men to support one another in preparation of land for cultivating crops and building new houses. Once a year, they cleared high brush and cleaned up properties. As McFarlane describes it, each of these responsibilities also created opportunities for building community through songs, storytelling, and drinking. Women, who were often busier than the men due to domestic labor and cultivating the land for crops, brought moments of joy to the community when they took the time to care for themselves and swim in the river with the men who had the privilege to regularly bathe in it. The act of caring for themselves brought warmth to the community and offered a break from demanding labor to cleanse oneself.

UNTITLED | BY BRENDA A. GATES

At the almost one-year mark of the COVID-19 pandemic, it was still not clear what the virus that caused so much chaos was all about. The most influential and powerful nations of the world insisted that they had developed effective vaccines. The newly developed treatments found their way into the bodies of millions. It is yet to be known what the long-term effects of these vaccines will be. What we do know is that we have a long history of learning to care for ourselves and one another based on our relationships to the land. Many chose to take the natural or more homeopathic route for treatments as opposed to taking a vaccine. And still others who opted into the vaccines have supplemented them with teas, tinctures, potions, and other natural remedies.

In the case of the coronavirus, there are communities of Black people all over the world who have come together in various ways to share knowledge and practices of how to take care of our bodies as forms of defense and proactive commitments to being well.

In the grander scheme, our knowledge of the Earth and how to take care of it serves as a tool for imagining and creating a world that can love and support Black people, wherever we exist, respectfully and with love. It means that we get to grow our own food supplies and control those supply chains to eradicate hunger. It means that we get to have the resources to provide adequate shelter and safe spaces for those of us in need so that none of us go without. It means we get to practice accountable communities so that we can practice the possibility of living in ways that are not reflective of the colonized mind and mechanisms that continue to be perpetuated today, ultimately at our own expense. It means we get to live in harmony with this planet as a key to our own well-being and not its compromise.

And the soil we must preserve and protect has given us so much in return too. It has offered nourishment in all kinds of ways, namely for our stomachs. The cultivation and cooking of dishes in kitchens across Black communities around the world is a reflection of both survival and joy. It's that feeling where you might shake your head from a shockingly good

taste or bang on a tabletop from a flavor you can't get enough of. It's the soup joumou on the first of January to commemorate the triumph of the Haitian Revolution or the tender stewed goat for Eid. It's in the everyday foods still eaten like injera and tibs from Ethiopia and doubles in Trinidad; the mangusi of the Kongo to mangu of the Dominican Republic; the Fufu of West Africa and the various mashed root vegetables across the Caribbean.

Writer, culinary historian, and educator Michael W. Twitty argues that food is a tool for repair "within the walls of Black identities." It serves as a bridge between our pasts, present, and futures through the literal practice and exchanges that occur in kitchens and anywhere else we make food for ourselves and one another. Twitty believes that how one survives their oppression is their greatest form of cultural capital in a world that is constantly trying to co-opt and monetize traditions not of their own. It's what he brilliantly describes as being the case for Black people the world over: "The cross-pollination of African cuisines and the exchange of knowledge among cousins, this capital is limitless."

Our continued practices of cooking are like those colonies of stalks that make up the thousands of varieties of moss that exist on this planet, each uniquely and distinctly serving a purpose that upholds the whole. It sustains it. And we know that in the moments when we may not have what we need to create the dishes we desire, we will innovate, holding out like the stalks in freezing conditions until we can get access to those missing ingredients. And in the meantime, we will innovate. It's that cross-pollination Twitty names as limitless. A constant remixing while also maintaining certain traditions that move the needle forward.

Prolific author Octavia Butler once wrote, "There is nothing new under the sun, but there are new suns." In few words, Butler gets at the truth: Though nothing may be new on this earth in terms of existence, there is a whole universe to still draw from, discover, and imagine with. And even if we were to stick to the sun, our sun in this solar system, there is still room to innovate and cultivate life regarding nature. One way to do that is to reconnect with it.

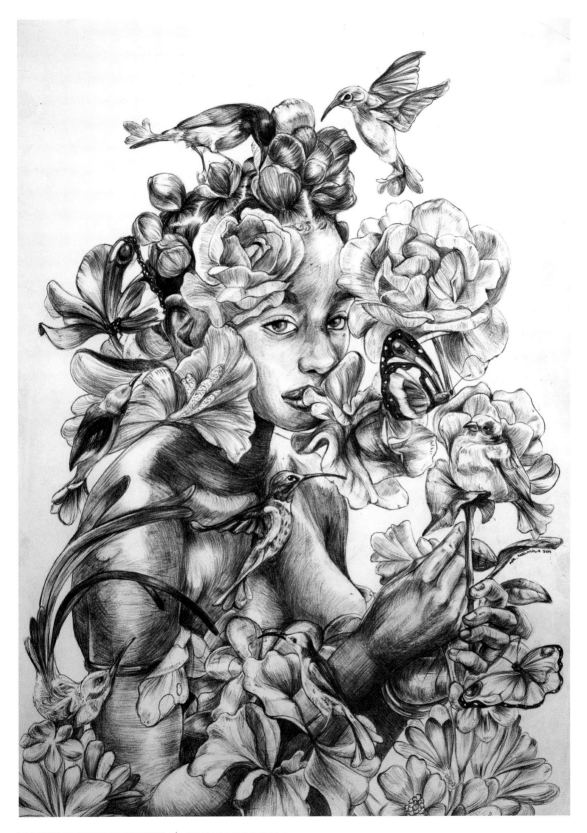

EMERGING FROM BLOSSOMS | BY MARK MODIMOLA

When I first watched Aaryn's conversation about digging deeper into our relationship with all life forms to further commit to practices of freedom, I decided I needed to reintroduce myself to nature. It wasn't a big sweeping moment; it started off simple, in fact. On my normal walks to the bus or just down the street I lived on, I would walk a little slower. I looked in every direction and not just ahead or down. I also wrote small poems as my written "Polaroids" of those moments—a brief capture of what I saw. After about three months of intentionally walking around like this, I felt the shift. It was clear how much was *alive* around me. Around all of us.

In the space of living in a country and world that is increasingly violent and hateful toward most people who are not white, cis, heterosexual, rich, male, able-bodied, neuro-typical, and so on, being present to *life* can be very hard to do. Even more, when you must exist in environments where the violence is hard to ignore, be it through ongoing physical violence, the psychological violence of oppressive media, or the spiritual violence that threatens us regularly, it can be hard to tap into this force that surrounds us.

As trite as it may seem, taking a moment to simply take in the sight of trees and flowers can be impactful. Let's say you live somewhere that almost nothing grows, maybe only patches of grass breaking through dried dirt or cracked concrete. That *is* enough to get a taste of this bigger message around nature and our joy. Is that patch of grass not disruptive? Can it not symbolize the persistence of life amid limiting conditions? Is its existence not an act of resilience? No, noticing a small moment like this won't change circumstances radically, but it *can* be fuel to keep moving toward that goal if we allow ourselves to tap into the joy and synchronicity of nature.

Today, moss can be cultivated indoors, even bought at a store, but it does not change its age or wisdom that has come with it. It is a living thing that journalist Rachel Cooke describes as one that can "tolerate stress like few other plants." Cooke goes on to describe how the plant can "lose up to 98% of its moisture and still survive to restore itself once the supply

of water is restored." Black people are no stranger to that story whether familiar with this plant or not.

Moss is one of the oldest life forms on Earth. In fact, it was here when there was no soil to draw moisture from at all. As it thrived, the environment became more fertile and conducive to new life. Its adaptiveness has allowed it to survive for *millions* of years. Presumably, it will be here for however much time is left on this planet for any life form. We can be like moss in that way too, harnessing our collective power and ability to contract for the sake of survival and to expand when we have the nourishment we need to thrive. We can have valuable parts of our experiences, if only the stories of them, utilized far into the future, and we can reflect on the impacts of empires like Kush and Mali or passed-down food traditions that harken to what was while encompassing what can be.

This ancient plant has been around before and during every era and epoch that humans have been around. It's borne witness to our survivals and demises. It's been there through it all, and so have Black people. Resilience does not come without its wounds and traumas. For those impacts, Black joy can also serve as a tool for healing.

FIERY DVD | BY JACQUELINE OGOLLA

7

HEALING

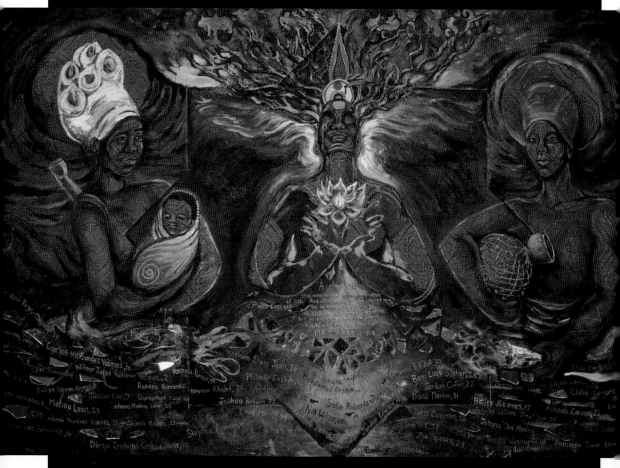

SAY OUR NAMES | BY LIZ GÓMEZ

lack joy restores and regenerates as much as it feels good. It can offer healing and a balm to navigate life. To heal can be a complicated matter, especially when considering factors like spiritual, physical, and psychological traumas one might experience, either directly or inherited. Black joy can be a tool for healing and it can provide a resource for support.

There is something to be said about prayer and affirmation too. Prayer is an action done to express gratitude or make a request of a higher power. Affirmation is the act of using words or practices that positively express a strong belief or desire.

Across centuries, people have participated in spiritual or religious practices in some form or fashion, both to find strength and to cope with suffering and pain, from mosques to churches, temples, living rooms, backyards, and sidewalks to a clearing in the woods. In that spiritual realm, it has proven useful to ask for healing and then do the work necessary to work toward it, by affirming its possibility both in words and energetically. For some, that has looked like kneeling in a pew asking for support to get through a trying time. For others, it has been sitting crossed-legged with a slightly arched back on the floor or on a mat in meditation. And still for others, it has meant simply being still and expressing gratitude for what they *do* have and the patience to get what they need.

What is clear is that pain is a part of life that cannot be avoided. What can be avoided is the level of suffering and pain we are forced to endure and what is often a lack of resources to work through it. It may seem frivolous or even irresponsible to say that Black joy is enough to offer healing through difficult experiences like cancer, unemployment, or losing

a loved one. However, Black joy offers a lens to see that world that can lead to healing and how focusing on what may bring you joy in any given circumstance can be more fulfilling and generative than focusing on what does not. Our minds and thought patterns are powerful resources we have access to, much like imagination. In fact, a meta-analysis from studies in a 2019 *Annual Review of Public Health* report titled "Happiness and Health" states there is some evidence to correlate affective well-being (feelings of joy and pleasure) and low cortisol (hormone linked with stress) levels.

This is not to say that if we think oppression and white supremacy will end, it will. The solution to this massive problem is far more complicated than that. But what it can mean is that experiences of joy or thoughts that evoke that feeling can support our general state of well-being. In an article titled, "Healing, with Joy," Yogacharya (teacher of yoga) Shameem Akthar offers that aromatherapy is one strategy to bring a healing joy into one's life—namely, smells like jasmine, ylang ylang, rose, geranium, and sandalwood. Like keeping a grandparent's favorite perfume after their passing or the scents from a kitchen while cooking certain comfort foods. Akthar shares that jasmine encourages self-love and esteem while geranium can initiate joy by making a person drop toxic memories. This also connects to the understanding that memory is strongly tied to smell. Memories that bring joy are also sources of healing, much like the morning The Black Joy Project started and the rush of reminders of better times.

Joy can also be a spiritual key toward that healing. When we can get behind the idea that this physical experience we are having on Earth is tied to something much bigger than we can tangibly make sense of, a door opens up for what else is possible.

For a minute, imagine you are a runner and are about three-fourths through a 26.2-mile marathon and you are starting to feel so exhausted that you don't think you can make it to the end. What often can help in that moment is not just assessing how much physical energy you have left in you; what can help is imagining the finish line. Visualizing yourself

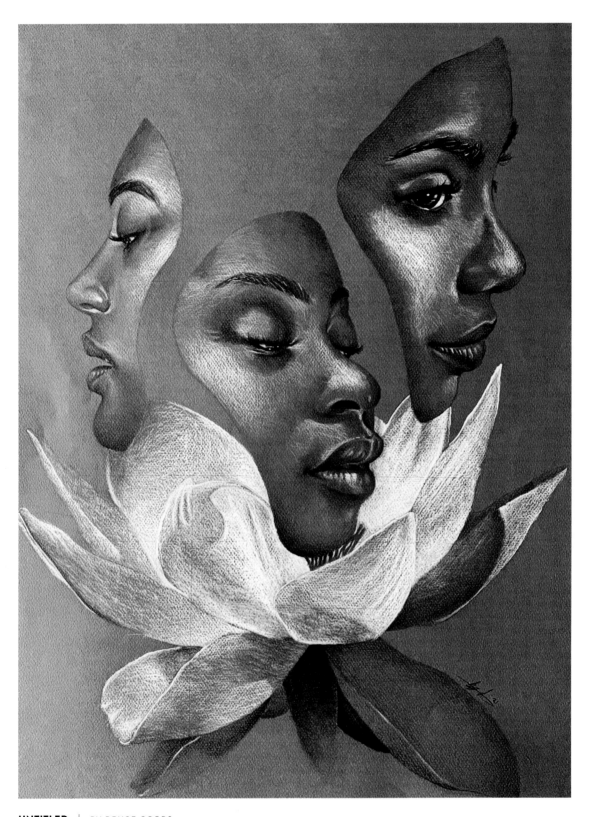

UNTITLED | BY BRYCE COBBS

UNTITLED | BY BRYCE COBBS

running past that finish line can be the boost you need to make it there. And isn't life exactly like a marathon sometimes, with all kinds of turns and terrains that will challenge us and, at times, get the best of us? Yet, time and again you *can* make it to the finish line. In the times that you don't need those moments, they are still useful and insightful to figure out how to be better the next time.

Consider one of the most famous revolutions in recorded history: the Haitian Revolution. Before the actual battles and necessary fighting that took place against the French, Haitian revolutionaries held intentional Vodun ceremonies and performed rituals to garner ancestral and spiritual strength to fully prepare for what was certain to be the most important battle of those Haitians' lifetimes. They held a vision of the possibility that they would no longer have to exist with their necks under the boots of colonizers and their brutal systems—a vision of the sweet joy of freedom. History also tells us they were successful in ending that reign of terror. It would take much more than the ending of that system of enslavement to improve life in the small country, but consider that the joy of that victory was so powerful it created a strong conviction that upon victory, Haitian revolutionaries continued to spread their cause. They supported many other peoples in their fights for independence and liberty. Joy is generous in that way. When healing occurs, more space is opened up to support others in their healing. Healed people heal people.

As has been mentioned before, joy is something that cannot be taken away because it was never given. It comes from within and from within communities—the collective.

There's something to be said about the power of spiritual healing and joy as it impacts the other aspects of living. For as long as humans have been around, there have been stories of people being healed by spiritual power—stories of someone walking into a sacred space with a physical ailment and then being "touched" by a greater power that allowed them to leave that same space in better health than they came into it. There are stories of the *joy* of a congregation praying for the healing of their fellow members and the *joy* once that healing is witnessed. Of course, this may

BLACK GIRLS ARE FLOWERS | BY AMANDA DIBANDO AWANJO

be contested from a scientific standpoint, but what if we suspended the belief that science is the end-all be-all reasoning for these types of situations and considered the power of affirmation? Of joy?

There's an old saying that we are the answers to our ancestors' prayers. When I hear those words, it makes me think of people who committed spiritually to the belief that the generations who followed them could live a better quality of life than they did. People who may have suffered greatly in their time for various reasons yet still held on to

the vision—the belief—that somehow, some way, somewhere down their lineage there would be people to experience the greatest joys possible, that they could have more joy in their lives than they ever did.

Pain and suffering, like energy, cannot be erased from our existence, but it can be transformed. Joy can be that key to turn toward a metamorphosis that does not bound us by what hurts and opens the space for the possibility of getting better.

It can be related to the elaborate ceremonies and rituals ancient Egyptians held to affirm the spirit of those who passed would prosper both in the spirit realm and in whatever form they reincarnated in.

If you carry a heavy bag every day for long enough, the idea of not having its weight on you can make your body feel like something is missing. You get used to the pain, and it starts to feel normal. It can feel so normal, in fact, that it is hard to think about healing because you don't realize anything is wrong. The thing about pain, trauma, and other forms of harm is that we can learn to live with it as a way to cope—a way to survive. Many of us have grown accustomed to living lives that do not fully acknowledge or offer us a reprieve from harm. We're in deep pain and don't even recognize it. In many places, there has been no other option but to live this way.

We learn to brush off triggers. We learn to tell ourselves it's no big deal to have anxiety, depression, or low self-esteem, if we acknowledge these issues at all. These are minor problems, we tell ourselves—"first-world" problems, pesky problems, not *real* problems. Others have it harder. What's to complain about?

We get so used to having those thorns in our sides that we think thorns are supposed to be there. In an odd but common twist of logic, the thorns may even begin to provide a form of comfort—a comfort that leads to feeling that even the thought of existing without said thorns is scarier than living with them. That is what life feels like when we don't heal. We end up with limited reference for a world without problems, and peace feels like the exception and not the rule. We become fearful of existing without these pieces of pain and hurt we've learned to function

OLD QUEER LOVE | BY TERRELL VILLIERS

with, whether highly or not, and can't begin to imagine life without them. And what a blessing in the face of this horrible state of the world to have a portal toward the guides that have been fighting with us all along.

Ancestral support and veneration are not an idea; they are a practice. We see this in many of the spiritual systems that we use around the world that call for us to name those that came before us, prepare meals and offerings for them, and tell their stories, and all the myriad ways we maintain those connections. Their purpose is to keep us connected to the legacies we have sprung from. It is the Akan belief of Sankofa, to go back in order to move forward. Moving forward is healing. Black joy can be an entry into this needed practice of curing and tending to wounds we (have) experience(d) in mind, body, and soul.

There is healing in those moments that bring us joy in who we are, in our fullness. That should be the baseline. Pain is unavoidable in life, but we are more than worthy of living full, healthy, and healed lives. We get to thrive. It's best to do so with as many of us together as possible— ideally, all of us. We are still aspirational in that way, but that doesn't mean that we must constantly suffer. Black joy as a form of healing means that we get to be in practice around a cure of love and of loving. It's part of the power, for example, of a second-line in the "northernmost point of the Caribbean": New Orleans. It's part of the legendary Maroons of Jamaica, after battles with colonizers, intentionally making time to mend their wounds, nourish themselves, and prepare for the next battle(s). It's the Black Joy Farm in the Bronx, organized by Tanya Fields and a team of loving people, providing organic produce at affordable prices in communities that often sell us tomatoes Sonia Sanchez once described as "being on the verge of a nervous breakdown."

It's the warm bowl of soup your grandmother makes when you aren't feeling well. It's a loved one's smile you catch that tells you they are proud of you. It's saying no and not feeling bad about it.

In its truest form, joy, and therefore part of the process of healing, must happen *actively*, between us. Joy is bound to healing because it has had to exist with a backdrop of a world that insists on devaluing Black life.

Healing is real and a real possibility. It can feel hard to believe or imagine sometimes when you have so many other pressing priorities for survival. Paying the rent. Paying the bills. Getting to and from work. Buying food. Supporting family. Supporting the people you believe in. All the surprise costs that pop up because you can't always account for people dying suddenly, getting injured, losing work, getting sick, etc. The list goes on.

The restorative power of joy can be found in a single moment too, which happens often when Black people come together to celebrate one another in ways that the world has yet to do for them. Like the moments

DREAM, SALLOMÉ, AND LEGACY | BY BARNABAS CROSBY AND COURTESY OF SALLOMÉ HRALIMA

everyone remembers (and even created GIFs of) Taraji P. Henson proudly applauding other Black women winning awards. Or friends dressed up to be in one another's company on a "Girls' Night" and committing to a good time no matter what else is going on in their lives. Celebration is a form of this healing. So many of us within various African and diasporic communities have had to learn that if we do not celebrate ourselves and one another, no one else will.

In 2017, a large coalition of Afro-Brazilian grassroots collectives came together in collaboration with the University of São Paulo's Law School and the city's Institute of Health to organize the first international conference of its kind in Brazil. The conference addressed the specific impact of incarceration, prejudice, and what Afro-Brazilians have intentionally described as a genocide on Black people in the Americas and Brazil in particular. Though panelists and participants from outside of Brazil were present, the convening was largely focused on bringing attention to Afro-Brazilians and their current state of crisis. The three-day conference was hosted between the uber white and conservative University of São Paulo Law School and a samba school in the Sapopemba neighborhood about forty minutes outside the center of the city, a neighborhood made up of primarily working-class people of color. It brought together more than a hundred activists, artists, experts, and people generally concerned about the welfare of Black people.

The first two days were mostly spent in a lecture hall whose perimeter was lined with busts of white men long gone. Over the tall balcony hung beautiful images of iconic Afro-Brazilians Carolina Maria de Jesus and Milton Santos as well as banners that read, "Periferia[*] contra o golpe (periphery against the coup)," "Contra genocidio da juventude preta (against the genocide of black youth)," and "movimento cultural das periferias (the cultural movement of the periphery)." These large banners served as visual markers of resistance and reminders of a long history

* *"Periferia" (or "periphery") is a term used to reference the geographic areas on the outskirts of São Paulo (the largest city in South America) that is home to millions of low-income Brazilians.*

of Black presence in Brazil. In between important yet heartbreaking and complicated discussions about the deaths and murders of young people, the economic disadvantages, and the general daily experiences of Afro-Brazilians, the conference offered artistic "interventions," where Black artists, from rappers to stilt walkers to an all-woman band, performed to sprinkle moments of joy and affirmation for Black Brazilians and Afro culture in and beyond the space to feel seen. The songs, monologues, poems, and performances disrupted the violent white space of the university as an allegory of much larger intentions in relation to Brazilian society.

On the last day of the conference, participants traveled to Sapopemba, a neighborhood in the periferia much like many working-class neighborhoods around the world that find themselves farther out from the city center, purposefully segregated. Specifically, within Sapopemba, participants were housed at the area samba school, a cultural space not just for dance and music but for community gatherings like this convening.

The intention of the last day was to end the conference in action. Participants were given options for working groups to split into for the day that would discuss predetermined issues and then brainstorm potential ways to address them. I chose to participate in the gender-based violence group to get insight on what this major issue looked like in the Brazilian context and learn about ways that it was being addressed there as a potential takeaway for my context in New York.

Though the intention of the group was to discuss gender-based violence (not explicitly focused on any one gender), it was almost entirely composed of women and femmes. The group of about forty people comprised organizers, people with general concern, mental health professionals, and social workers, to name a few. It is also worth noting that most of the group was Black, but not exclusively.

While the group was deep in discussion, a woman could be heard crying from across the large, covered space we shared. She was mourning

the loss of her young son who had been murdered by the police. She was not part of the circle I sat in, but her wailing penetrated it. Her cries reminded me of my own grandmother's tears as she mourned the sudden death of her son. I did not need to speak the language to recognize the pain of a mother who has buried her child. Around the space was a banner with cropped photos of the faces of young people who had also fallen victim to the state-sanctioned violence of

ABUELA Y MIKO | COURTESY OF JAVIELA EVANGELISTA

the police. Her son was on that banner. The freshness of that pain, always around the corner, simmers in a mother's heart.

Those cries spoke so clearly to the constant strife present in everyday life for too many Afro-Brazilians with the threat of life-taking violence constantly at the helm. Her cries made the severity of the situation that much more real.

Later that day, after lunch was served and eaten and the groups had come together for in-depth discussions, the more than one hundred people gathered in the heart of that samba school found themselves in an impromptu musical moment. At first, it was a slow rhythm with people dancing along to the beat. The soft drumming eventually transitioned to an upbeat song with the room full of people moving and singing along with a community organizer jumping as she gripped the microphone in her hand tightly and chanted, "FORA UPP!," to echo the popular

demand to put an end to the notorious Unidade de Policia Pacificadora (Pacifying Police Unit), a police initiative launched in Rio de Janeiro's favelas that has killed Afro-Brazilians at an unfathomably alarming rate since its inception in 2008. What at first seemed to be just a fun and light moment at the surface (especially if one did not speak Portuguese) quickly became an intentionally joyful and healing moment to affirm that this violent force (and others like it) cannot, will not, exist forever.

RAMONA | BY ANDREA WALLS

It was a healing tied to imagination, a radical tool necessary to create the world *after* revolution. We cannot fight for revolution without a vision for what comes after it. History has taught us that when revolution is fought without a future vision, another, if not the same, version of life before the revolution will occur again.

In those moments of celebrating and creating spaces for ourselves and one another, we are practicing a way to be. There is no need to wait for permission; it is our volition to create joy and lean into it when it feels right. It took one voice on a microphone to begin a song that was joined by drummers, that was joined by dancers, that was joined by people singing and moving to that rhythm to sing a song about taking down a violent force. A song that fueled a vision, that fueled action to make those lyrics reality. And it will take many days to ultimately get there.

Unfortunately, police violence among the many sanctioned forms of violence by the Brazilian state continues. Hope is not lost though, and that song break gave the people in the space that day some more fuel to keep going, to keep climbing a tall mountain. This is not to mention the personal issues and obstacles they must work through in their individual lives in addition to what is thrust upon us.

That contrast between joy and its thieves is evident in the colorful and busy murals found all around São Paulo and other parts of Brazil. That can also be found in cities and towns like it all over the world—reflections of people's artistic interventions in the physical spaces they must interact with regularly, be it on large walls along highways, around buildings, in alleys, on the metal gates of businesses, under tunnels, or, as made famous in New York City in the 1980s, on modes of public transit like trains. This art form serves as a window and a mirror toward what can be and perhaps how the people of a community see and understand their realities. Even as local and national governments make efforts or legislate laws to erase these striking pieces, artists continue to create new ones, sometimes on the very same spot that got painted over.

The healing that joy brings *is* worth it, though. As the instructions go on a flight, we must remember to secure our oxygen masks first before going to the aid of others. We

NOLA COUPLE | BY EVA WOOLRIDGE

each get to be the source of our own joy first in order to be that source for those around us. It's more complicated, of course, because we don't always get to separate ourselves in that way, but the intention is to make it okay to get clear on your joy and the healing that can come of it before you can fully support others in doing the same.

This is no easy task. It takes effort, and it also takes occasional failure. Sometimes you tell yourself you're great and *worth it* and other affirmations, but somehow the message just doesn't get through. The routine of life and not making enough space for any form of joy gets in the way, and a cycle of carrying unhealed baggage continues. There will be times you would rather live the rest of your life with certain thorns in your side even though you deserve better because the work of getting better feels too hard. You deserve better. We deserve better.

"We gather a lot to resist and not nearly enough to celebrate" is what Elisha Greenwell once said about the importance of an inaugural event like no other. On the last Sunday in February 2018, more than fourteen thousand people came together in downtown Oakland for the first Black Joy Parade hosted by Greenwell's nonprofit of the same name. The organization is dedicated to celebrating "the Black experience and community's contribution to history and culture" through this signature event and beyond. Coincidentally, the parade's launch that year was on the heels of the global phenomenon that was Marvel's *Black Panther* film.

In the area cordoned off for participants of the parade to gather at the start of the event was a crew of four little Black girls dressed up perfectly as the iconic Dora Milaje, geared up for war. All around them collectives of people prepared to walk the length of the parade along Oakland's downtown area. There were urban cowboys, bands, musicians, singers, floats of various sizes, dancers, dance teams, and myriad other people gathered in this historic Black community to uplift this vital force.

It was a busy day that started with a parade and ended with a small street festival and performances from local and big-name artists such as Nigerian American rapper and singer Jidenna, who headlined the event. The excitement, the joy, in the air was palpable yet hard to describe fully.

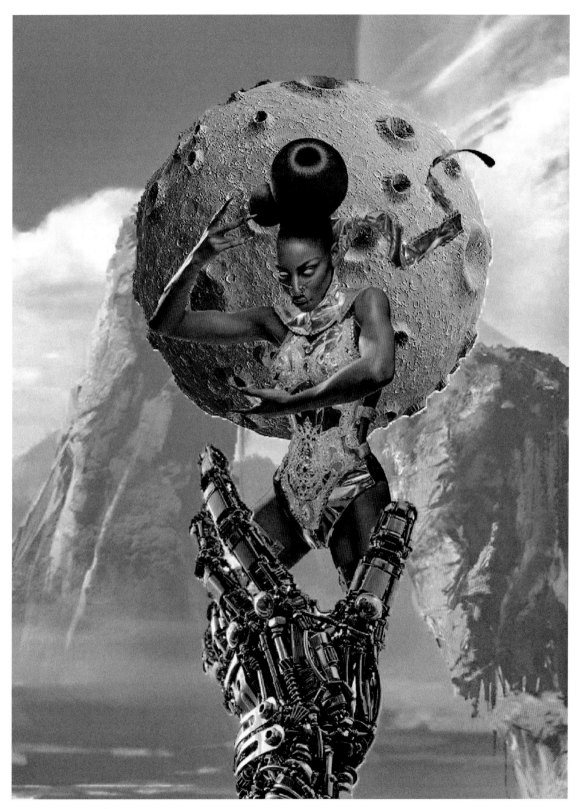

MOTHER MOON | BY KALI MARIE

CAMOUFLAGE 05 | BY ALEXANDER IKHIDE

There was a sense of gratitude for a space to just be free and have fun for the sake of having fun and to be encouraged to do so throughout the day whether through tasting food from local vendors, buying from local small businesses, or simply dancing along with strangers and exchanging warm smiles on that sunny day. What Alysha, a parade goer, described as "moving through spaces without apology . . . demanding energy intentionally or unintentionally . . . play . . . roots . . . we are powerful."

We are powerful. As the old adage goes, hurt people hurt people. The opposite is true as well: healed people heal people. And on the other side of a healing process, more room is made to support those around us who need healing too. It's evident, for example, in many homegoing rituals like

a repast where people come together after the burial of a loved one to share a meal and memories. Stories are told that everyone might have heard a million times and others never told before. It's in the memorials that pop up in front of apartment buildings or on the sides of highways to commemorate the loss of a life. Many candles, usually white, are lit. A bottle or cup of liquor is placed next to it, with balloons, pictures, signs, and loving words on them to remember they were loved, are loved.

In collective healing, we make room to dig deeper into what all is preventing joy from being more present or generally an existence with less pain and suffering. It's the opportunity to love more deeply and compassionately whether we understand one another fully or not.

As so many have said and continue to say, the healing that is required of us is massive. As much as Black joy can be the actual healing we need, we also know that healing from anything requires more than a moment or a day; often, it is a lifetime of work. And Black joy may not always be the healing we need, but it can certainly serve to get to that necessary space. It can certainly operate as a catalyst for the changes that will bring us peace and a sense of wholeness, absent of pains and traumas we've learned to carry along the way.

MARIA LUISA/ABUELITA | COURTESY OF
KLEAVER CRUZ

SISTA ZAI ZANDA

Black Joy on Stolen Blak* Lands|

These days,
I live

Twenty-six-hour journey from

Harare &

Two generations removed from

Rocking daily & all day like a baby
Body nestled snug, ear pressed tight against the warm and soothing
Triple-heart-beat rhythm of

Ancestral Home Land—

Ku
Mu
Sha.[†]

Ku-mu-sha: roots.

Ku-mu-sha: land.

Ku-mu-sha: lineage.

KuMu Sha: ancestry; the unshakeable and irremovable foundation;
 the spring of joy; the bones; the grounding rhythm of my round and
 soft Black body; or simply "home."

* *Visual artist Destiny Deacon devised the term "Blak" in 1990, when she decided to take the
 c out of "Black." Blak is now widely used to reference and distinguish Aboriginal and Torres
 Strait Islander experiences.*
† *"Kumusha" is a Chivahnu (or Shona) word from one of the languages spoken in Zimbabwe.*

At birth, my people named me Joy
After my natural frequency,
My infectious and warm gurgle,
A body that so effortlessly pulsates at the highest vibration.

This name is a reminder
of my uncorrupted self,
my purpose on
Earth enduring a thirst for more joy, more love, more magic.

These days—
I live as a Black African on stolen Blak Lands.
When white delusion gazes at my Black body with contempt,
dismissive eyes trace the voluptuous contours of my travelling
 Black-body-home

Colonial border patrols suspiciously
Stare down free-spirited Black and Brown immigrants' passports as
 potentially fraudulent,
how capitalism derisively washes its hands of the unhoused

These days, when greeted with such
Gaslighting,
Contemptuous
Dismissive
Suspicious
Unwelcoming,
Derision
Towards my Blackness so beautiful,
I consciously disconnect
Go within
find my spring of joy
My body-temple's enduring triple heart beat rhythm.

I pump up the joy.

I dig within to tap into that deeply imprinted triple-heart-beat rhythm of

Ku
Mu
Sha.

Ku-mu-sha: **roots.**

Ku-mu-sha: **land.**

Ku-mu-sha: **culture.**

Ku-mu-sha: **lineage.**

KuMu Sha: ancestry; the unshakeable and irremovable foundation;
 the spring of joy; the bones; the grounding rhythm of my round and
 soft Black body; or simply "home."

So, these days when that dehydrating gaze threatens to soak up my joy,

Focused inwards, I easily remember

Ku-mu-sha
Ku-mu-sha

Ku-mu-sha

Ku-mu-sha!

These days
Joy is
My Home is
My Roots is
My Body is

My Kumusha.

Kumusha is
This temple is
A home is
"An altar is never the sacrifice."*

Alchemy happens here in this body-altar
Where the sacred blends so seamlessly with profane.

..

* *Inspired by an Instagram post by Moniasse Laurence Sessou, which reads "I am the altar,*
 never the sacrifice."

This name,
Given to me at birth
Enshrines and honours my natural frequency.

In a world gone awry,
This name anoints
My body-temple as
My inviolable and sacrosanct abode.

I am that one.
Joy.

My body-temple, dubbed Joy,
Is an Ark for my soul's most sacred covenant.
Especially here in this time where I live
Uninvited guest on stolen Blak Lands
But always in awe and Black solidarity with unbreakable
Blak lineages at least sixty thousand years strong.

clitories

RADICALLY HEALING RAPTUROUS SELF LOVE | BY RUKAYA SPRINGLE

8

WE GET TO BE FREE

MOMMY CALL ME SPIDER-MAN | BY LEX MARIE

It started as an impulse. The Black Joy Project sprung from a place of deep depression and uncertainty of how to hold grief, chaos, and violence while insisting on living a life on my own terms—a life that was not first defined by pain and suffering or centered around it. I wanted to feel better, and the calling I heard the morning this all started led me to post one picture with no intention other than to follow this pull toward a new direction—a pull to seek people outside of myself to move toward that healing.

Since late 2015, this project has morphed and manifested itself organically into whatever form or shape it needed to be for the people and communities it has become a part of. As the person at the helm of this initiative, it's also become a way of life and not simply images to post on the internet or answers to interview questions. Black joy has become a compass in my toolbox necessary to eradicate all that is in the way of getting free, collectively.

Just like The Black Joy Project, we as individuals on our journeys toward joy must give ourselves and one another the room to grow, to transform as necessary. We must support one another to live life unapologetically and without constraint or harmful interruption, to become fully self-expressed and do so safely. Critically, James Baldwin often talked about the notion that racism (like other systems of oppression) didn't just kill Black people; it killed everyone it touched. White supremacy and all the -isms that spring from it kill *all of us* in one way or another. It's what insists that Black men and boys be "hard" and that Black women and girls be "strong," and the rest of us Black people are supposed to contort ourselves into those tight boxes and binaries.

Deep down, we all know that none of us want to be limited like this. Deep down, we know that each of us is an entry into all the ways that Black people can exist, however we want to exist. We are each portals to joy in our own unique way(s), each serving a distinct purpose. That's part of where that feeling of joy comes from in the moment of experiencing it. For a moment, we get to be *present* to what is at hand and move from there. Yes, Black joy can be a relief from the constant bombardment of violent and hateful images we continue to see regularly, on and off screens, but it's much bigger than that.

Black joy is also a cycle between our ancestors, our present time, and the ancestors we will become. It is generous and welcoming too. Most times that I've spoken to people about joy, they have offered stories that involved at least one other person. That to me has affirmed the belief in the relationship that joy has to community. Of course, we can be great all by ourselves, but there are levels to joy. The highest levels are tied to our relationships with one another. Yes, that means Black people. It also means all the other forms of life we share this planet with. I'm not saying everyone needs to go out tomorrow and become a hiker or gardener. I'm saying we have room to gain deeper respect for the natural world that has existed long before we have. It's fair to say those beings know a thing or two about life we can learn from. The way the life of peas taught young Malcolm the power of planting seeds, nurturing them to full growth and continuing to dream during the process.

Imagination—Black radical imagination—is key to creating the practices, beliefs, and values that will move us toward a world that loves Black people more than it loves to exploit us. Radical imagination is allowing your mind to stretch and expand further than you thought possible—further than we have been taught is possible. It's imagining life beyond the revolution, beyond the downfall of white supremacy. What exists in that vision?

A space to *be* as expansively and fully as possible. Period. Harm is not welcomed there, though it may come. May it be healed fast and reduced permanently.

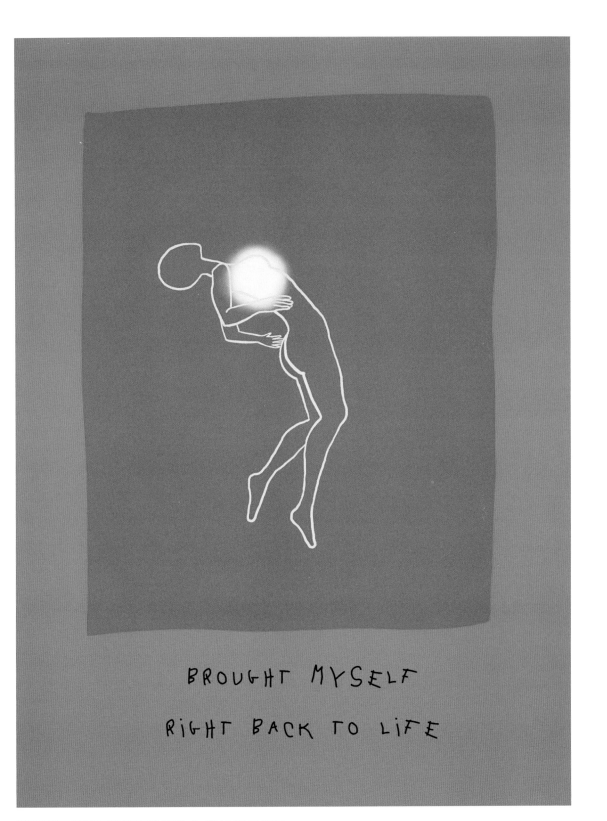

BROUGHT MYSELF BACK TO LIFE | BY IMAN DIARRA

BASKING IN MY BRIGHTNESS | BY IMAN DIARRA

In that joy, there is a freedom where we, all of us, are nourished, supported, healed and full of love. The freedom that Nina Simone famously defined as "having no fear." Healthy boundaries are established in this liberating vision, and we are worthy because we *exist*, not because we can do or provide something.

The most exciting and fulfilling part of the journey of The Black Joy Project has been learning about and connecting with other people creating, uplifting, and amplifying the power of Black joy. The people who have hosted parties, taken up space in parks, created tool kits, crafted zines, written articles, made videos, written poems, drawn pictures, recorded music, curated art, choreographed dances, led meditations, and given speeches, and all the ways they've been led to shine light on this powerful source. This book is but one more contribution to the growing landscape and visibility of a life force that has been here all along.

Consider this an invitation to continue to add to the world of Black joy wherever you are, whoever you are, however you are. There are so many voices and stories left to be heard and to learn the power of Black joy from. We need as many of our voices and perspectives in this work as possible. Those of the incarcerated. Those of the nameless. Those of nonbinary and trans people. Those who speak languages other than English. Those who may not be the best readers or writers but know so much about the ways of the world. The list is infinite.

As with most forces, there is strength in numbers. We need more books about Black joy. More movies. More TV shows. More community spaces. More parties. More schools that offer this lens of history. More workspaces that encourage it. More funding to support these efforts, not funding to policing and incarceration. More governments that prevent any roadblocks to it. More inventive ways to continue this calling to joy as a pathway toward the world(s) we must build after the many revolutions we must have to dismantle oppressive systems, practices, and beliefs that continue to attempt to, and sometimes successfully do, steal our joy daily.

Remember that like Toni Cade Bambara powerfully declared in 1970, "The revolution ain't out there." Joy must come from within us and among

UNTITLED CROWN | BY ASHANTÉ KINDLE

us, as it always has. Joy can be the entry point to make the necessary shifts in body, mind, and spirit to not run away from the horrible and often challenging realities many face every day but as a salve to walk through those fires still burning. And though the constant and consistent large battles with the forces outside of Black spaces continue, there is still much healing that joy can offer to the issues we face within our own communities. Opportunities to connect from a good place to address ongoing harm and hurt. We cannot address that which we do not confront. Joy can be part of that solution.

From the beginning, the vision for The Black Joy Project has been to amplify Black joy and increase its understanding of the constellations of joy makers it exists within. Continue to share your joy by living in it. Every day, people around the world are going through it. Through. It. *And* Black joy breaks through anyway, by any means necessary. That is worth protecting. And *why* that joy is threatened is an important question tied to this mission to understand *how* and *what* we can do about it. These deeper interrogations will help more of us see this transphobic white patriarchal cis-hetero capitalistic world for what it is: a thief of our joy(s) and well-being.

This vision of joy may not come to fruition for all of us in our lifetimes, but we must commit to imagining it, practicing it, and contributing to its full manifestation in this moment today, *right now*, for those who will come after us. These are the times we must come together to defend ourselves and one another fiercely. To get there, we must continue to learn from and understand the truth of those who came before us too as we navigate our current conditions, so that as their progeny, Earth's youngest children, we can learn from all those who dared to live so that we could thrive. In joy, we can make clear decisions in our best interests and have a positive impact on everything outside of ourselves. It can fortify the will as well as the support we need to keep going when we wish we hadn't gotten another chance to take a breath at all. In the prism of joy, Black joy is celebrated deeply, abundantly, unabashedly, lovingly, communally, continually, as needed and whenever possible. In that joy, we are loved. In that experience of Black joy, we are our most liberated. We get to *be*. Free.

Choose love.

Choose to love yourself.

Choose joy.

Choose Black joy.

ACKNOWLEDGMENTS

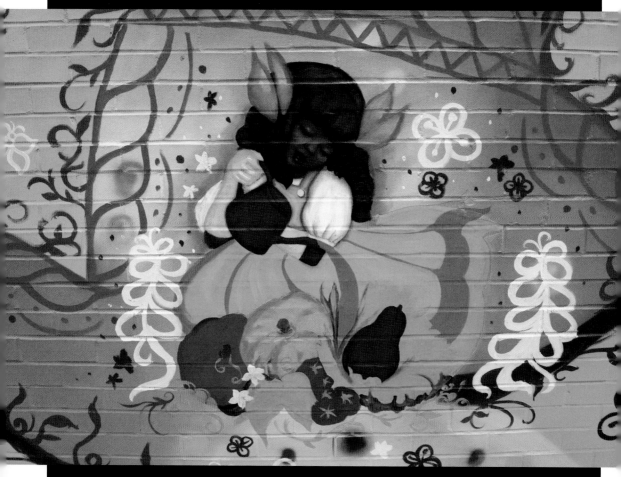

HOMEWOOD HARVEST, PANEL 4 DETAIL | BY MARLANA ADELE VASSAR

First and foremost, *thank you* to my ancestors and protective spirits. It is through and with you that we are here. Gracias, Abuela Ramona, Tio Ali, Tio Pupo, Abuela Zoila. To those whose names I know and those I have yet to learn. There are not enough words for how your presence and guidance has led me throughout this journey to affirm me in the moments of doubt and lift me up in the moments of hype. *Le pido que me siguen protegiendo, guiando y ayudando.*

Thank you is not enough to my family! My abuela, Maria Luisa, for being one of the deepest examples of joy as resistance I've ever known, even if we've never put those words together to describe you. My mom, Romelia, whose smile started this whole journey and who has been my rock in this lifetime. Truly a testament to joy. To Walter, for being there to listen and hype me up when I was down and scream together whenever we got good news, and for a lifetime of shared joys. To Shasho, for being one of the first faces in this impulse and offering really encouraging feedback. To my love, Ricky, who came into my life and changed it for the better, dried my tears on the hard days, and is the best thirty-second-dance-party partner anyone could ask for. Stephanie and Jason, I appreciate all the love you show me just for being myself and for giving me my favorite nieces in the world! To Syreeta C. Gates, couldn't ask for a better bestie and partner in crime as we both navigate this book game and the game of life. To Shantrelle P. Lewis, for constantly nerding out with me on all things Black and adding chapters to the journey. Gracias, AP. To my 250-milly gang, Akua Soadwa, Ashley Mui, Holley Kholi-Murchison,

Sallomé Hralima, and Gates, for literally offering provisions when I needed support and all-around encouragement as we each take the world by storm. To Sabrina Frometa, for bringing all those deep, contagious laughs and an ear to listen for the difficult stories.

Ms. Rita Fields, you get your own dedicated line because I am certain that I would not have written this book without you and the encouragement you gave second-grade Kleaver to write. You unlocked a door that changed my life forever.

Mille grazie to Alessandra Bastagli, who sparked the fire that led to meeting the people who would make this book possible and for consistently believing in my potential. Thank you to Bridgett Davis, who cosigned me publicly in a way that pushed me closer to finding my editor. Thank you to Rakia Clark, for your "tweet heard around the world," your call for a project around Black joy, your deep belief in me and what I am up to in the world, and your patience through a process full of events I don't think either of us could have ever imagined. Thank you to Ivy Givens, for your consistent enthusiasm, feedback, and contributions to this project. Muito obrigado, Renata De Oliveira, for listening so intently and bringing the words and images of these pages to a beautiful place as its designer. And thank you to everyone on the Mariner and HarperCollins teams who put in so much time and love to manifest these pages. Thank you to my agent Marya Spence and the Janklow & Nesbit team, for answering my many questions throughout this process and reminding me that books are a result of a team, not one person. Thank you, Tia Ross, for the copy edits. Shout-out to the HarperCollins Union for standing their ground! Thank you, Katie O'Donnell, for taking me under your wing when you did and getting my feet wet in this book world. Thank you, M. J. Williams, for not just being an incredible legal adviser but also an all-around support throughout the years with any questions/ideas/thoughts that I needed your eyes on.

Thank you to Yahaira "Yari" Tarr and Mackenzie Golbourne, who served as project assistants for different parts of this book. Thank you is not enough for your support and contributions!

Special and major shout-out to Veronica Dance, my therapist, cheerleader, and coach for the last few years. I am certain I wouldn't be where I am today without your support and encouragement. You spoke life into me in many moments when I could not do it for myself.

Un millón de gracias to my community and support in Pittsburgh: Angie Cruz, for being more than one of my OGs in this book world, but someone who makes me feel less crazy and more valuable as a storyteller on a mission; Dr. R. A. Judy, shukran, for giving me the space I needed and never questioning it, only pushing it forward; Dawn Lundy Martin, for giving me a deeper love of poetry and the intentional arrangement of words; Dr. Shaundra Myers, for opening a door in my mind around the history of literature and its material significance that I will gladly never close; Philippa Carter, for being a lifeline and resource that got me through some really hard spots; Willie Kinard III, for being my sibling in lit and life, our shared love of language is a gift; Taylor Waits, for all the riotous laughs and energy in moments when we didn't know what else to do; Fatima Jamal, for being my NY sib in the PGH streets and the many convos we've had and will continue to have about life on this floating rock; Justin Reed, for being the best neighbor a kid could ask for; and K. Henderson, for being you and always being a stand for me. Thank you to all the folks in PGH that made this kid from the BX feel a little more at home.

Thank you to Deron Dalton, for being the first journalist to reach out to me when this was still all very much an impulse and deciding that it was worth your time to write about it. Shout-out to Choyce Miller, for being the first producer to create a video about this journey toward joy and providing an opportunity to create a record of some of the people I love most. And thank you to all the journalists and media makers who have covered The Black Joy Project in some way and have moved the project forward! There are not enough words of gratitude for WAAD and all the ways you have inspired and held me. Thank you to AAAVC, for being early supporters and showing so much love over the years. Thank you to every single person who said yes in those early days of The Black Joy Project, when neither of us knew what would come of it.

This book would not have been possible without the benches, tables, chairs, and quiet and sometimes not so quiet rooms at the many New York Public Libraries I wrote in because I don't drink coffee and being around books is more inspiring. Similarly, thank you to the Carnegie Public Libraries. And big shout-out to all public spaces that make it easier and affordable for writers and artists like me who don't really drink coffee to get their work done.

Monica Dennis, there will never be enough words of gratitude to express the amount of appreciation I have for you and how you show up in the world. Thank you for being a supporter (and inspiration for this whole joy thing) from the jump; Nakisha Lewis, you are a lifeline, period!; Janisha Gabriel, hermana en el cielo, your life has left a mark on mine and so many others; Carmen Dixon, thank you, fam, for being an early supporter and just all around an amazing being; Vivian Anderson, you already know you have a special place in my heart in this lifetime and the next. Thank you to everyone in the BLMNYC crew from back in the day for supporting The Black Joy Project in every and any way that you have.

FunkFlex bomb drop TK + Conscious aka Bondfire Radio, thank you for not just giving The Black Joy Project a literal platform to grow but also being incredible cheerleaders and supporters of this work. Shakira O'Kane, thank you for inviting me to go on that trip with you and for just being you. BX to the world! Thank you to Rob Fields and Obden Mondésir, for creating an archival space for The Black Joy Project at the Weeksville Heritage Center; thank you, Elyse Ambrose, Nwabisa Tolom, and Richard Brookshire, for trekking through a winter storm to get trained on oral history making and then volunteering your time to contribute to this necessary archive. Thank you to every and any one who has quoted, posted, or talked about The Black Joy Project in a way that breathed more life into it.

Thank you to the Art Kultured, for offering an invaluable digital space that led me to find some of the contributors to this book.

Thank you is not enough for every single artist who said "yes" to being a part of this project. Your patience and graciousness have not gone unnoticed.

Thank you to the Loghaven Artist Residency, for taking care of me in more ways than I could have imagined in the final stretches of this project. Special special shout-out to my fellow artists: Daniel Corral, Alexander Gedeon, DaEun Jung, Jennifer Wen Ma, and Jane Wong—no better company to enjoy kudzu and wine with.

Big thank you to and appreciation for Darnell Moore, for insisting that I apply for that internship and for the many words and spaces we've shared over the years. Kiese Laymon, thank you for being the person who woke up my love for words at the moment I needed it. Thank you, Husani Oakley, for all those happy hour chats and for that support in my move to PGH when I really need it! To Indiana Garcia, thank you for being a rider through all these years and the many ways you've shown up as a real source of support and encouragement. Biany Perez, thank you for that reading that gave me peace of mind in this process that I'm not sure how I would've gotten otherwise. Jasmine Graves, thank you for being such a source of joy and deep intellectual exploration. Taj Shareef, even though we technically only shared space once, it's amazing how your consistent messages of encouragement have made it seem like many more times. Anyiné Rodriguez, thank you for the many shared writing sessions on weekend mornings and for putting me on to the Pomodoro Method!

I am thankful to have gotten through some of the most challenging years of my life while working on this book and am now better for it.

To the readers, thank you, all!

Ubuntu.

CONTRIBUTORS

HOOD CONGREGATION #1 | BY SADIA ALAO

Akua Soadwa

Alabi Mayowa

Alexander Ikhide

Amanda Dibando Awanjo

Andrea Walls

Angie Boutin

Anyiné Galvan-Rodriguez

April Kamunde

Arteh Odjidja

Ashanté Kindle

Becca Brown

Brenda A. Gates

Bria Sterling-Wilson

Bryce Cobbs

Cecilia Lamptey-Botchway

Cheriss May

Derrick Adams

Destiny Brady

Destiny Moore

Dominique Sindayiganza

Elizabeth Renee Gómez aka
 Liz Gómez

Emerald Arguelles

Eva Woolridge

Geoffrey Haggray

Iman Diarra

Jacqueline Ogolla

Jamaica Gilmer

Jamel Shabazz

Janaya Nyala

Javiela Evangelista

Justice Dwight

Kali Marie

Kiki Toussaint

Ladasia Bryant

Laylah Amatullah Barrayn

Letlhongonolo Mokgoroane

Lex Marie

Mark Modimola

Marlana Adele Vassar

McKinley Wallace III

Mithsuca Berry

Munganyende Hélène Christelle

Mwende Katwiwa

Nadia Huggins

Romelia Cruz

Rukaya Springle

Sadia Alao

Sallomé Hralima

Shantrelle P. Lewis

Sierra Clark

Sista Zai Zanda

Stephen Towns

Syreeta Gates

Tajh Rust

Terrell Villiers

Walter Cruz

Wesley George

Yannick Lowery

Ziana Pearson

NOTES

CHILDREN'S DRUM CLASS | NYPL

CHAPTER 1

4 *"My brother, when Langston gets to Cuba"*: "Afro-Ricans: The Black in the Brown in the US," YouTube, The AfroLatino Project, June 12, 2014, https://www.youtube.com /watch?v=WSCxbs-MO3o.

4 *who discovered this letter in 1975*: "CCCADI Annual Report 2021," CCCADI ANNUAL REPORT 2021, https://cccadi2021.report/.

CHAPTER 2

19 *we want it to be*: bell hooks, *The Will to Change: Men, Masculinity, and Love* (New York: Atria Books, 2004).

20 *and to preserve length*: Lauren Valenti, "How the Nomadic Women of Chad Are Keeping the Ancient Hair-Care Ritual of Chébé Alive," *Vogue,* March 8, 2022, https://www .vogue.com/article/chebe-hair-ritual-chad.

20 *the ongoing corruption*: Virginia Pietromarchi, "What Is Happening in Chad?" Politics News/Al Jazeera, October 21, 2022, https://www.aljazeera.com/news/2022/10/21 /dozens-of-protesters-killed-in-chad-what-happened.

20 *economically poor countries*: Al Jazeera, "In Chad, a Mobile School Offers Nomad Children Hope," Education News/Al Jazeera, September 21, 2022, https://www.aljazeera .com/news/2022/9/12/in-chad-a-mobile-school-offers-nomad-children-hope.

20 *celebration since 2002*: "Festisumbe Adiado Para 2016," *Comunidade Do Amboim—Kwanza Sul,* September 19, 2015, https://boaentradacadareencontros.weebly.com/noticias-de -destaque–kwanza-sul/festisumbe-adiado-para-2016.

20 *a beach in Sumbe*: "Unitel Festi Sumbe 2022: Unitel Festi Sumbe 2022: By Platina Line," Facebook, Platina Line, September 17, 2022, https://www.facebook.com/platinaline /videos/unitel-festi-sumbe-2022/1058329778127599/.

20 *FestiSumbe is electrifying*: "Festsumbe 2022—Festival Internacional De Musica Do Sumbe 2022," YouTube, uploaded by STTOP TV, September 19, 2022, https://www .youtube.com/watch?v=ycHA1IlintE.

20 *two-decade-plus civil war*: "The Angolan Civil War (1975–2002): A Brief History," South African History Online, February 5, 2015, https://www.sahistory.org.za/article/angolan -civil-war-1975-2002-brief-history.

21 *of all ages together*: José Casimiro, "Festival De Música Do Sumbe Regressa Este Ano à Marginal," *Jornal De Angola,* September 7, 2022, https://www.jornaldeangola.ao/ao /noticias/festival-de-musica-do-sumbe-regressa-este-ano-a-marginal/.

23 *"from all tribal ties"*: Miriam Tlali, *Muriel at Metropolitan: A Novel* (Washington, D.C.: Three Continents Press, 1979).

25 *African American blues*: "The Humble Roots of Old-School Bachata," *All Things Considered,* NPR, July 31, 2008, https://www.npr.org/2008/07/31/93140350 /the-humble-roots-of-old-school-bachata.

25 *Dominican identity and culture*: Deborah Pacini Hernandez, "Urban Bachata and Dominican Racial Identity in New York," *Cahiers d'Études Africaines* 54, no. 216 (2014): 1027–54, accessed September 9, 2022, http://www.jstor.org/stable/24476193.

26 *taking down the dictatorship*: Edwidge Danticat, *Create Dangerously: The Immigrant Artist at Work* (New York: Vintage Books, 2011), 2.

29 *"as it is about avoiding death"*: Danticat, *Create Dangerously,* 16.

30 *living in British Colonies:* James Cantres, "Black Spaces in Britain: On the Windrush and Small Axe," blog of the American Philosophical Association, January 20, 2021, https://blog.apaonline.org/2021/01/19/black-spaces-in-britain-on-the-windrush-and-small-axe/.

30 *hundreds of migrants from Jamaica:* "Windrush Passenger List," Goldsmiths, University of London, June 19, 2019, https://www.gold.ac.uk/windrush/passenger-list/.

30 *the ship's listed 1,027 passengers:* Lucy Rodgers and Maryam Ahmed, "Windrush: Who Exactly Was On Board?" BBC News, June 21, 2019, https://www.bbc.com/news/uk-43808007.

31 *much like The Black Joy Project:* Black Cultural Archives, "A History of Notting Hill Carnival," Google Arts and Culture, 2019, https://artsandculture.google.com/story/a-history-of-notting-hill-carnival-black-cultural-archives/pwXhDoHj8Po6Kg?hl=en.

32 *In an insightful article:* Adela Ruth Thompson, "'London Is the Place for Me': Performance and Identity in Notting Hill Carnival," *Theatre History Studies* 25 (June 2005): 43–60, https://www.proquest.com/scholarly-journals/london-is-place-me-performance-identity-notting/docview/214042438/se-2?accountid=147304.

32 *"because we deserve it":* Winsome Pinnock, "A Rock in Water," *Black Plays: Two,* ed. Yvonne Brewster (London: Methuen, 1989).

35 *from across colonized lands:* Taylor Waits, Willie Kinard III, and Kleaver Cruz, "Recovery + Re-distribution: Black Women's Literary & Artistic Legacies 1960–1985," Prezi.com, December 1, 2019, https://prezi.com/p/m_ehj98gbyup/recovery-re-distribution-black-womens-literary-artistic-legacies-1960-1985/.

36 *something that can be consumed:* Las Alegrias de las Palenqueras Video, YouTube, Kucha Suto Colectivo, December 6, 2012, https://www.youtube.com/watch?v=bG8xAYMuHu8.

38 *"the energy to continue thriving":* Patia Braithwaite, "Black Joy Should Be a Public Health Recommendation," *Self,* May 22, 2020, https://www.self.com/story/black-joy.

42 *culture, lifestyle, and fashion:* Alice Gbelia and Sanaa Carats, *Black Joy,* 2019.

42 *which she was searching:* Lillian Ogbogoh, interview with Alice Gbelia, *Shine Out Loud Show,* July 4, 2018, https://www.shineoutloud.tv/a-special-shine-out-live-interview-with-alice-gbelia/.

47 *in their home country:* "A Timeline of Denationalization," We Are All Dominican, May 12, 2014, https://wearealldominicannyc.wordpress.com/resources/a-timeline-of-denationalization/.

50 *He ran to save his own life:* Anna Malaika Tubbs, *Three Mothers: How the Mothers of Martin Luther King, Malcolm X and James Baldwin Shaped a Nation* (New York: Flatiron Books, 2021).

53 *Marie Pierra-Kakoma:* "Meet Lous and the Yakuza, the Belgian Artist Who Can Sing in Any Language," *Newsroom,* Spotify, May 22, 2020, https://newsroom.spotify.com/2020-05-22/meet-lous-and-the-yakuza-the-belgian-artist-who-can-sing-in-any-language/.

CHAPTER 3

63 *being raided by the police:* Channing Gerard Joseph, "The First Drag Queen Was a Former Slave," *The Nation,* January 8, 2021, https://www.thenation.com/article/society/drag-queen-slave-ball/.

65 *"Here he found tranquility":* Anna Malaika Tubbs, *Three Mothers: How the Mothers of Martin Luther King, Malcolm X and James Baldwin Shaped a Nation* (New York: Flatiron Books, 2021), 88.

67 *resistance to white supremacy there:* Tubbs, *Three Mothers.*

83 *"ain't no such animal as an instant guerrilla"*: Toni Cade Bambara, "On the Issues of Roles," in *The Black Woman: An Anthology*, ed. Toni Cade Bambara. (New York: New American Library, 1970).

84 *three thousand ethnic groups*: United Nations, Department of Economic and Social Affairs, Population Division (2022), World Population Prospects: The 2022 Revision, custom data acquired via website, population.un.org/wpp; African Languages of the World. Emory University, 2019, http://linguistics.emory.edu/home/resources/polyglot /low/low_nc.html; "Introduction to African Languages," Introduction to African Languages. Harvard University, n.d., https://alp.fas.harvard.edu/introduction-african -languages.

CHAPTER 4

99 *In the spring of 1994:* Ignatius Ssuuna, "25 Years After Genocide, Can Rwanda Heal? 6 Villages Try," Associated Press, April 6, 2019, https://apnews.com/article/ap-top-news -africa-rwanda-international-news-genocides-719ac8f0c4da4d2b80976057d869562a.

100 *at the hands of Hutus:* Anna Kamanzi, "A Nation Without Ethnicity: The Rwandan Reconciliation Model," Debates Indígenas. International Work Group for Indigenous Affairs, October 1, 2021, https://debatesindigenas.org/ENG/ns/132-nation-without -ethnicity-case-of-rwanda.html.

100 *One of those methods:* Julena Jumbe Gabagambi, "UPDATE: A Comparative Analysis of Restorative Justice Practices in Africa," Hauser Global Law School Program, New York University School of Law, 2020, https://www.nyulawglobal.org/globalex/Restorative _Justice_Africa1.html.

CHAPTER 5

111 *"Without community there is no liberation"*: Audre Lorde, "The Master's Tools Will Never Dismantle the Master's House," in *This Bridge Called My Back: Writings by Radical Women of Color*, eds. Cherríe Morraga and Gloria Anzaldúa (New York: Kitchen Table Press, 1983), 94–101.

116 *the chaos of European colonization:* A version of this segment originally appeared in *Cultured* magazine's Sept/Oct/Nov 2020 Issue.

116 *The festival was originally scheduled:* "The Dakar Festival Colloquium on Negro Arts, April 1966," *Africa* 36, no. 4 (1966): 439–41.

116 *"presence of Blackness in the world"*: Alex Poinsett, "FESTAC '77," *Ebony*, May 1977.

PIECE OF JOY

134 *"Here there is disaster and possibility"*: Christina Elizabeth Sharpe, *In the Wake: On Blackness and Being* (Durham, NC: Duke University Press, 2016).

135 *"it is crucial as bread"*: Judith Butler, Essay, in *Undoing Gender* 29 (2004).

135 *beyond the quagmire of the present:* José Esteban Muñoz, *Crusing Utopia: The Then and There of Queer Futurity* (New York: New York University Press, 2009).

CHAPTER 6

139 *unity at the edge:* Kleaver Cruz, "Sacred Moss," in *Even Wildflowers Need Sun or Two Flowers Can Be Beautiful at Once* (unpublished, 2020).

140 *"the coral reef of the forest"*: Krista Tippett, "Robin Wall Kimmerer—The Intelligence of Plants," produced by the *On Being* Project, August 20, 2020, https://onbeing.org/programs/robin-wall-kimmerer-the-intelligence-of-plants-2022/.

140 *the survival of all the stalks*: Skye Cahoon, "The Resiliency of Mosses," Midcoast Conservancy, March 17, 2022, https://www.midcoastconservancy.org/newsfeed/the-resiliency-of-mosses.

141 *"we are each other"*: Matthew Burgess, "Rigorous Play and Necessary Joy," *Teachers & Writers Magazine,* November 4, 2019, https://teachersandwritersmagazine.org/rigorous-play-and-necessary-joy-an-interview-with-poet-and-teacher-ross-gay/.

147 *"human to beast, you get it"*: Aaryn Lang, "Miss Lang Presents | What's Really Goin' On?" YouTube, October 22, 2020, http://www.youtube.com/watch?v=k-xq0LYZvQs.

153 *religion, trade, and politics:* "Black Past Timelines," Black Past, August 19, 2022, https://www.blackpast.org/black-past-timelines/.

156 *"seeding sovereignty in the food system"*: Soul Fire Farm, 2022, https://www.soulfirefarm.org/.

157 *"progress of the society in question"*: Amílcar Cabral, trans. Maureen Webster, *National Liberation and Culture: Amílcar Cabral* (Syracuse, NY: Syracuse University Press, 1970).

158 *1970s account of Maroon history:* Milton McFarlane, *Cudjoe the Maroon* (London: Allison and Busby, 1977).

160 *"there are new suns"*: Gerry Canavan, "'There's Nothing New / Under the Sun, / but There Are New Suns': Recovering Octavia E. Butler's Lost Parables," *Los Angeles Review of Books,* June 9, 2014, https://lareviewofbooks.org/article/theres-nothing-new-sun-new-suns-recovering-octavia-e-butlers-lost-parables/.

162 *"tolerate stress like few other plants"*: Rachel Cooke, "Robin Wall Kimmerer: 'Mosses Are a Model of How We Might Live,'" *Guardian,* June 19, 2021, https://www.theguardian.com/science/2021/jun/19/robin-wall-kimmerer-gathering-moss-climate-crisis-interview.

CHAPTER 7

166 *In fact, a meta-analysis:* Andrew Steptoe, "Happiness and Health," *Annual Review of Public Health* 40 (April 2019): 339–59, https://doi.org/https://doi.org/10.1146/annurev-publhealth-040218-044150; Patia Braithwaite, "Black Joy Should Be a Public Health Recommendation," *Self,* May 22, 2020, https://www.self.com/story/black-joy.

166 *"Healing, with Joy"*: Shameem Akthar, "Healing, with Joy," India Abroad, August 29, 2014.

173 *"a nervous breakdown"*: Byron Hurt, *Soul Food Junkies* (USA: God Bless the Child LLC, 2012).

178 *since its inception in 2008:* Charlotte Livingstone, "Armed Peace: Militarization of Rio De Janeiro's Favelas for the World Cup," *Anthropology Today* 30, no. 4 (2014): 19–23, http://www.jstor.org/stable/24030396.

180 *"not nearly enough to celebrate"*: Samantha Clark, "Photos: Oakland Celebrates Black Joy Parade," KQED, February 25, 2018, https://www.kqed.org/news/11652237/photos-oakland-celebrates-black-joy-parade.

180 *this signature event and beyond:* "About," Black Joy Parade, accessed February 2, 2023, https://www.blackjoyparade.org/about.

CREDITS

CREDITS

210

STEFEN POMPÉE

A lover of words and their meanings across languages, **Kleaver Cruz** (they/he) is a Black, queer, Dominican American writer and educator from New York City. Cruz is the creator of The Black Joy Project, a digital and real-world affirmation that Black joy is resistance. The Black Joy Project has been featured in *British Vogue*, on Vibe.com, in the *Huffington Post*, and in various other publications in print and online. Cruz is a member of We Are All Dominican, a U.S.-based, grassroots collective that works in solidarity with movements led by Dominicans of Haitian descent fighting for inclusion and citizenship rights in the Dominican Republic. Cruz is also an alum of the Voices of Our Nations Arts (VONA) Foundation's emerging writers nonfiction workshop and *The Kenyon Review* Writers Workshop in fiction. Kleaver believes in the power of words to write the stories that did not exist when they needed them the most.

HarperCollins books may be purchased for educational, business, or sales promotional use. For information, please email the Special Markets Department at SPsales@harpercollins.com.

FIRST EDITION

DESIGNED BY RENATA DE OLIVEIRA

Library of Congress Cataloging-in-Publication Data

Names: Cruz, Kleaver, author.
Title: The Black joy project / Kleaver Cruz.
Description: First edition. | New York : Mariner Books, [2024]
Identifiers: LCCN 2023027841 (print) | LCCN 2023027842 (ebook) | ISBN 9780063294363 (paperback) | ISBN 9780358588757 (hardcover) | ISBN 9780358588689 (ebook)
Subjects: LCSH: Black people in art. | Joy in art. | Arts, Modern--21st century--Themes, motives.
Classification: LCC NX652.A37 C78 2024 (print) | LCC NX652.A37 (ebook) | DDC 704.9/42--dc23/eng/20230912
LC record available at https://lccn.loc.gov/2023027841
LC ebook record available at https://lccn.loc.gov/2023027842

ISBN 978-0-358-58875-7

23 24 25 26 27 TC 10 9 8 7 6 5 4 3 2

CIRCA NO FUTURE NO. 10 | BY NADIA HUGGINS